D

5554

Norman Foster
Richard Rogers
James Stirling

New directions in British architecture

Deyan Sudjic

Norman Foster

Richard Rogers

James Stirling

**With 170 illustrations
34 in colour**

Thames and Hudson

The publishers wish to express
their gratitude to Richard
Bryant, who has provided the
majority of the photographs used
in this book. The sources of
illustrations are given in detail on
page 201.

Designed by
Simon Esterson

This edition first published
in paperback 1988
Reprinted 1989

Printed and bound in Singapore
by C. S. Graphics

Contents

Introduction

Opposite *one important theme that
links all three architects is an
imaginative concern for urban
planning. This is seen at its most
radical in Rogers's 1986 plan for a
new bridge across the Thames, of
which a conceptual sketch (drawn by
Laurie Abbott) is shown here. This
structure, which would replace
Hungerford Bridge, is part of an
ambitious project for revitalizing the
South Bank – a development of
Rogers's unbuilt Coin Street scheme
(see pages 62–68). Rogers plans to
divert to Waterloo all the rail services
at present carried by Hungerford
Bridge. Charing Cross station would
be closed, and the new bridge would
be for pedestrians only. It would be
flanked by pontoons carrying
restaurants and other amenities.*

For all their apparent differences – in their
personalities as much as in their work – the
three British architects Norman Foster,
Richard Rogers and James Stirling have far
more uniting than dividing them. For perhaps
the first time in two generations since Edwin
Lutyens and Charles Rennie Mackintosh,
Britain has not just one but three architects
capable of earning attention on a world stage.
Their work has been a catalyst for a
fundamental reassessment of architecture in
Britain, as well as an important contribution to a
similar debate currently being conducted
internationally about the direction that
architecture will take in the present climate,
where no one view of the subject predominates.

For the past thirty years or more, the three
have continually crossed each other's paths.
They have addressed the same problems, which
are for modern architecture the most critical
ones: how to build in cities, and how
architecture can proceed after the easy solutions
of the previous generation have lost their gloss.
They have gone a long way toward re-
establishing the importance of urbanism as a
concern of contemporary architecture and they
have each, in different ways, attempted to come
to terms with the issues of architectural context
and the impact of technology.

Stirling taught Rogers at both the
Architectural Association in London and at
Yale, where Foster was also a student, and it was
he who recommended the fledgling Foster and
Rogers practice, Team 4, for its most significant
commission – the Reliance Controls building in
Swindon. The roles have since been reversed:
in the 1980s Rogers, as chairman of the trustees
of the Tate Gallery, became the titular employer
of Stirling and his partner Michael Wilford for
the Tate Gallery extension and the Tate master
plan, as well as for their conversion of part of the
Albert Docks complex in Liverpool to house the
Tate's northern outpost. Foster and Rogers,
after meeting as postgraduate students at Yale,
returned to the optimistic Britain of the early
1960s to establish an architectural practice
together. As they began to achieve success in the
1970s and early 1980s, they also both began to
feel the problems faced by those in Britain in
that period who attempted to offer fresh
solutions to the difficulties the country faced
rather than sharing the general nostalgia.

Clearly the work of each of the three
individuals is his own; in each case it is
distinctively different. And yet they have certain
things in common. For all the eagerness of those
who have sought to portray modern architecture
as dead, each of them is a modern architect in
his own way and each depends on partners,
associates and employees. Stirling and Wilford
share responsibility for projects and Rogers's
partners, John Young, Marco Goldschmied and
Mike Davies, play distinctive roles in creating
the partnership's buildings.

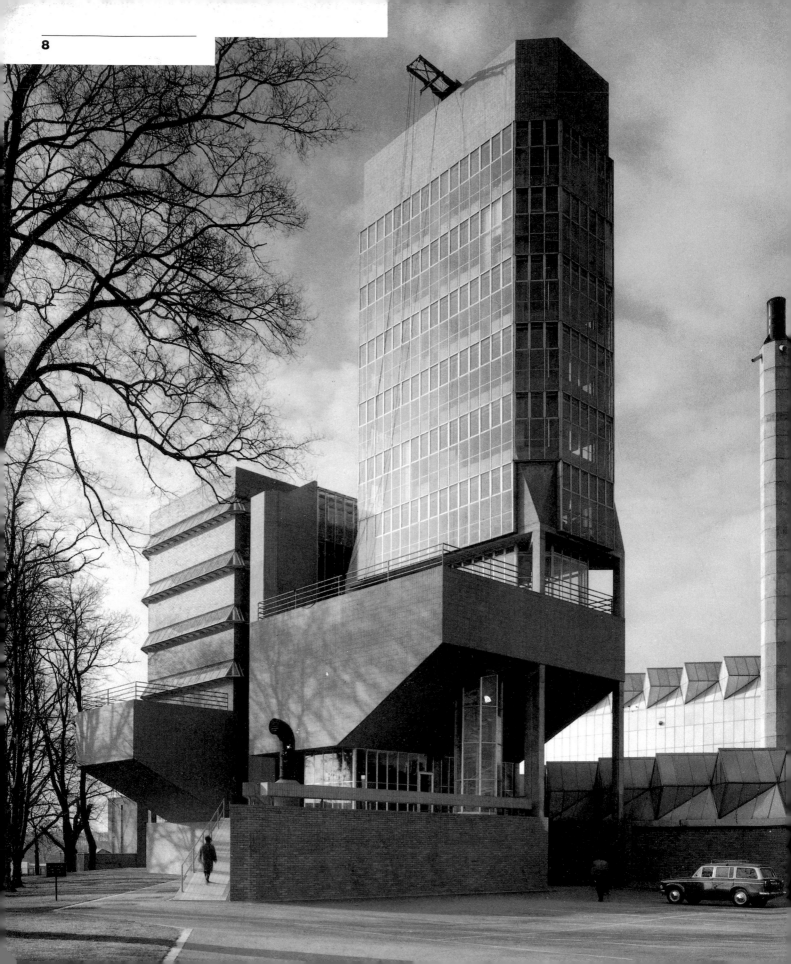

Three careers

Designed in 1959, Stirling and Gowan's Leicester University Engineering Building, with its jutting lecture theatres and its tower – its height a product of the department's need for a 100-feet-high head of water for hydraulic experiments – marked the emergence of Stirling's personal style.

For the more reflective of architects, the 1980s have been perplexing, not to say bemusing, times. Their stock has risen and fallen with bewildering speed. At one moment, they are pilloried by those who purport to represent or reflect public opinion for being arrogant formalists, technologically incompetent, and sinister, if inept, social engineers. The next instant, the celebrity-hungry media rediscover the star potential of architecture once more: against a background of benighted concrete and senseless urban chaos, even the most banal mirror-glass palaces in Houston can provide enough fleeting glamour to make their creators into 15-minute celebrities.

It is architects who have borne the brunt of the burgeoning public mistrust of professionals of all kinds which has been encouraged by both ends of the political spectrum. At one extreme, conservatively inclined governments in both Britain and America have successfully put an end to what they see as the monopolistic practices of the professions, at least as far as architects are concerned. Their fixed scale of fees, their prohibitions on advertising and on competing with each other over prices have all been swept away. At the other end of the spectrum, left-wing activists have attacked them for their elitism, arrogance and irrelevance to the concerns and needs of everyday life.

Despite the shrill tone and sometimes exaggerated language in which these charges have been made, they have not always been ill-founded, especially when they concern the unacceptably high levels of technical and social failure. But even architects with unblemished records have had to face unprecedentedly litigious clients and contractors, and have had to work in the context of ever more convoluted and arbitrary planning procedures. In Britain at least, many architects of ability have found themselves trapped into paper architecture, starved of work, eking out a precarious living by teaching. British architects are still routinely described as 'young' at forty-five, although a better description might be 'underemployed'. Above all, architects have had to come to terms with a fundamental shift in the intellectual landscape in which they must work. It is a shift which is not caused only by the greatly exaggerated reports of the death of modern architecture, as retailed by certain over-excitable critics and practitioners.

The day that *Women's Wear Daily* printed a picture of America's leading post-modernist architect, Michael Graves, cancelled out by a large red cross was in some ways a much more illuminating event than the endlessly recapitulated affair of the dynamiting of Minoru Yamasaki's Pruitt Igoe flats in St Louis. Pruitt Igoe demonstrated that mistakes had been made of both a technical and a social nature. But this was hardly a startling revelation, for mistakes have always been a possibility. The *Women's*

Stirling and Gowan established their practice together in 1956 on the basis of a commission for a development of private flats at Ham Common, in an outlying suburb of London. Some purchasers were startled by the bare brick walls that formed part of the interiors.

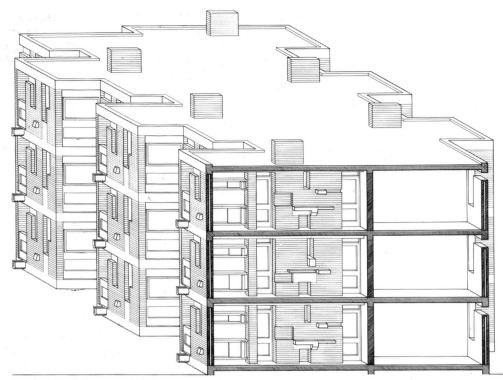

Wear Daily episode proved devastatingly the extent to which architecture had become simply another visual commodity, its imagery subject to the same greedy pillaging by a media-jaded world as pop music, soap opera and royalty. Enjoying brief fame, but inevitably consumed by it, architecture is then discarded, sucked dry of all meaning, in the same way that the endless repetition of certain passages of music for advertising purposes leaves them tired and threadbare.

In the 1920s and 1930s it was commonplace to deplore the 'misleading' impact of architectural photography, with its repertoire of filters and lenses. By means of the specialist magazines in which this photography appeared, architects became known to each other more by the image of their work than by its substance. But by now the process has exploded beyond control, and beyond regret. Piano + Rogers's Beaubourg Centre appears on record covers, as the backdrop to television commercials advertising motorcars, even as a film set, and its most conspicuous features have provided the inspiration for everything from fast-food restaurants to factories. To see the building narrowly as architecture, and to discuss its significance only in the traditional academic sense, becomes impossible.

Another change in our perceptions, brought about by a similar process, and in part a reaction against it, is concerned with the way in which we see our immediate past. Architecture has of course always been subject to continuous reassessment, to changing interpretations of its significance and quality. But in Britain, and in a different way in America, the only criterion that counts now is that of age. In some circumstances, all it takes for banality to be transformed into heritage is the elapse of say thirty years. Oddly conflicting though these two phenomena are, they have between them brought about what is inevitably a very different kind of architecture from that of the pre-industrial age. It is these changes that mark a real departure from the past, much more than any break with the heroic period of modernism – a break, incidentally, which has been neither as sharp nor as recent as is often maintained.

James Stirling, Richard Rogers and Norman Foster, all born within nine years of each other (Stirling, the oldest, in 1926), belong to the first generation of architects who have matured within such a context. To the youthful James Stirling in the 1960s 'Modern Architecture' was already separated from him by an unbridgeable gulf. It might not be dead, but it was certainly quite different from the activities in which he and his contemporaries were then engaged. Writing in the *Architectural Review* in 1955 after visiting two Le Corbusier houses close to Paris, Stirling compared the purism of Les Terrasses, built for Michael Stein at Garches in 1927, with the Maisons Jaoul, then under construction.

Stirling found a change in Le Corbusier that suggested to him that modernism of one kind at least was already over. 'To imply that these houses will be anything less than magnificent would be incorrect', he wrote of Jaoul. 'Their sheer plastic virtuosity is beyond emulation. Nevertheless, on analysis, it is disturbing to find little reference to the rational principles which are the basis of the modern movement, and it is difficult to avoid assessing them other than as "art for art's sake". More so than any other architect of this century, Le Corbusier's buildings present a continuous architectural development, which however has not recently been supplemented by programmatic theory. As homes, the Jaoul houses are almost cozy, and could be inhabited by any civilised family, urban or rural. They are built by, and intended for, the status quo. Conversely, it is difficult to imagine Garches being lived in spontaneously except by such as the Sitwells, with never less than half a dozen brilliant and permanent guests. Utopian, it anticipates, and participates, in the progress of 20th century emancipation. A monument, not to an age, which is dead, but to a way of life which has not yet arrived, and a continuous reminder of the quality to which all architects must aspire if modern architecture is to retain its vitality.'[1]

But if Stirling's intellect drew him toward Garches, it was the power and force of Jaoul – the rough and ready brickwork, the curved Catalan vaults, the texture of the raw concrete and the manipulation of the spaces within it – that were to leave the strongest impression. So much so that only a year later, the first building of consequence by the newly formed partnership of Stirling and James Gowan (which lasted from 1956 to 1963), an apartment complex at Ham Common in London, was heavily under the influence of late Le Corbusier, despite Stirling's earlier strictures. (Stirling's career, it should be noted, has spanned two partnerships; the second, with his long-standing collaborator Michael Wilford, began in 1971. From that date Wilford and Stirling have joint responsibility for all the partnership's buildings.

The Ham Common flats attracted the

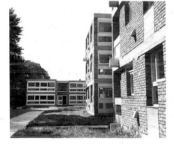

Right and above *The combination of brick walls and a raw concrete structure at the Ham Common flats clearly owes a large debt to Le Corbusier's Maisons Jaoul in Paris (1954-6), a scheme that Stirling had described at length in the 'Architectural Review' of 1955.*

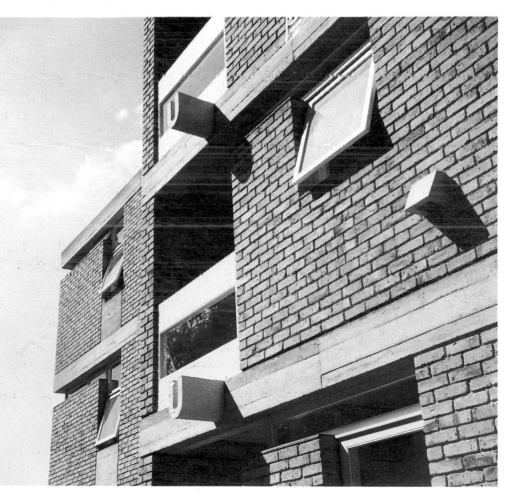

Stirling and Gowan's unsuccessful entry for the limited competition in 1958 to design Churchill College, Cambridge. They proposed building an outer wall of student rooms enclosing a giant cloistered courtyard that would have housed the college's communal facilities: hall, library and chapel.

attention of Nikolaus Pevsner's most distinguished student, the English critic Reyner Banham, and a place in the history of English Brutalism, the chimerical movement that seldom amounted to more than a journalistic label – a label that Stirling has always rejected. (The Brutalists were distinguished by their determination to use such materials as raw concrete or rough brick as they found them, without concealment.) From the vantage point of the 1980s, an era in which architectural flamboyance is so much the norm that it has desensitized us to subtler nuances of meaning, it is no longer obvious just how much of a departure the Ham flats, built in the grounds of a Georgian house as a high-quality speculative development, represented at the time. To recapture their full impact, it is necessary to examine the climate of the late 1940s and early 1950s. It was a period in which Stirling, a parachute veteran of the D-Day landings in Normandy, completed his architectural education at Liverpool University (1945-50) and then at the London University town planning institute. After what he once described as the shortest time on record on the payroll of the London County Council's planning department, he took his first steps in architectural practice as an assistant with the firm of Lyons, Israel and Ellis, an office that was expanding on the strength of a series of commissions for new schools, part of the post-war reconstruction of the state educational system. At the same time, Stirling worked on his own account on the design of a series of private houses. None of the five that he designed was built, and four of them were rejected by the planning authorities on aesthetic grounds.

These were frustrating times for members of the architectural avant-garde, of which Stirling

would certainly have counted himself a member. The euphoria of the Labour election victory of 1945 and the political transformation it promised had seemed like an ideal opportunity for an equivalent physical transformation of Britain. The serious-minded modernism of the MARS group (the British disciples of the Bauhaus), and the idealism of newly qualified architects who had led the series of revolts in their schools against traditional academic teaching methods, ought to have been the natural accompaniment for the welfare state.

Despite isolated examples of sophisticated home-grown talent in the years before 1939, such as Denys Lasdun's suave Corbusian house in Paddington, Maxwell Fry's apartment block for the London Gas Company, or Amyas Connell's house High and Over, and despite distinguished work by émigrés such as Berthold Lubetkin and Erno Goldfinger who elected to stay in Britain after Serge Chermayeff, Walter Gropius, Marcel Breuer and Erich Mendelsohn had left for America, the pre-war period was not fertile ground for modernism in the United Kingdom. Before the war, such leading figures within the profession as Sir Reginald Blomfield campaigned publicly against what he called the alien 'modernismus' threatening Britain from the continent. And even Voysey went out of his way to reject attempts by modern movement proselytizers to coopt him as a founding father.

Yet the European modern movement, by now well out of its experimental phase, could not fail to make a huge impact on the younger generation in Britain, particularly in the absence in the 1930s and 1940s of any traditionalist able to match Lutyens's finest work. Le Corbusier's writings were translated into English from the late 1920s onward, and his work together with that of the other pioneers was quickly, if erratically, published by the *Architectural Review*. In the schools of architecture, demands for a revised curriculum, guided by what was perceived as the rationalist model of the Bauhaus, began to make themselves felt. One architectural school, the Architectural Association in London, witnessed what amounted to a revolution led by students of a radical persuasion.

A subtler state of affairs prevailed at Liverpool, then Britain's largest university school of architecture, and, under the direction of Sir Charles Reilly in the 1920s and 1930s, one of its most distinguished. Although Liverpool could hardly have been called modernist until the end of the 1940s, it was a place at which such matters were discussed.

Stirling recalls his first year there, under Professor Budden, rendering the classical orders, detailing an antique fountain, and designing a house in the manner of Voysey. Thanks to the legacy of Reilly's impressive range of personal contacts, and his determination to maintain a link with America (a direction in which Liverpool, with its liners and metropolitan civic monuments, was already predisposed), the school had an open-mindedness that made it quite different from any other in Britain and made it a natural destination for Stirling, the son of a Scots ship's engineer who had migrated to the city in 1927.

Stirling's education was at Quarry Bank High School, followed by a brief pre-mobilization spell at Liverpool College of Art. As Stirling describes them, the post war years were a period of turmoil within the Liverpool School of Architecture. 'There was furious debate as to the validity of the modern movement, tempers were heated and discussion was intense. Some staff resigned and a few students went off to other schools; at any rate I was left with a deep conviction of the moral rightness of the new architecture.'[2] Within the school, the presence on the teaching staff of the influential English critic Colin Rowe, who was to have a lasting influence on, and friendship with, Stirling, and the company of students such as Robert Maxwell and Douglas Stephen, who were to move on to London with Stirling after completing their studies and become leading figures in the architectural world of the 1960s, contributed to a far more sophisticated awareness of the nature of modernism than prevailed elsewhere in Britain. It was a school that was quite capable of understanding that modernism was not a monolithic movement; there was, for instance, an appreciation of the differences between the Italian modernist Giuseppe Terragni and Gropius. 'We oscillated backwards and forwards, between the antique and the just arrived "Modern Movement" – which for me was the foreign version only – as taught by Colin Rowe. In addition to *Towards a New Architecture*, the book which influenced me most was Saxl and Wittkower's huge atlas-like *British Art and the Mediterranean*.'[3]

But it is clear that Stirling's experiences as an exchange student, working and travelling for five months in America, were to prove equally formative. Later he was to write gloomily of the divergence between American and European architecture. Given Britain's post-war austerity, America alone seemed able to pursue technologically advanced modernism, leaving Europe to enforced pragmatism. That combination – experiencing the vigour of American optimism at first hand, while appreciating the essential rigour behind European modernism of the pre-war period – made the triumph of picturesque whimsy in the Britain of the 1950s especially hard to bear for Stirling and others of his generation, such as Alison and Peter Smithson. Colin Rowe recently summed up their feelings toward the Festival of Britain phenomenon with the word 'disgust'. How could it have been anything less? Here was the much advertised assertion of Britain's emergence from war and austerity, but, despite the presence of individual works of quality on the Festival of Britain site, the school which the festival inspired turned out to be no more than a celebration of the cute and the picturesque, in compromised and second-hand forms. It seemed nothing short of a betrayal.

'The Hertfordshire schools might be considered our best post-war effort', wrote Stirling in 1958, referring to Britain's much respected experiment in prefabricated building, 'but they do not set a standard either in conception or in style. They were, at least initially, motivated by a will to modernity. But one only has to compare the Crystal Palace to the Festival of Britain, or the Victorian railway

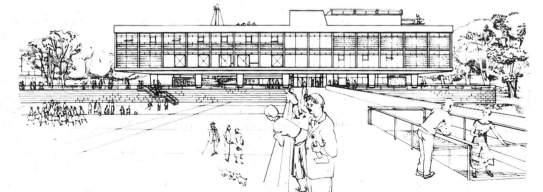

Stirling's thesis project for the University of Liverpool in 1950 was the design of this town-centre building for Newton Aycliffe, Durham. His admiration for Le Corbusier is evident in the building's asymmetry and the use of pilotis; the toylike weather vane was to become something of a Stirling trademark (see page 143).

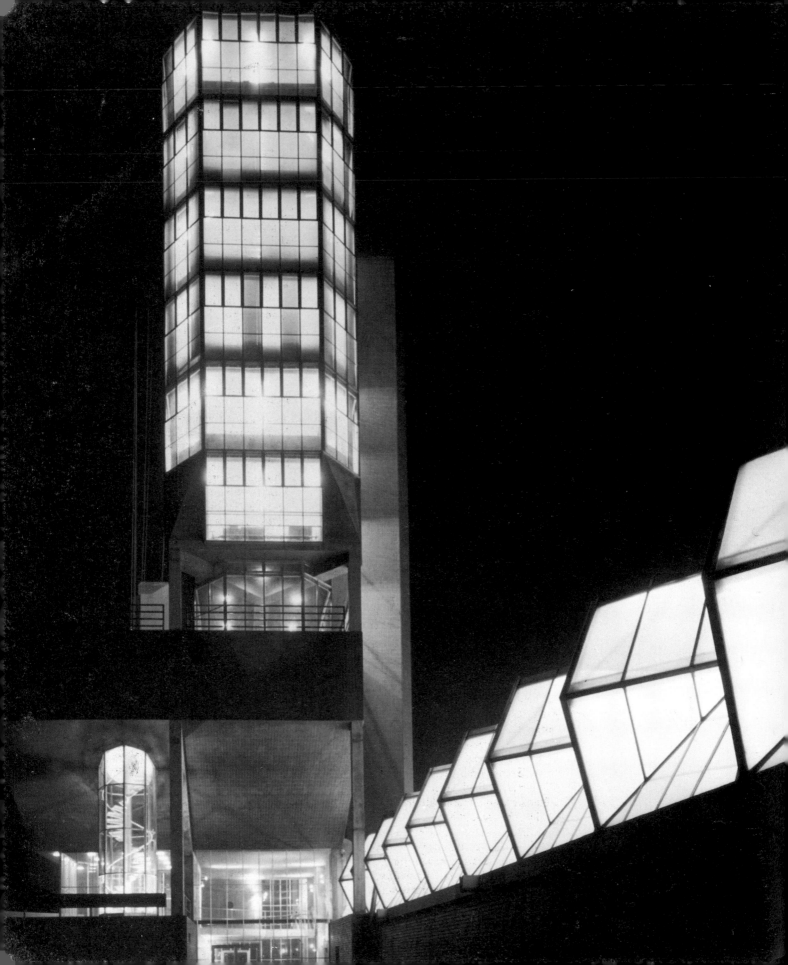

Left *Leicester University's Engineering Building was a landmark in post-war British architecture and went a long way to establishing Stirling's international reputation. Its dynamic composition and use of industrial glazing techniques were in sharp contrast to the saccharine architectural tradition of the Festival of Britain. The tower on the left houses the academic offices; part of the engineering workshop shed is on the right.*

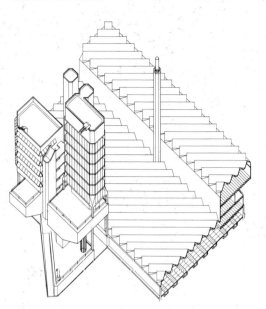

Right *Isometric view of Stirling and Gowan's Leicester University Engineering Building. Two towers and two lecture theatres rise out of a long, low workshop building. The geometry of the project has often been explained by Stirling's preference for the axonometric and isometric techniques of projection.*

stations to recent airports, to appreciate the desperate situation of our technical inventiveness today, compared with the supreme position which we held in the last century.'[4] Clearly Stirling saw Britain at the end of the 1950s declining into provincialism, a nation dotted with prim new towns that negated the very idea of urbanity, full of thin-lipped Scandinavian-influenced cosmetic details and skin-deep prettiness which was at the time passed off as the pinnacle of modern achievement.

Stirling was, however, enough of an optimist to offer a solution to this bleak prospect, or at least a way out for those with a mind to try to find one. 'Today, Stonehenge is more significant than Christopher Wren', he wrote. 'The exploitation of local materials and methods is perhaps the only alternative to the conventional or the "contemporary" left open to the European architect confronted with a minimum budget.'[5]

To Stirling, faced with the manifest inability of Britain to build with technical sophistication – because of the lack of resources and materials during this period – the only escape was to develop his sensibility toward the industrial vernacular, in particular the anonymous but forceful nineteenth-century buildings of Liverpool, of which he had busily been collecting photographs. He enthused about 'the ability to be stimulated by actual contact with an object, even though its author may be unknown, and theories appertaining to its appearance unwritten'. Such inspirations might come from '19th century warehouses and office buildings, in fact anything of any period which is

unselfconscious and virtually anonymous. It should be noted that the outside appearance of these buildings is an efficient expression of their specific function, whereas, today, they may be appreciated picturesquely, and possibly utilised arbitrarily.'[6]

Stirling wrote these thoughts in his early thirties, as a background to housing studies he was working on for Team X, the Smithson-dominated group of young Turks organized to ginger up the by now fading Congrès Internationaux d'Architecture Moderne (CIAM), the international network of modernist architects who had drawn up the international style's guiding principles. These studies have echoes of the Independent Group, the informal coalition of artists, architects and writers, spanning from Reyner Banham to Eduardo Paolozzi, that gathered around the Institute of Contemporary Arts, and which provided the seedbed for the emergence of pop art in the 1960s.

The statement was to prove prophetic of Stirling and Gowan's first realized work of international importance, the Engineering Building for the University of Leicester, designed from 1959 onward, and fully occupied in 1964. It was a commission, awarded as the result of a recommendation by Sir Leslie Martin, which restated themes already contained in Stirling and Gowan's project for Selwyn College, Cambridge (1959). Critical reaction to it was overwhelmingly enthusiastic right from the start, despite some dissent from Pevsner who saw worryingly expressionist indulgence in it. In the *Architectural Review*, John Jacobus wrote of the building as 'so complete and integral a solution, that one is consumed with a paradoxical fury. Why have we been willing to settle for anything less? How is it possible that this achievement is the exception and not the rule?'[7]

In a Britain in which the most significant realized works of note since the war had so far been the Smithsons' Miesian Hunstanton School, some point-blocks by Lasdun (still under the spell of Tecton), and the TUC headquarters by David du R. Aberdeen, Leicester was a revelation. Its inventiveness seemed to suggest that at last British architecture was capable of recapturing the leading position that it had abdicated with the passing of Mackintosh and Voysey – the two names that Stirling mentioned at the time as representing the summit of achievement for this country in the twentieth century. Later he might have added the name of Lutyens as well, but in

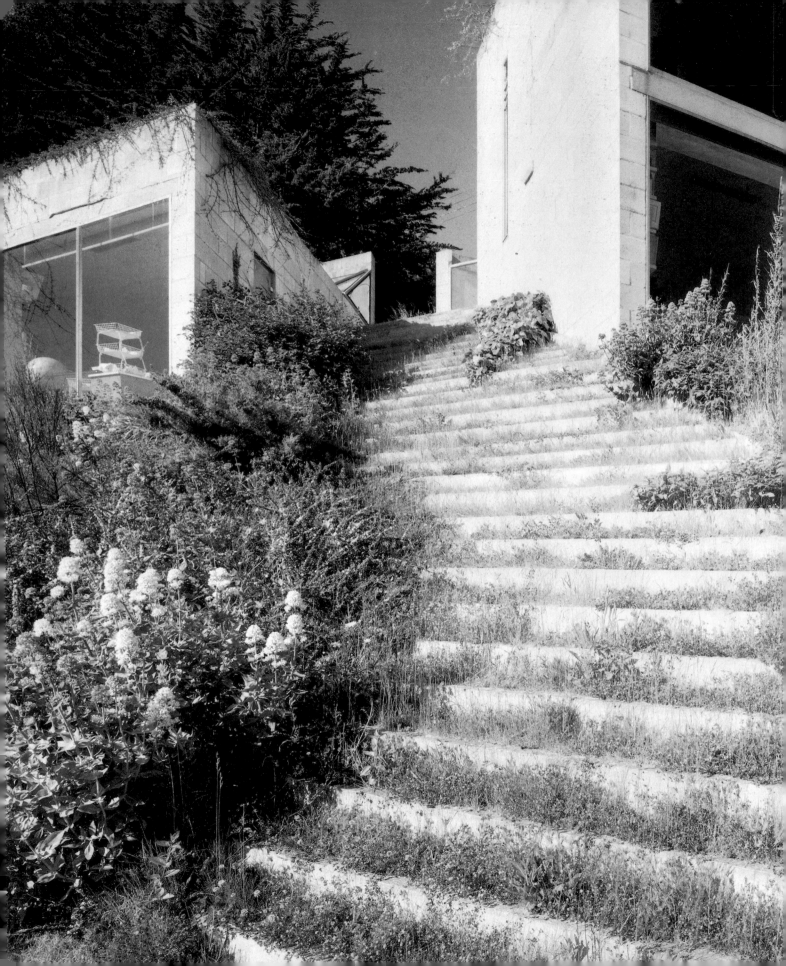

Left and above *Working together as Team 4, Foster and Rogers's first building of note was a house for Rogers's parents-in-law at Creek Vean in Cornwall, completed in 1966. The architects took advantage of the magnificent cliff-top site to half-bury the honey-coloured blockwork structure into the landscape. A top-lit corridor provides gallery-like hanging conditions for an extensive art collection (above).*

those days the Smithsons maintained a strict ideological quarantine around him. Critics like Jacobus were quick to identify undertones of futurism and constructivism in the Leicester building's tower and workshop blocks, patent glazing, sharp geometry and crystalline additive composition. Certainly there were reminders of modernism's past, but the anonymous industrial buildings of the nineteenth century that Stirling had talked of were an equally important source. Transformed in Stirling and Gowan's hands into a highly self-conscious means of expression, the mannerisms of Leicester were to form the basis of a completely new architectural vocabulary that enjoyed a strong vogue around the world.

Stirling was also moved to compare the skewed profile of Leicester to the profile of an aircraft carrier, its bridge set to one side of its split-level flat-top flight deck. In so doing he triggered off a whole train of contingent nautical deductions that had critics busy exploring the seafaring past of his father, and identifying the colour-washed engineering apprenticeship drawings he made as inspiration for his son's graphic technique.

From the completion of Leicester onward, Stirling was a worldwide celebrity. It was a building that had the power to break out of the claustrophobic architectural world and make an impact in the broader cultural sphere. Its fame gave Stirling access to the steady flow of commissions from Britain's expanding universities in the 1960s that was to be the mainstay of his work for the next decade. It also made him in demand as a teacher and lecturer. He taught both at the Architectural Association – which proved a fertile recruiting ground for his office – and at the Regent Street Polytechnic. And it gave him the chance to return to America, as a visiting critic at Yale.

It was at Yale that Stirling was to encounter Richard Rogers once more (he had previously taught him in London) and Norman Foster for the first time. Both were completing their architectural education with a spell on Yale's postgraduate planning course, and were shortly to set up in partnership together as Team 4. It was on the face of it an unlikely combination. Rogers, born in Florence in 1933 of Anglo-Italian parents, and the nephew of Ernesto Rogers, the celebrated Italian architect, cut an exotic figure in early 1950s Britain. Rogers graduated from the Architectural Association in 1959, the year after Peter Cook and the other members of what was to become Archigram arrived. It was a period in which the

Architectural Association was at the peak of its prestige. James Gowan, Peter Smithson and John Killick, as well as Stirling, were among its many distinguished teachers.

Norman Foster was born in Manchester in 1935, into a family in which, as he puts it, going to university or becoming an architect never seemed a possibility. It was only at the comparatively advanced age of twenty-one that he started his architectural education, after a stint in the City Treasurer's office in Manchester Town Hall and two years' national service in the Royal Air Force. Foster and Rogers met at Yale as scholarship students, collaborating on planning projects under the direction of Serge Chermayeff, but also much influenced by the more distant presence of Louis Kahn. After graduation, both Rogers and Foster worked in America briefly. Rogers went back to Britain to set up in practice, and Foster returned to join him. Their practice, the somewhat self-consciously named Team 4, formally constituted in 1963, remained in being until 1967. It was composed of Rogers, Su Brumwell (his first wife), Foster, and his wife, Wendy Cheeseman. The circumstances in which it was established were very different from those surrounding Stirling's first steps in practice. Britain, despite its continuing underlying economic decline, was entering a period of unprecedented prosperity for the mass of its people. It was a time of full employment, the invention of affluence brought about by readily available consumer credit, and the first signs of what Harold Wilson was to label 'the white-hot heat' of the technological revolution.

It was a period which seemed set on abolishing the class-ridden obsessions of British society – an unfulfilled hope – and in which such innovations as jet travel and television became widely available for the first time. It was the birth of a decade which was to see unprecedented questioning of the norms of English society and its values. The very word tradition became a pejorative expression. For the under forties, hedonism and an attempt to construct a new social order were priorities. Rogers in particular immersed himself in this ferment to the full, and the ideas which still inform his practice owe a great deal to it.

Team 4's first project of note was however a highly traditional commission for young architects embarking on a career, a house for a relative. They were asked to design a home for Marcus and Irene Brumwell, and their art collection, in Cornwall. Rogers's father-in-law, Marcus Brumwell, was a founder of Misha

The Reliance Controls factory, Team 4's swan song, was completed in 1967. It is the harbinger of important themes of its architects' later careers: the use of a tense metal skin in many of Foster's buildings and Rogers's enthusiasm for expressed structural bracing.

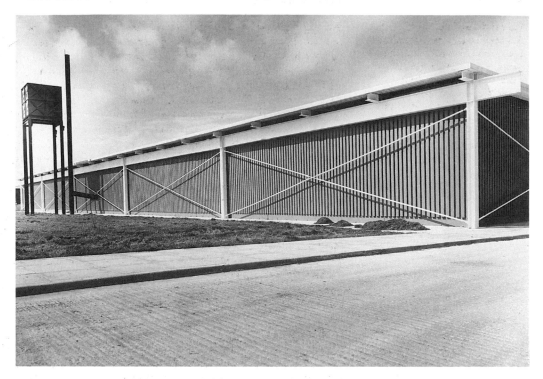

Black's design consultancy, DRU, and the connection was to provide useful commissions later.

The house is a *tour de force* which exploits to the full a magnificent coastal site, perched on the edge of a narrow creek. It is half-buried into the contours of the site, and offers a spatial complexity and informality that seem closer to California than to Cornwall. Living and dining rooms are contained in a compact two-storey block, and a longer, lower wing houses bedrooms and hanging space for an impressive collection ranging from Mondrian to Hepworth. There are few signs of the preoccupation of both Foster and Rogers with lightweight prefabricated buildings; indeed, the materials have a monumentality and permanence to them. Floors are slate, and blockwork is used to create bookshelves and worktops. But the bridge, spanning a steep gully between the road and a turfed roof, has a suggestion of Foster's and Rogers's later work. Nevertheless, the house was an exceptionally handsome and impressive work for its day, albeit one that has had few followers among other architects.

Team 4 designed several other houses, and entered a number of competitions, but the project which really enforced their claim to attention was Reliance Controls' new factory on the outskirts of Swindon, completed in 1967 just before the partnership was dissolved. For a radical young architect at this period of the 1960s, the design of one-off private houses, no matter how elegantly conceived, and sensitively sited, presented certain difficulties. Such specific and small-scale design problems seemed to cut across the utopian, socially responsible aims which architecture more and more appeared to encompass.

Rogers somewhat quixotically wrote in 1975: 'In the face of such immediate crises as starvation, rising population, homelessness, pollution, misuse of non-renewable resources, and industrial and agricultural production, we simply anaesthetise our consciences. With problems so numerous and so profound, with no control except by starvation, disease and war, we respond with detachment. Today at best, we can hope to diminish the coming catastrophe by recognition of the existing human conditions and by rational research and practice.'[8] Britain was in fact in the midst of a building boom, fuelled by both public and private money. Politicians of both major parties vied with each other to raise each year the number of housing starts, which touched 300,000 in 1969 before tailing away. Slum clearance programmes replaced Victorian terraces with tower blocks. A ring of county towns was chosen as sites for inner London overspill, and a second generation of new towns was embarked upon. At the same time the banks and pension funds were pouring money into commercial

Overleaf Completed in 1967, Stirling's building for Cambridge University's history faculty continued the inventiveness of his work at Leicester. Using glass in huge quantities, he created a reading room that looks like both a futurist dream and an evocation of a nineteenth-century library. Michael Wilford took a leading rôle in the design.

redevelopment schemes, funding new shopping centres and office blocks. With hardly an exception, the developers carrying out these schemes had no interest in engaging architects with anything more than administrative and commercial skills. The quality of design was rarely an issue, and as a result their work led to the disembowelling of city after city, aided and abetted by highway engineers and ambitious local politicians. Architects like Rogers and Foster, to say nothing of Stirling, for all their ambition to take part in a utopian remodelling of society through design, were almost entirely excluded from all this activity, forced to sit impotently on the sidelines. With the single exception of the Olivetti training centre at Haslemere in Surrey, Stirling's work was entirely in the universities and the new towns. In effect, the profession was split into two camps: those who worked for developers, and those who built schools, hospitals and universities.

Team 4's Reliance Controls building was a rare example of a commission given to a design-orientated architectural practice from outside the narrow circle of academia and the public sector. It was not by any means Britain's first example of the factory as architecture. There is a tradition of such buildings, ranging from Sir Owen Williams's highly advanced complex for Boots at Nottingham (1930–2) to the art deco Hoover building in west London. Kevin Roche's plant for the Cummins Engine Company in Darlington, built about the same time as the Reliance Controls factory, deploys a

similar but more monumental vocabulary of exposed structural members. But Cummins, with its long history of architectural patronage, was a special case. Reliance Controls on the other hand was in the kind of industry that would generally have made do with a conventional asbestos-sheet-roofed industrial shed of the type which at that time made up the vast majority of new industrial buildings. However, under the leadership of Sir Peter Parker, and with a recommendation from James Stirling, it went to Team 4.

Built on a shoestring, the Reliance Controls factory is not only the celebration of a particular philosophy of architecture that derives from such American precedents as the house which Charles Eames, the architect and furniture designer, designed for himself at Pacific Palisades and the Southern Californian prefabricated schools system of Ezra Ehrenkrantz; it is also an attempt to provide much more civilized working conditions than were then the norm. It boasts views for its workforce, sunshine, and, with its frankly exposed diagonal structural bracing, an elegant appearance. Its wall-high glazing, metal cladding, and approach to structural design were all signals of what was to come in the work of both Rogers and Foster.

With the dissolution of Team 4 in 1967, Richard and Su Rogers set up in practice on their own, moving eventually to a plastic attic extension to the DRU building in Aybrook Street, London. Foster and his wife established their own office (Foster Associates) and were later joined in partnership by Michael Hopkins. They worked on projects far more modest than the Reliance Controls building until they built a new terminal for the Olsen shipping line in London's docks in 1971. Stirling meanwhile had consolidated his reputation as the most original talent of British architecture in the 1960s with the Cambridge History Faculty Building, designed in partnership with Michael Wilford, who played a major rôle in its creation (Stirling ceased to practise with Gowan in 1963).

The History Faculty Building's dynamic fan-shaped plan and its brick and tile clad towers demonstrated in the most effective way possible that Leicester had not been an isolated success. As at Leicester, Stirling drew on constructivist precedents, but he also looked to the industrial tradition of nineteenth-century Liverpool. But by the time the building was completed, Reyner Banham, writing in the *Architectural Review* in 1968, felt it necessary to devote a substantial part of his appraisal to a

The isometric projection of the History Faculty Building helps to reveal Stirling's methods of design: his buildings are conceived as sequences of spaces that present constantly changing views to the spectator walking through them. There is no single unifying facade.

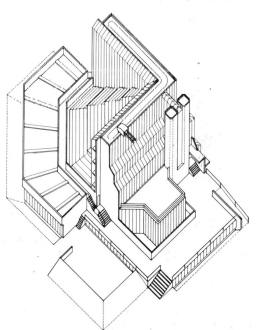

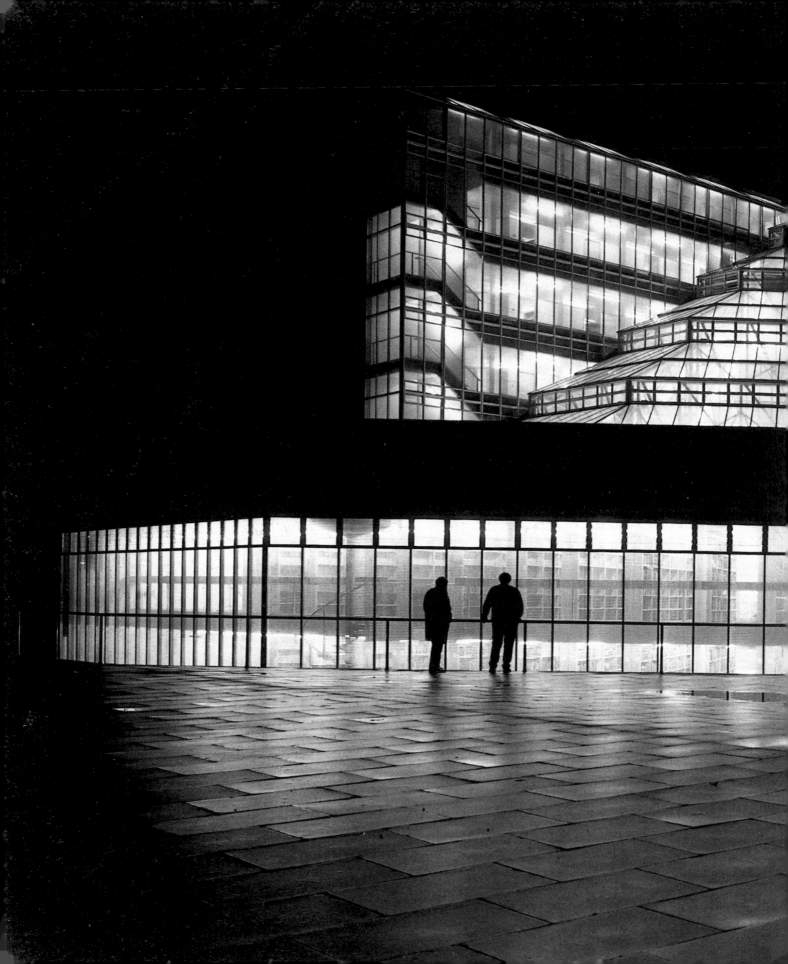

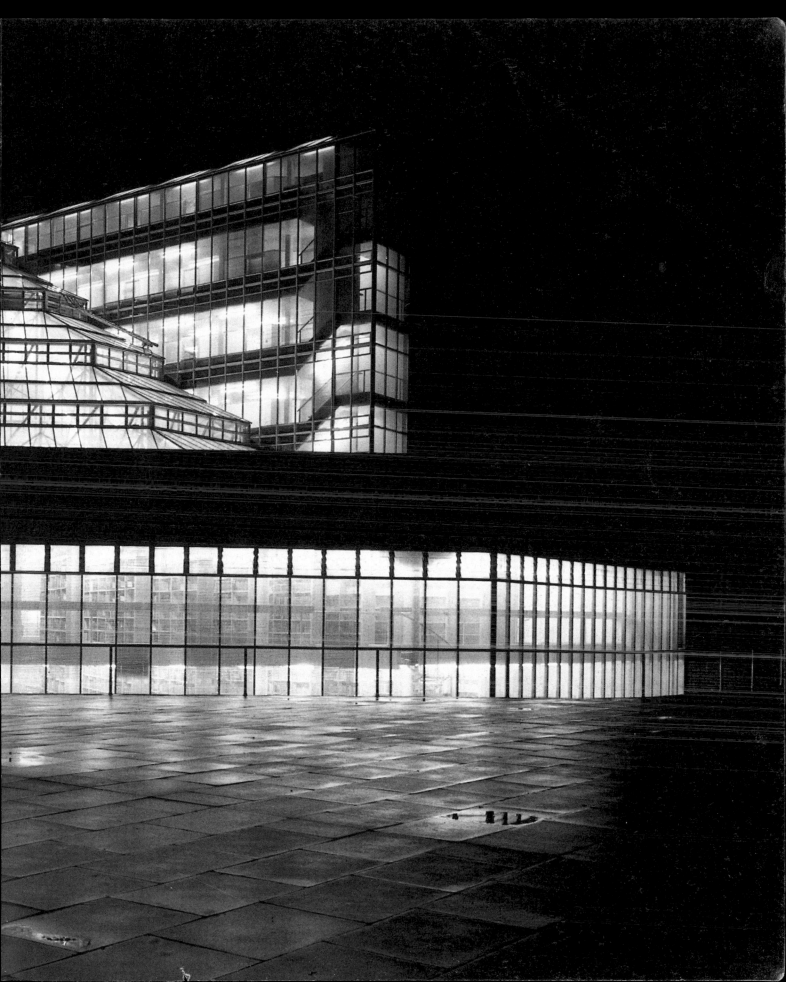

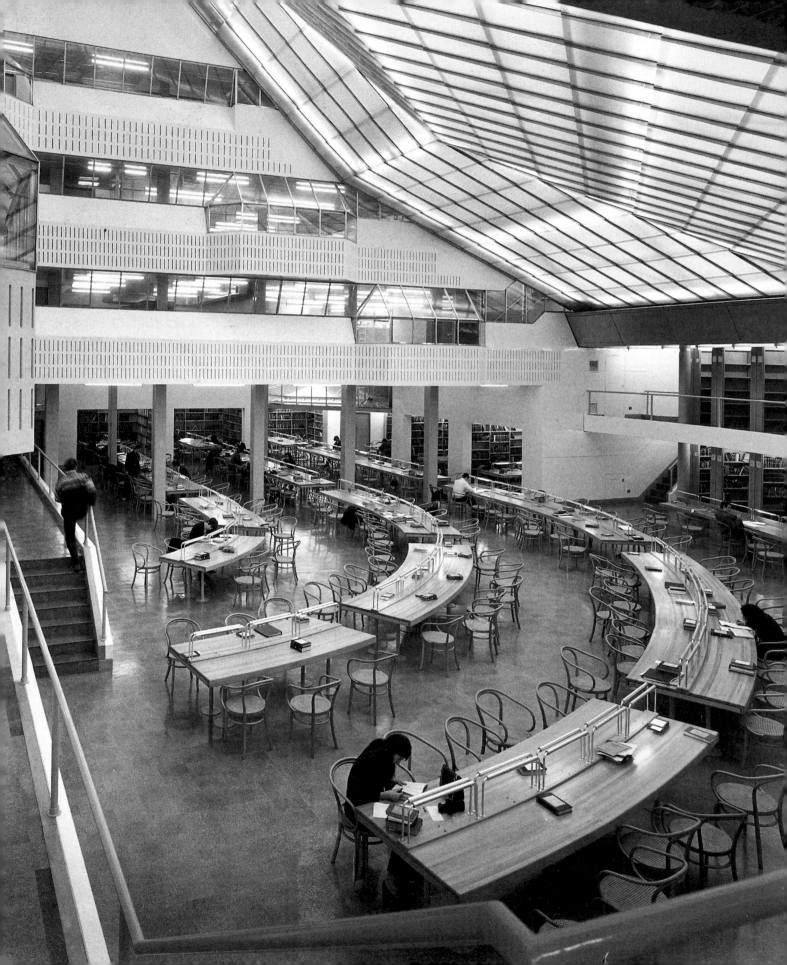

Left *The fan-shaped plan of the Cambridge History Faculty Building's reading room allows for supervision from a single point at the entrance. The room is overlooked by corridors which provide access to the faculty offices above and run into the double-skinned glass roof, visible at top right.*

Right and below *Stirling's residential building for the University of St Andrews, Scotland (1964-8), designed to house an expansion in student numbers. Because of the site's remoteness from sources of appropriately skilled building labour, Stirling opted for a prefabricated concrete construction system.*

defence of its technical capabilities, in particular of the alleged tendency of the glazed reading room to unacceptable levels of solar gain. Despite strong support for the building from within the history faculty, which had chosen Stirling's design after a limited architectural competition, the building attracted unrelenting hostility from a certain section of the Cambridge establishment. It was a hostility that continued to haunt the building until the 1980s, when its demolition was seriously considered, although rejected, by the university Senate (see below, pages 68–71).

Echoing Le Corbusier's restlessness, Stirling refused to remain content with any one form of architectural expression. After Cambridge, he adopted a quite different vocabulary for his next academic building, a hall of residence for the University of St Andrews (1964-8). Ostensibly because of a lack of skilled local building workers, Stirling and Wilford designed the project using a specially detailed crane-installed concrete panel system. The

Florey Building in Oxford (1966-71), however, restated the themes of Cambridge. But thereafter each new Stirling and Wilford building tended to be an exploration of a fresh constructional approach. After the completion of the Olivetti training centre in 1972 Stirling found himself starved of work. In the ten years before the completion of the new Staatsgalerie in Stuttgart in 1984, Stirling's only realized project was the final phase of his housing scheme for Runcorn. He had fallen victim in part to the serious downturn in the British economy that began in the early 1970s. The university building programme all but came to a complete halt. And Stirling and Wilford's industrialist clients, Olivetti and Dorman Long, found themselves having to cut back too, and cancelled their projects. The 1970s were bleak for Stirling. His reputation around the world had never been higher, but lack of work left him increasingly frustrated. His public attitude became one of ironic detachment.

Rogers and Foster fared rather better in the 1970s. Both contrived to grow from small studios with a handful of employees into large scale, highly businesslike organizations. In 1971 Rogers went into partnership with Renzo Piano, an architect from Genoa who shared his taste for radical applications of technology, and, as they saw it, its liberating potential. 'Technology cannot be an end in itself, but must aim at solving long term social and ecological problems', wrote Rogers. 'This is impossible in a world where short term profit for the "haves" is seen as a goal at the expense of developing more efficient technology for the "have nots".'[9]

Almost by accident Piano + Rogers (as the partnership was called) entered the international competition organized by the French government for the design of a cultural centre in Paris to cover one million square feet on a carpark site in the Les Halles area. It was officially christened the Centre National d'Art et de Culture Georges-Pompidou, but is now

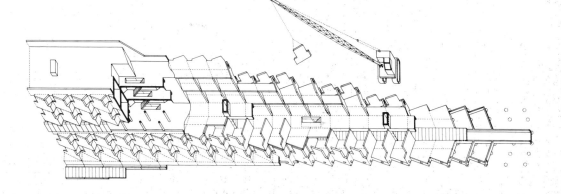

Right *One of the drawings with which Piano + Rogers's team won the international competition for the design of the Beaubourg arts centre in Paris. Though some features were omitted, notably the video-screens for information display, and the overall height was reduced because of fire regulations, the conception was remarkably close to the final building, completed in 1977.*

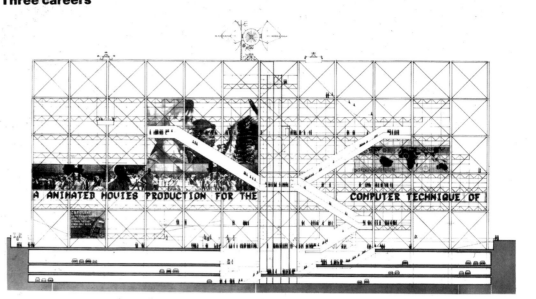

Opposite and overleaf *From the day it opened, the Beaubourg attracted crowds, drawn by the street entertainers who use the piazza for impromptu performances, by the building itself, and simply by the chance to use the exterior escalators that provide one of the finest views of Paris. Despite its considerable bulk and striking outline, the Beaubourg has taken its place within the existing fabric of streets and squares. Its full impact is visible only from the sky (overleaf).*

more commonly known as the Beaubourg. Rogers has subsequently admitted to having had to be persuaded to enter the competition against his initial instincts. He saw no prospect for producing a building that would be anything other than a monument to the highly centralized, autocratic French presidential system. In the event, Piano + Rogers's entry, selected by a jury that included Jean Prouvé, Philip Johnson and Oscar Niemeyer, was a literally fantastic fusion of futurism, the seductive but unrealizable imagery of Archigram (the gentler English followers of Marinetti at two generations remove) and the most flamboyant traditions of Victorian engineering. Underpinning the whole entry was a passionate conviction that the traditional didactic museum was no longer an appropriate building type. In its place, Piano + Rogers envisaged a high tech agora, a special place within the city that would be part of the public domain, a substitute setting for the life driven off the streets by the destructive impact of modernist-influenced town planning policies, with their insistence on the separation of functions into distinct zones, and their subordination of historic city fabric to the motor car.

Without being entirely clear how it could be realized, Piano + Rogers proposed a structure designed by Ted Happold and Peter Rice of Ove Arup and Partners that was more a flexible framework than a traditional building and had a clear debt to Cedric Price's Fun Palace project of 1961. They wrote: 'It is our belief that buildings should be able to change, not only in plan, but in section and elevation. A freedom

which allows people freedom to do their own things, the order and scale and grain coming from a clear understanding and expression of the process of building, and the optimisation of each individual element, its system of manufacture, storage, transportation, erection and connection, all within a clearly defined and rational framework. This framework must allow people to perform freely inside and out, to change and adapt, in answer to technical or client needs, this free and changing performance becoming an expression of the architecture of the building – a giant Meccano set, rather than a traditional static transparent or solid doll's house.'[10]

Completed in 1977, and a remarkable achievement despite the numerous compromises in its design that were forced on its architects, the Beaubourg was of course entirely dependent on the power and prestige of the French presidency for the speed with which it was built. It became a huge popular success, attracting vastly more visitors than had been planned for and storing up maintenance problems in the process. It had the effect of catapulting Rogers from relative obscurity into world-wide fame. But when the Beaubourg was complete, Rogers considered closing the office, and turning to teaching full time. With the exception of a few modestly scaled factories and laboratories in Britain, the London office of Piano + Rogers had no work.

For all the success that the Beaubourg had in restoring the fortunes of architecture at a particularly low ebb in the mid-1970s, there were voices of caution raised. Some critics suggested that the very universality of the space

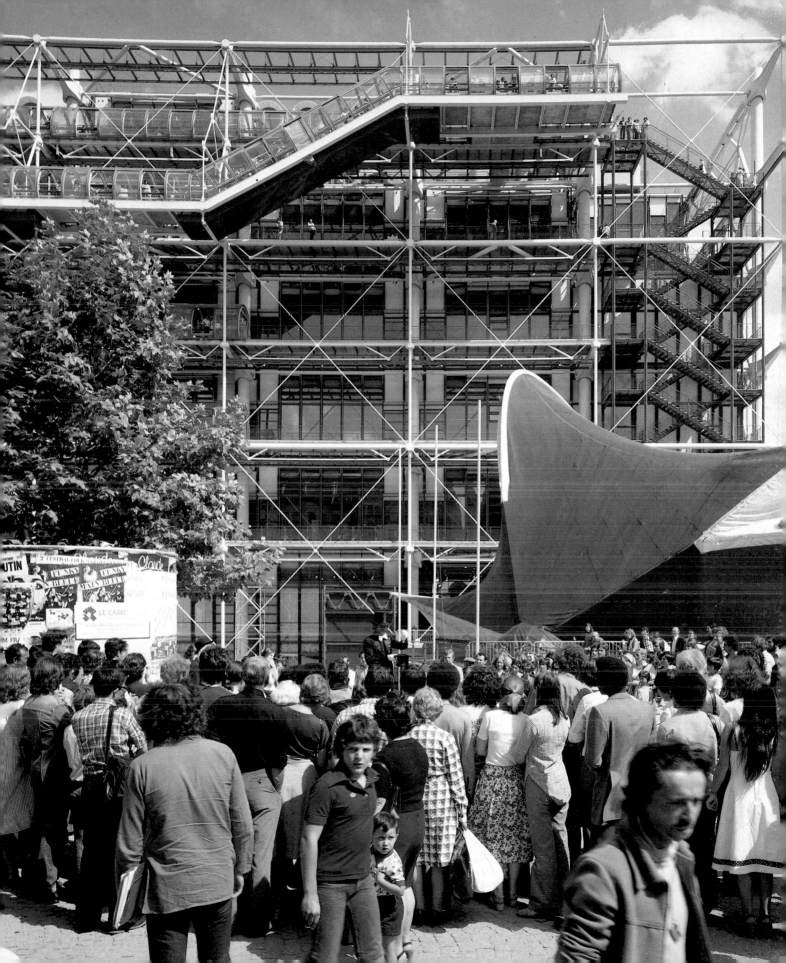

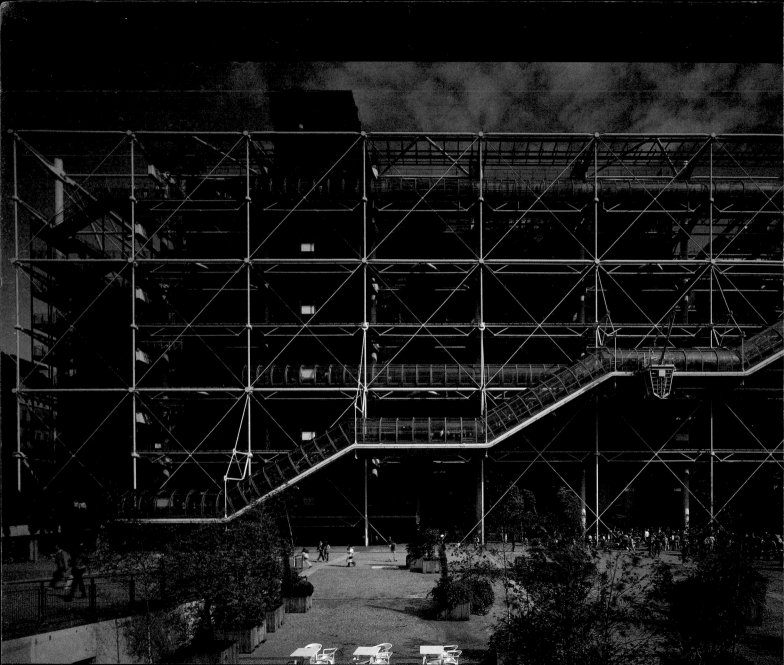

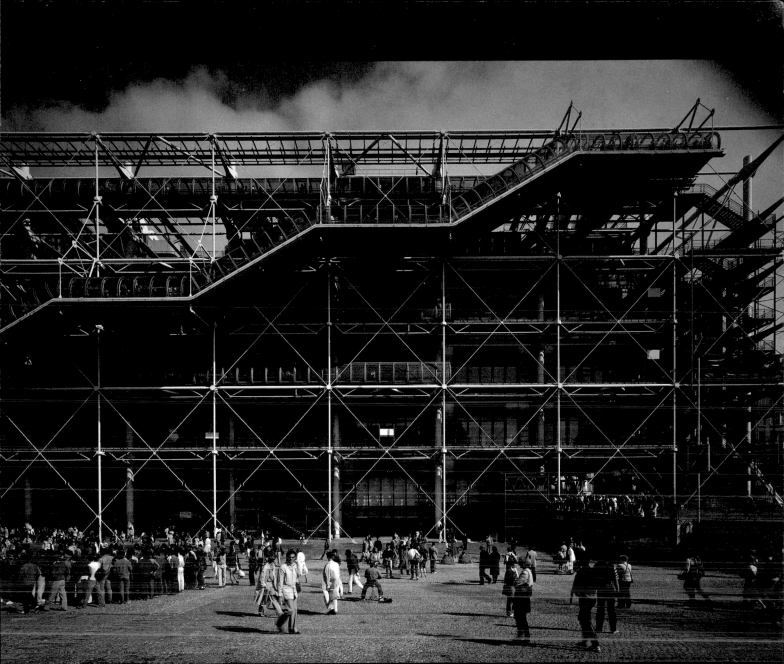

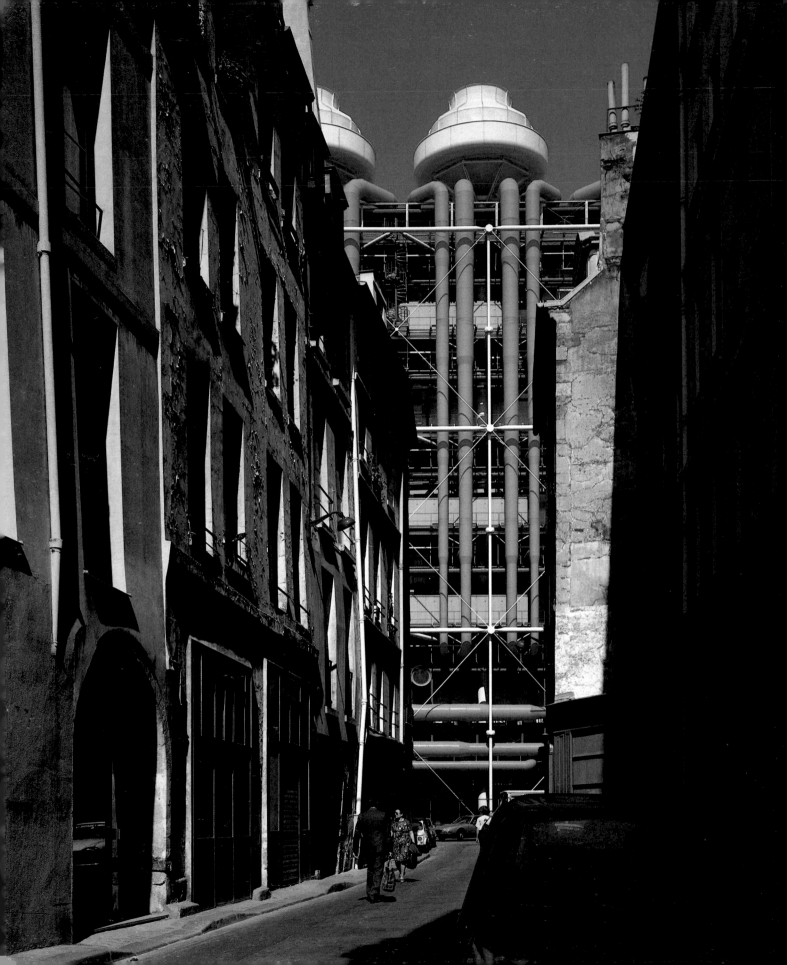

The Beaubourg has two strikingly different facades. Its public face, at the front, has glass escalator tubes and an open grid structure. At the rear, on the rue du Renard, the service pipes, air conditioning and lift mechanisms close up to create a solid wall.

that it created was not without difficulties as a precedent for other buildings. In *Architectural Design* Alan Colquhoun wrote of the Beaubourg that 'this concept of architecture as servicing mechanism suffers from too reductionist an attitude. It suggests that architecture should not be conceived with any typology of spaces or human uses, but that functions should be handed over to the spontaneous forces of life. This assumes that architecture has no further task, other than to perfect its own technology. It turns the problem of architecture as a representation of social values into a purely aesthetic one, since it assumes that the purpose of architecture is merely to accommodate any form of activity which may be required, and has no positive attitude to those activities. It creates institutions, while pretending that no institutionalisation of social life is necessary.'[11]

Foster's career in the 1970s ran on different lines. Until 1975, he designed and built the kind of modestly scaled projects that have long been the staple of moderately successful but still struggling architectural practices. There were small office buildings, a couple of schools, shops, some factories. In other hands conventional enough briefs, but in each case the results were distinguished by the singlemindedness with which Foster pursues an idea. He transforms the ordinary and the everyday by his knack of treating industrial building materials like jewellery, and by his commitment to an unassertive polished elegance.

Foster's own experiences as an NCO in the RAF, in the City Treasurer's office in Manchester Town Hall, and in a variety of part-time jobs that he took to pay his way through university, gave a personal edge to his determination to use design as a weapon against the class-ridden divisions and squalor that still blighted so many workplaces. Foster's first commission on a significant scale after Team 4 was the Olsen line terminal in London's Dockland. What made him most enthusiastic about the scheme was the way such elementary civilizing gestures as carpeting the dockers' mess room and matching the amenities of blue collar and white collar workers went a long way to taking the sting out of notoriously poor labour relations in the docks, at least so far as Olsen's were concerned. As Foster put it, 'we were concerned to break down the distinction between us and them, posh and scruffy, front office and workers' entrance'.[12] Olsen's local success did not however stop the quickening pace of the closure of the old dockland wharves. By 1982 the Foster office building for Olsen had been taken over by the London Dockland Development Corporation as the headquarters for its bid to regenerate the area's thousands of derelict acres.

There was more to Foster than a talent for civilizing workplaces. His enthusiasm for technology is bound up with the power that mastering it gives an architect to sidestep traditional solutions, and to reinvent completely a building type. In 1968 he solved the short term accommodation crisis of a fast-growing Hertfordshire computer firm by using an

Right Completed in 1971, Foster's terminal for the Olsen line in London's Dockland gave him a chance to realize his theories about the civilizing potential of architecture. The building provided working conditions for both dockers and management that were well above the customary standards of the industry. Foster is an enthusiast for furniture by Charles Eames, who designed the chairs seen here. For an exterior view, see page 93.

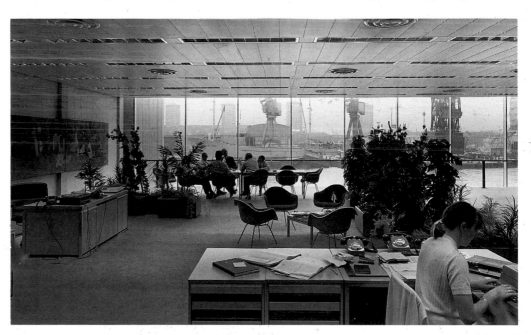

inflatable bubble to house its temporary offices. Foster's first head office for IBM, at Cosham, was a limitlessly flexible glass box, with a prefabricated steel structure that could be installed by fork lift truck.

In 1975 Foster had the chance to prove that he was something more than a technocratic wizard. The insurance brokers Willis, Faber and Dumas commissioned him to design for them a new administrative headquarters in Ipswich. Once a gentle East Anglian town, with a rich tradition of twisting lanes and tiled and half-timbered vernacular buildings interspersed with occasional stone churches, Ipswich today is as sad an example of the destructive potential of post-war architecture and planning as one could hope to find. Stumpy office blocks, ring roads, multistorey carparks and banal architecture have brutally violated the sense of place. Foster's solution of the problems involved in inserting another large office block into this setting was a bold gesture: a flowing black glass building with an irregular ground plan, recalling a truncated version of Mies van der Rohe's Berlin skyscraper project of 1919. The undulating reflections in the seamless glass had the effect of insinuating the new building into a quiet corner of old Ipswich with remarkable skill and delicacy (see below, pages 36–43).

For Foster it was a turning point, setting him on the path to tackling larger urban problems. His scheme for Hammersmith in west London would have had an even greater impact on town planning had it been realized (see below, pages

117–119). And his project for the BBC's radio headquarters, also unbuilt, and for the Hongkong and Shanghai Banking Corporation's tower, address the problem of building within cities in very different ways, but always with force and imagination (see below, pages 118–129 and 147–159). On the other hand, the Sainsbury Centre for Visual Arts, opened in 1977, is a much more self-contained building that sidesteps any interest in urbanism. Gleaming like a perfectly finished aluminium craft object, it is set within lush green Norfolk meadows, and connected by only the most fragile of glass umbilical cords to the heavy concrete of the rest of the University of East Anglia (for a detailed account, see pages 59–61 and 100–105).

During his lean years in the 1970s Stirling had plenty of time to ponder and to explore on paper. Although he would be reluctant to accept that the buildings of the later part of his career represent a break with his earlier work, it is clear that the constructivism and the engineering vernacular of his university buildings, and the technological experiments of the Olivetti training school and St Andrews' residential accommodation, were not such pressing concerns in projects like the Stuttgart Staatsgalerie. The gap between the two extremes might have been bridged by his designs for the projected arts centre at St Andrews, and for rebuilding Derby's Assembly Room, had they been built. In both cases Stirling came to grips with the problems of a building's context, which had become an

Iann Barron, director of Computer Technology Ltd, asked Foster in 1968 to design him a building that could instantly resolve a temporary space crisis and later be dismantled. Foster's inflatable structure, which was needed for less than a year, was an elegant solution. Iann Barron later commissioned the Inmos factory from Rogers (see pages 58-59).

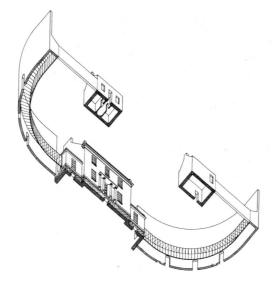

Axonometric view from below of Stirling and Wilford's unrealized 1971 project for an arts centre at St Andrews University. The new building would have taken the form of a pair of wings attached to an existing sturdily classical house.

increasingly important issue for him, to the perplexity of enthusiasts for his early work.

The string of entries that he produced for competitions such as the Wallraf-Richartz Museum in Cologne and the Wissenschaftszentrum in Berlin appeared to represent a step away from the modernism that he had once embraced, a particularly significant step in the then increasingly highly charged climate that accompanied the growing post-modernist lobby. But in fact Stirling's vocabulary had always allowed for the allusion and symbolism that the post-modernists claimed for their own. It is true, however, that at this time the influences that Stirling responded to were changing. He had taken his long-standing associate Michael Wilford into full partnership, and the Luxembourg-born architect Leon Krier had passed through, leaving a swathe of idiosyncratic, half-ironic drawings, and a good deal of mistrust of the CIAM planning theories of the past. Yet, as the completed Stuttgart Staatsgalerie conclusively proved, Stirling was still a master of the manipulation of form and the creation of public spaces, despite his enthusiasm for irony and collage. 'We are, alas, too well known for a small part of our output, namely the University buildings of the early '60s, particularly at Leicester and Cambridge, and recently I've heard the comment, "why has our work changed so much?"' Stirling said in his 1980 acceptance speech for the Royal Gold Medal for Architecture. 'Whilst I think change is healthy, I do not believe that our work has changed. Maybe what we do now is more like our earlier work, and that oscillating process is still continuing.'[13]

By the early 1980s, all three architects had reached the peaks of their careers. Despite a temporary shortage of work that had tempted Rogers to become involved in full-time teaching, rescue had come in the form of a massive commission for a new building for Lloyd's insurance underwriters, a project for which Rogers was put on the shortlist by the RIBA itself. Rogers, indeed, through his chairmanship of the trustees of the Tate Gallery, had unusually for architects of his generation begun to take a leading role in the cultural world outside architecture. In 1977 he dissolved his practice with Renzo Piano, and took John Young, Marco Goldschmied and, later, Mike Davies into partnership.

Foster, with the commission for the headquarters of the Hongkong and Shanghai Banking Corporation (another project channelled by the RIBA), was able to establish a huge office and elaborate prototyping facilities to explore the most challenging of tasks, the skyscraper. Stirling and Wilford found themselves commissioned in Britain once more, called in by the Tate to design the new Clore Gallery for the Turner collection, and to tackle the project to redevelop the area behind Mansion House in the City of London, once schemes to build a tower by Mies van der Rohe had been defeated.

In the thirty years since Rogers and Foster started their architectural education and Stirling completed his, Britain has lost its empire, entered the EEC and undergone a period of steep economic decline. Its towns and cities have been rebuilt, scarcely to universal approval. Its brave housing experiments have hardly been unalloyed successes. Economically many of its industries are in ruins. Some optimists, however, professed to see the glimmerings of changing attitudes. The architectural establishment, which through its influence over major commissions is still a force to be reckoned with, has rallied round Stirling, Rogers and Foster, treating them as standard bearers in a struggle to raise the status of architects once more. The lessons of the unfettered building boom of the 1960s have not gone unnoticed. Certain developers and corporations have concluded that there is much to be gained in terms of prestige, and even of commercial return, in deploying architects acceptable to that architectural establishment. Indeed, the public reaction to the schemes of the 1960s and a genuine desire on the part of some developers to build better architecture have combined to improve the picture.

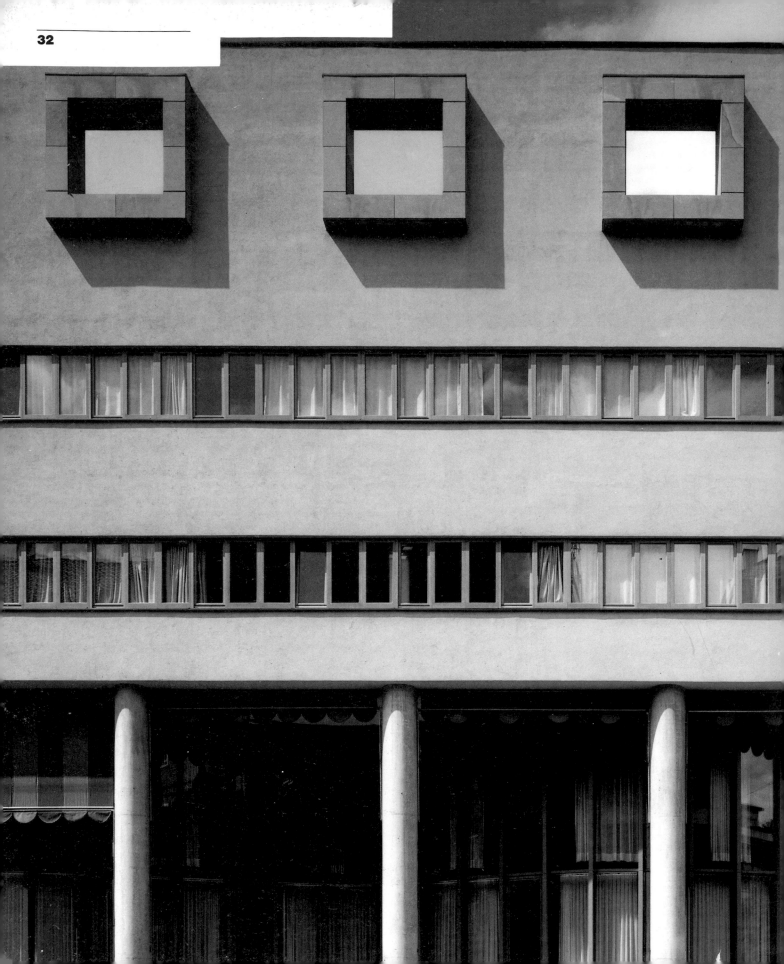

The modern tradition

Stirling and Wilford's Staatsgalerie in Stuttgart, completed in 1984. Strip windows and pilotis demonstrate that the modern movement is for them as much a source of architectural imagery as any other period. The library is on the lowest floor; above are the curator's offices. See pages 159-175.

The dominant approach to architecture in the first sixty years of this century was modernism. In essence the modernists argued that buildings should reflect their times and that an industrial age should have an appropriate architecture – abstract, unornamented and functional. From about 1960 architects and critics who now style themselves 'post-modernists' have argued that such abstraction is not rich enough to meet all the emotional demands made of architecture. Buildings should also have a symbolic and decorative content. Revisionist accounts of the modern movement often argue in addition that the movement's partisans overstated the significance of modernism by ignoring traditionally rooted forms of contemporary architecture which are possibly more important. These accounts usually describe modernism as a naive and joyless negation of history. But they base this assertion mainly on a combination of a highly selective choice of quotations from the published writings of the pioneer modernists, and on the built works of their commercial followers (although 'follower' seems too strong a word). Yet on this basis critics of a nostalgic persuasion, who favour a return to the classicism of the orders, and those who seek to establish a more eclectic post-modernism have condemned virtually all the buildings of the past fifty years with a rashness that surpasses even that of the doctrinaire modernists of the 1920s and their contempt for the *fin de siècle* styles.

Gropius's *The New Architecture and the Bauhaus* (1935) is often cited for the single-minded finality with which it consigns the past to oblivion. 'A breach has been made with the past, which allows us to envision a new aspect of architecture, corresponding to the technical civilisation of the age we live in. The morphology of dead styles has been destroyed, and we are returning to honesty of thought and feeling', wrote Gropius.[1] Such a reading of modernism as a revolutionary negation of the past naturally allows for an equally radical reaction against it.

Logically such a clear-cut and uncomplicated belief could indeed be described as 'dying'. But anything more than the most prejudiced examination of the modernist pioneers makes it abundantly clear that modernism was never the singlemindedly exclusive creed that it has since been presented as. It is true that there were those who could be described as subscribers to the 'history is bunk' view. But equally it is obvious that Le Corbusier believed no such thing. And even Mies van der Rohe felt able to remark in 1964 that 'advancing technology provided the builder with new materials and more efficient methods which were often in glaring contrast to our traditional conception of architecture. I believed nevertheless that it would be possible to evolve an architecture with these means, I felt that it must be possible to harmonize the old and the

new in our civilisation. Each of my buildings has been a statement of this idea, and a step in my search for clarity.'[2]

When modernism is couched in these conciliatory terms, James Stirling's refusal to identify himself with post-modernism, and such, for him, unusual public stands as supporting the plan to build a tower block by Mies van der Rohe in the City of London become rather less surprising. In his acceptance speech for the Pritzker Prize in 1981, Stirling said: 'Just as, many years ago, we declined to be categorised as 'New Brutalists', so now I must state that I don't think that our work attempts to be post-modernist.'[3] For better or worse, Stirling still sees himself as a modern architect, of an undogmatic kind. And no amount of critical sleight of hand can make him into anything else.

When the writer Charles Jencks announced not only that modern architecture was dead (in his book *The Language of Post-Modern Architecture,* first published in 1977), but also ascribed a precise moment to its passing, namely the day that the late unlamented Pruitt Igoe flats were demolished, he went even further and maintained that 'the fact that many so-called modern architects still go around practising a trade as if it were alive can be taken

as one of the great curiosities of the age'.[4] For all the uncertainty of tone, which intentionally mixes facetious journalism with criticism, it was a statement outrageous enough at the time to distract any rational consideration of its content.

In the overheated atmosphere of the time, either one was for the Jencks view in its totality, or one was against it. But if architectural criticism is not a subtler affair than that, it is nothing. However, it is a tribute to Jencks's powers as a propagandist, and to his sure sense of his own role in history, that his view went unchallenged for so long by anyone other than diehard Gropius followers. But in the face of the manifest failure of a substantial number of architects possessing talents that he could not deny to conform to the patterns that he wished to set for them – to declare themselves post-modernists, and hence, presumably, his followers – Jencks was forced to invent further categories, in particular evasions such as the odd designation 'late modern' for Rogers and Foster. Odd in the sense that it is a trifle tardy to discover late modernism only after one has already declared modernism dead and post-modernism its successor.

Jencks's attempts to play Ruskin or Morris to architecture and design in the 1980s suffered their greatest setback from Stirling's refusal to

Study for an unbuilt project by Stirling and Wilford for a UK headquarters building for Olivetti at Milton Keynes (1971). Stirling himself makes an appearance in the foreground, in one of his Thomas Hope chairs. The bust on the right is of Leon Krier, then an assistant in the Stirling office.

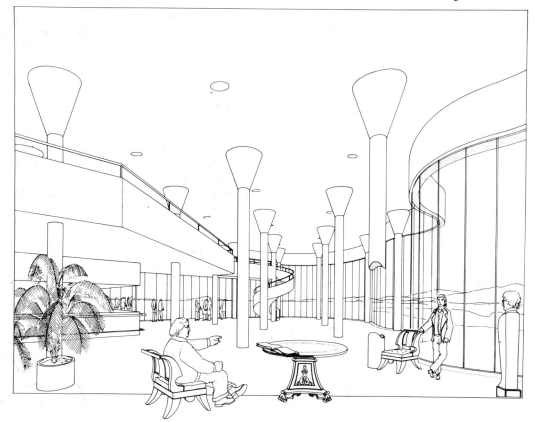

accept the post-modern label after Jencks had already declared him the greatest British architect since Wren, or possibly Hawksmoor. The refusal may perhaps go some way toward explaining why Jencks has increasingly transferred his critical favours to Michael Graves. In retrospect, the whole post-modern affair is beginning to look greatly oversold. The language was more violent, but the impact may in the long term turn out to be no greater than that of other attempts to reassess modernism, such as brutalism or metabolism, except that post-modernism, unlike the earlier tendencies, managed to impinge on the public consciousness as well as on the profession's.

It is true that there have been changes of emphasis in architecture in the last fifteen years. In particular there is a much greater tolerance for what would once have been seen as deviant outsiders. And, in America at least, there has been a wholesale adoption by the large commercial architectural practices of what might be seen as an art deco revival for corporate headquarters, taking their cue from the work of Michael Graves. Judging by the already rapidly fading attractions of such once photogenic manifestations of post-modernism as Charles Moore's Piazza d'Italia in New Orleans (1975–9), it would seem that the movement was a short-term diversion, like art nouveau perhaps, rather than a long-lasting affair.

This is not to say that post-modernism could not be an enjoyable diversion, and in some hands was capable of producing serious works of art. In the longer term, the evidence of the work of architects such as Rogers, Foster and Stirling, who in different ways have continued to work in what can only be called a modernist mode, albeit one that has radically widened its concerns from the pioneering days of the 1920s, has proved the lasting power and potential of modernism – a potential that is also exhibited by such diverse architects as Mario Botta in Switzerland, Arata Isozaki in Japan, Hans Hollein in Austria and many others. Stirling welcomes the passing of what he calls 'the revolutionary phase' of the modern movement and he looks forward to a 'more liberal future producing work perhaps richer in memory and association in the continuing evolution of a radical modern architecture'.[5] Stirling and Wilford believe that 'the mainstream of architecture is usually evolutionary, and though revolutions do occur along the way (and the modern movement was certainly one), nevertheless revolutions are minority occasions.

Today we can look back and regard the whole of architectural history as our background, including most certainly the modern movement, high tech and all. Architects have always looked back in order to move forward, and we should, like painters, musicians and sculptors, be able to include "representational" as well as "abstract" elements in our art.'[6]

Taking this view does not mean that when Stirling is deploying Romanesque arcades at Rice University, or neoclassical devices at the Clore Gallery attached to the Tate Gallery in London, or masonry drums vaguely reminiscent of Asplund's Swedish neoclassicism in his design for a library at Latina – or for that matter a Corbusian villa among other motifs at the Stuttgart Staatsgalerie – that he is being anything other than a modern architect. He is not a revivalist like Quinlan Terry (who during his years at the Architectural Association was employed by Stirling). Terry's classicism, although more than a wooden reconstruction of the past, jettisons any sensitivity toward, or interest in, architectural development since about 1820. Stirling on the other hand is always modern. His motifs may be quotations from the past, but, however deeply felt, they are never used other than as elements in a modern composition. Once acquired, a modernist sensibility is not easily discarded. Lost innocence is impossible to recapture. The real clue to the direction of Stirling's work comes from the architects and designers that he expresses an admiration for, and an interest in. These have varied remarkably. He admits that once the greatest influence on his career was Le Corbusier. But after a visit to the United States in the mid-1960s he expressed an admiration for the support structures of the NASA buildings at Cape Canaveral. The most enlightening of his enthusiasms, however, is for Hawksmoor. 'As soon as I graduated and got to London in 1950, I set about visiting the bombed out churches of Hawksmoor. I was intrigued by the English Baroque architects such as Archer, Vanbrugh and Hawksmoor, and admired the adhoc techniques which allowed them to design with elements of Roman, French and Gothic, sometimes in the same building.'[7] A comparison between Stirling and Hawksmoor, an architect who was, in the words of Sir Denys Lasdun, 'profoundly concerned with the roots of architecture', is particularly revealing. In his compositional approach, his collaging of often inconsistent architectural fragments, and his at times almost abstract treatment of space and form, creating an architecture stripped of

Detail of the exterior of the Willis, Faber and Dumas building, completed in 1975. A jointing system of almost oriental elegance allows heavy sheets of specially produced glass to appear to hang with no visible means of support. Foster chose a gently reflective glass and faceted the building's surface, so creating a much subtler pattern of reflections than appears in the harsh mirror-glass buildings of the 1970s.

familiar representational elements, Hawksmoor could almost be described as a modernist in the sense that Stirling would count himself one. Hence too, Stirling's enthusiasm for the remarkable furniture of Thomas Hope, an extreme and highly individualistic exponent of the neoclassical. Stirling collects Hope's furniture avidly, and has furnished his drawing-room with it, where it cohabits with Aalto and Le Corbusier pieces. It also makes periodic appearances in Stirling's office drawings – in the perspectives for the Olivetti headquarters in Milton Keynes for example.

Stirling, who has always been notably reluctant to commit himself to manifesto-like pronouncements of faith, and habitually adopts a slightly unconvincing diffidence when talking about his own buildings, maintains that his work has almost always been misunderstood. His earlier designs were, he believes, misinterpreted at the time as being more singlemindedly modernist than he intended, and the significance of the historicist elements in his later projects has been similarly exaggerated.

The nearest that Norman Foster has ever come to publicly expressing an architectural doubt is to concede that perhaps there might

have been better ways of handling the entrance to the Sainsbury Centre than inserting it unobtrusively into the side of the building. In the general course of events, Foster is even less given to architectural pronouncements than Stirling and Rogers. He confesses to finding discussions on aesthetics unwelcome: 'you take it for granted that buildings should be beautiful', he once said.[8] His interest in the past has little to do with academic subtleties of planning and meaning. Foster's view of history, such as it is, is a purely instinctive response to a series of buildings and projects.

In contrast with Stirling and Wilford's office, which has some of the cluttered charm of the Soane Museum, Foster Associates' London office is embellished with photographic celebrations of triumphant pieces of engineering: the Eiffel Tower, the Forth Bridge and the Lunar Module. There is also a prominent model of a project on which Foster was collaborating with Buckminster Fuller at the time of Fuller's death. It is an autonomous house, a development of the Dymaxion House, a double-skinned dome so arranged that each skin is capable of rotating independently of the other. Since each skin is half glass and half solid,

Right *The amoeba-like plan of the Willis, Faber and Dumas building recalls Mies van der Rohe's skyscraper studies of 1922, which have a similarly irregular form. Foster's preference for escalators rather than lifts as a means of circulation through his buildings is already apparent.*

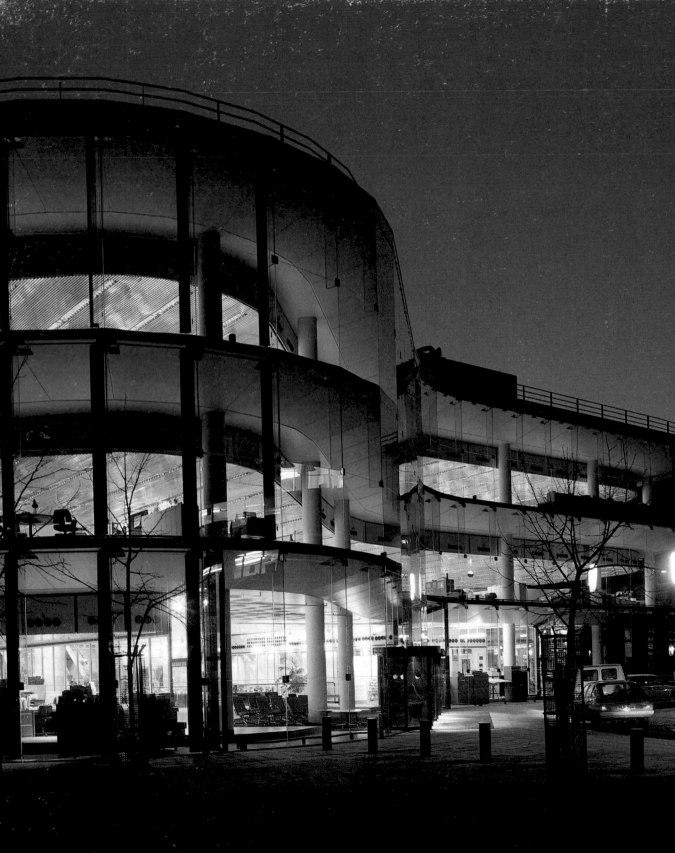

Left *The Willis, Faber and Dumas building presents two strikingly different characters. During the day, its undulating black glass skin reflects its surroundings. But after dusk, when the internal lights come on, it becomes completely transparent.*

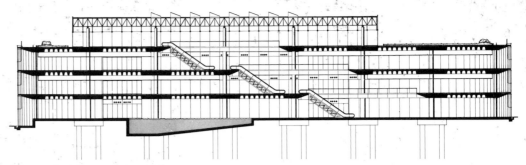

Right *Foster planned the Willis, Faber and Dumas building around two different structural systems: concrete for the three office floors and a steel pavilion on the turfed roof. In the basement is a swimming pool, evidence of a commitment to good working conditions for the company's employees.*

the house could be completely closed up at night, and during the day can be programmed to track the path of the sun.

Foster is perfectly well aware that there is something known as post-modernism abroad, but it has touched him not at all: 'a game for consenting adults in private only', he once said.[9] More guardedly, he concedes that the debate about post-modernism has 'raised some perfectly valid questions about certain aspects of architecture. I do not see [this debate] as being in any way irreconcilable with what we have been doing, but, on the contrary offers us greater possibilities for richness and diversity without stooping to pastiche.'[10]

The explanation for this *sangfroid* from an architect who is generally identified as among the world's leading modernists may partly lie in the fact that the architects with whom Foster most readily identifies have always been peripheral figures. For Foster, Joseph Paxton's Crystal Palace was the greatest piece of architecture of the nineteenth century, and has still hardly been equalled. Yet Paxton, who was initially a gardener, was hardly considered an architect at all by his contemporaries. Of the twentieth-century pioneers, the names that Foster mentions as influences – Konrad Wachsmann, Charles Eames, Jean Prouvé, Buckminster Fuller – have also been on the edge of architecture, far away from the well-publicized debates about functionalism and modernism. From them, Foster has absorbed a passion for lightweight buildings, for flexibility and transparency.

The buildings that Foster enjoys most – Giuseppe Mengoni's Galleria in Milan, Decimus Burton's Palm House at Kew, the vehicular assembly building at Cape Canaveral that so much impressed James Stirling, and the Bradbury Building in Los Angeles – are equally outside the narrow line of development of orthodox modernism. With their huge single-volume spaces they have clearly been an important influence on Foster. They were the product in the main of independent-minded

inventors, people content to get things done and to leave the theorizing to others. And when post-modernism appeared as another tendency, bidding to take over the mainstream of development, Foster was equally content to pursue a similarly independent line, aloof from the arguments of others.

One of the most intriguing of Foster's enthusiasms in the 1970s was for the Gossamer Albatross, a man-powered aircraft designed and built by Paul McCready, an American aeronautical engineer. McCready's solution to the technically highly demanding problem of devising a machine that would allow a man to fly aided only by his own strength was achieved partly by employing extremely lightweight structural and cladding materials that had only recently been developed, but also by abandoning all preconceptions about how the plane should look. The first impression that the Gossamer Albatross gives is not that it is a product of the age of jet aircraft at all, but that it is closer to the earliest experiments of the aeronautical pioneers at the turn of the century. There is even something in its birdlike lines that recalls the sketches of a Renaissance inventor. But any memories invoked are for strictly technical rather than nostalgic reasons. Clearly Foster identified with McCready. Foster sees himself carrying out a very similar approach to architecture by making the most of new materials to reduce both the mass of buildings and their need for a high energy input to make them habitable. These materials allow him to achieve ever greater technical feats with his building, such as expanding structural spans and increasing the flexibility of interior dispositions. At the same time, Foster feels equally free to abandon any formal preconceptions as to how buildings should look.

Performance is one of Foster's most consistent goals. He was particularly struck by one of Buckminster Fuller's more quixotic insights, the habit he had of asking architects the disconcerting question, 'how much does your building weigh?' Heavy buildings can span long

Overleaf *Compared frequently to a black-glass grand piano, the shape of the Willis, Faber and Dumas building adapts itself to the conditions of the site by following the pavements and gently introducing itself into the surrounding streets.*

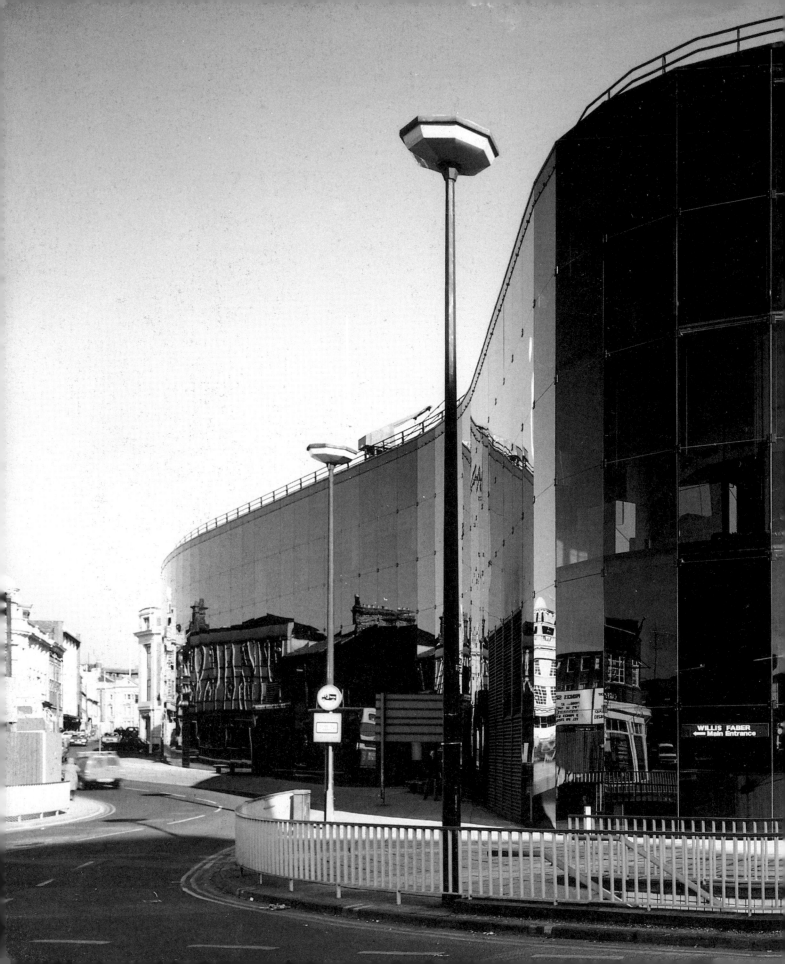

WILLIS FABER
← Main Entrance

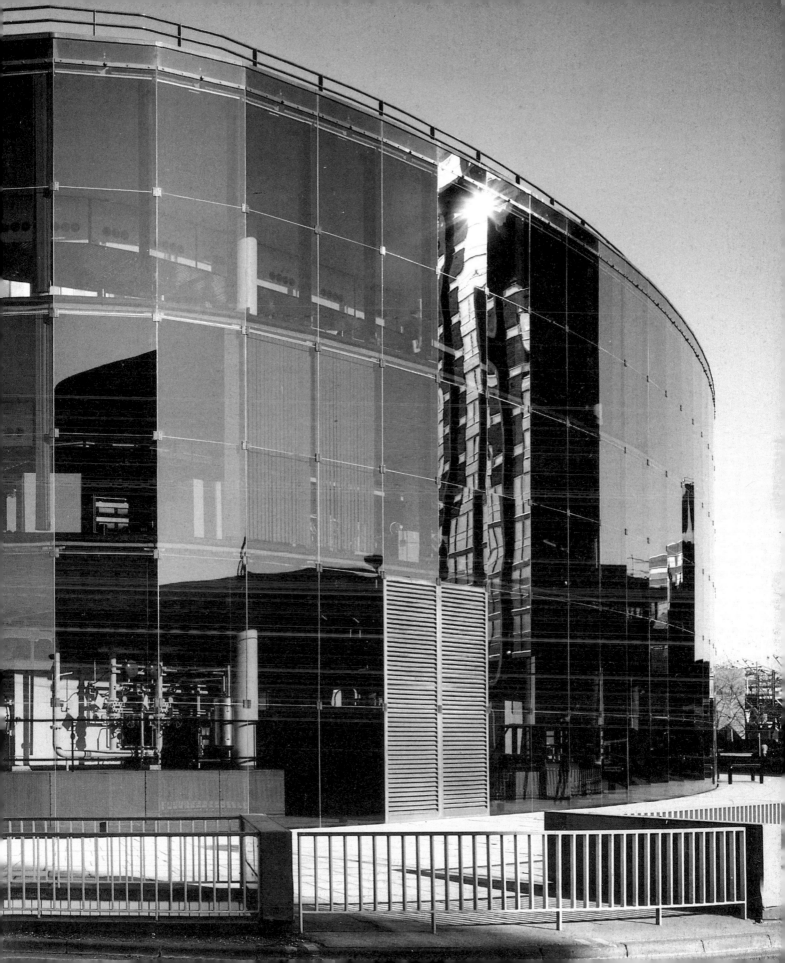

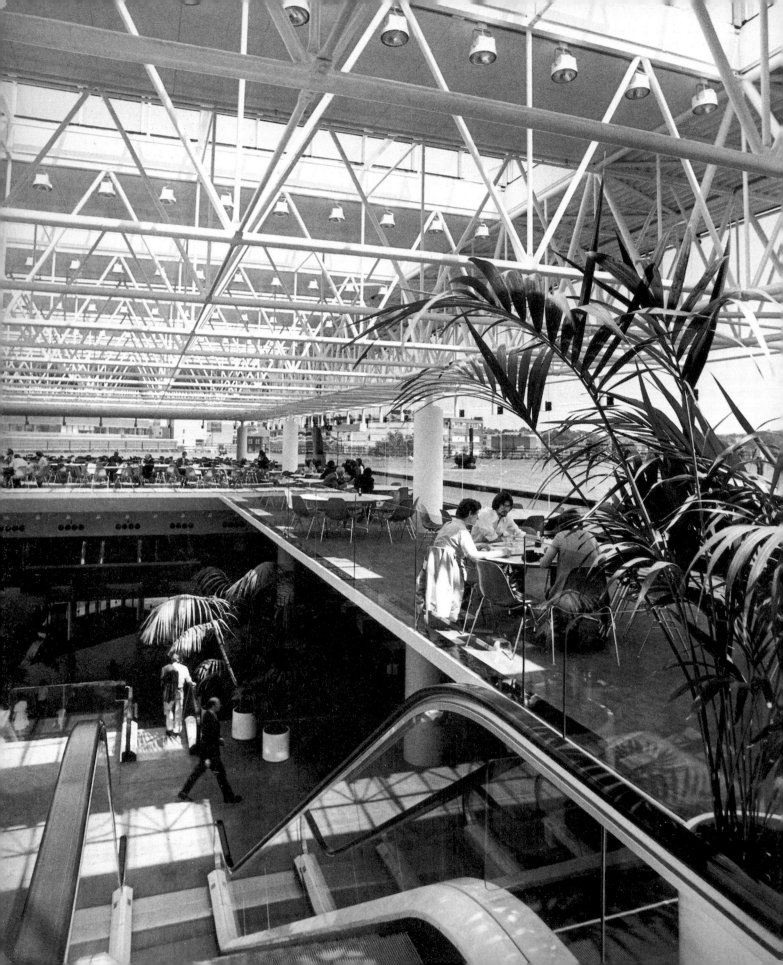

The Willis, Faber and Dumas building is really two structures, one on top of the other. The lower levels are the irregularly shaped office floors with the black glass walls that can be seen on the street; above them, the rooftop restaurant is a separate pavilion surrounded by well-tended roof lawns.

One of Foster's design sketches for the Willis, Faber and Dumas building, showing two different attempts to solve the problem of supporting heavy glass sheets on the external wall as unobtrusively as possible.

Right This drawing by Foster is part of a submission for a competition in 1967 to design a new school for Newport, Gwent. High-level service distribution, flexible use of space, and moveable partitions have all characterized Foster's work since.

distances; it is the technically more demanding task of doing the same job with less material that can be called 'high performance'. Foster knows exactly how much the Sainsbury Centre weighs, and that the greatest part of that weight is in its concrete basement. To him, the point of a building is not so much what it is, but what it does. In that sense, Foster is quite outside the traditional view of architecture as a question of self-conscious aesthetic and spiritual sensibility. He is closer to the British tradition of engineer-inventors than to other architects. This is not to say that the aesthetics of what he does are unimportant, but as a subject of discourse for Foster, aesthetics are peripheral.

In the early years of Foster Associates' existence, Foster was always careful to project a self image of the architect as the omnipotent scientist, committed to team work and efficiency, and adopting the most technocratic of working methods. Writing in *Architectural Design* in 1972, Foster began without any other preamble by stressing 'the high priority that we place on cost control and programme disciplines as a framework within which to control quality and attempt innovation'. Foster continued by talking of the 'broadening range of skills necessary to realize truly integrated design solutions, and the importance of team work to that end'.[11] This technician's approach needs to be considered against the background of the time at which it was pursued. All through the 1960s and well into the 1970s, the view of architecture as a branch of technology rather than an art was particularly powerful. It became common, for instance, for architects to refer to a 'systems approach' to design methods, borrowing a term from computing. Elevational drawings were habitually suppressed in favour of plans and it seemed entirely possible that the traditional practice of architecture might disappear altogether as a consequence of the burgeoning number of prefabricated kit buildings becoming available.

But for all his independence of mind, there are precedents for some of the forms that Foster has adopted. With its profiled sheet cladding, rounded, seamless eaves, and all-glass gable ends, Foster's Modern Art Glass factory in Thamesmead (1973) seems to provide a faint echo of Gropius and Meyer's Machine Hall at the Cologne Werkbund exhibition of 1914. Foster's first office building for IBM in Havant, originally intended to be temporary, but now a permanent part of the expanding IBM campus, has the lightweight, ethereal quality of buildings by Eames and Ellwood.

The Willis, Faber and Dumas office building is clearly influenced by the visionary phase of Mies van der Rohe, although it also has the surreal invention of a turf lawn on the roof, and a doughnut plan equipped with escalators that has been compared to an Edwardian department store. In the Hongkong and Shanghai Bank, the influence of Jean Prouvé's Ministry of Education project for Paris of 1970 is evident in the hollowed-out cross section, the use of escalators for circulation and the rooftop terraces. It is just possible to find the ghost of Le Corbusier here too, lurking in the idea of the vertical city. Foster incidentally warmly acknowledges his debt to Prouvé, and indeed he once flew Prouvé to London for an informal consultation on the work then in the Foster Associates office.

Richard Rogers's architectural education was a catholic one. It placed himself-consciously within the tradition of modernism in a European context. His halting first drawings as a teenager were made in the studio of his Italian relative Ernesto Rogers in the Milanese architectural practice BBPR. Rogers retained a sympathy for BBPR's work, despite the hostile attitude of those who regarded it as a betrayal of the purism of modernism. Rogers's first tutor at the Architectural Association in London was Robert Furneaux Jordan, a man who preached unswerving commitment to a view of

The Climatroffice, a 1971 study by Foster Associates, designed in association with Buckminster Fuller. There is no building in the conventional sense other than a closed, transparent bubble in which the office floors float. Lush vegetation creates a micro-climate. This is Foster at his most utopian, but the scheme is an interesting forerunner of his designs for the Hammersmith Centre (page 117).

modernism that included ineluctable social progress as one of its given aims. Subsequent tutors included Stirling, Alan Colquhoun, John Killick and Peter Smithson, who was then engaged with Team X on developing a sternly rationalist critique of CIAM's planning principles.

At Yale, Rogers and Foster both became students under Paul Rudolph, one of the first generation to have graduated from Walter Gropius's Harvard School of Architecture. Philip Johnson, still in his Miesian phase, also taught there. But it was to be Louis Kahn and Serge Chermayeff who were to prove the two most lasting influences. Kahn's Yale Art Gallery building (1951-3) was already long completed when Rogers was in New Haven, and Kahn had built the Richards Medical Research Building for the University of Pennsylvania (1957-60) and had started on the Salk Institute in La Jolla, California (1959-65). Kahn's monumental buildings were a powerful new impulse in the architecture of the 1960s, for they mixed technology with a poetic view of form and space. His 'served and servant spaces' division was to leave a permanent mark on Rogers.

A closer influence – for Kahn had given up teaching at Yale by the time Rogers arrived – was Serge Chermayeff, Russian born, but long a British resident, who had joined Gropius and Breuer on the transatlantic crossing before World War II. Chermayeff tutored both Rogers and Foster. At the time he was writing *Community and Privacy* (1963) with Christopher Alexander, and its ideas on the manipulation of the balance between public and private spaces within the city to stimulate social interaction have been a continuing theme of Rogers's work. Interestingly, Chermayeff had little time for the formalist modernists. 'I hope that our shapemakers will, like old soldiers, or the Cheshire Cat, fade away with their "creations". I hope to see them replaced by "problem-solvers"'.[12] A view which Rogers, with his conception of the building as an enabling frame, certainly shares.

Paradoxically, the more that Rogers's buildings become overtly technologically influenced in their imagery, the more has his concern for the urban effects of buildings grown. And, at the same time, the further has he shifted his position from doctrinaire functionalism. Rogers talks about the Lloyd's building, with all its mechanical symbolism, in terms of the traditionally admired qualities of architecture – texture, grain, silhouette and light. And he feels perfectly comfortable making

comparisons between Lloyd's and the medieval towers of Bologna and San Gimignano, or the Gothic revival fervour of George Edmund Street's law courts in the Strand. Rogers is interested not in any attempt to mimic a style, but in the use of buildings to maintain the flow of public and private spaces within a city.

Whereas Foster's buildings are concerned with finite perfection, Rogers's are more ad hoc and improvisational. For Rogers, the triumph of modernism in the early part of this century was a flawed victory. He sees that period now in terms of a battle between scientific positivism, with which he would align himself, and historicism. By adopting the position that all architectural problems were susceptible to scientific solutions, and that aesthetic history could therefore be safely jettisoned, modernism won. But, wrote Rogers, 'these slogans became dogmatic and simplistic excuses for minimum economic standards, which even now destroy the very thing that the modern movement was pledged to create, a conscious world for democratic man'.[13]

Rogers acknowledges the power of the landmarks of the modern movement's pioneers, the freestanding buildings such as the Villa Savoie, the Guggenheim Museum, and the Seagram Building. But he also maintains that 'although often highly inventive, buildings such as [these] were often taut, white and pristine, and therefore unable to respond to the ebb and flow of contemporary life'. According to Rogers this crystalline, purist form of modernism has been 'leading to a conflict between the aesthetics of permanence, and man's changing needs. In the public realm, rather than following the tradition of overlapping different activities, such as shopping, living, working, leisure and culture, these activities were segregated for reasons of formal, rather than functional clarity'.[14]

Yet while Rogers's buildings have followed the logic of this position – and have gone out of their way to provide that overlap, and also to consider with great care their relationship with the streets and spaces of the city within which they are located, they still adhere to some of the most familiar underlying impulses of modernism: consistency, and congruency between interior and exterior. Rogers remarks, 'the interior and exterior of buildings may respond to different forces, and therefore may need to be visually different. But both parts must be infused with the same overall integrity. In complex urban situations, it is often impossible to express these different public and

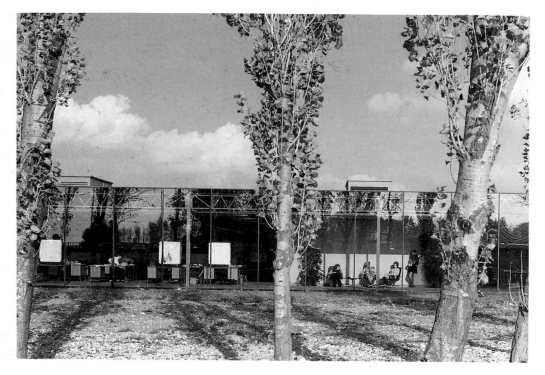

IBM's advance head office at Cosham, Hampshire, completed in 1971, was designed by Foster for fast construction, low initial cost and a high degree of flexibility. But the building was successful not only in a strictly utilitarian sense: this tinted glass pavilion transformed the image of what office buildings in Britain could be like.

private roles by the use of modern, thin, taut skins. For the modern movement to continue to be valid, it must be capable of development and adaptation in response to new information and new considerations.'[15] Although asserting the importance of history for architecture, Rogers maintains an entirely traditional modernist view that there is a difference between the treatment of architecture as an affair of ephemeral styles – such as art nouveau – and what he calls the 'total integrity of the truly great periods of architectural history'.[16]

Rogers's position is to concede that modernism did include fatal weaknesses as well as great strengths, but, in his view, many of the post-modernist attempts that allegedly set out to remedy these shortcomings are in fact ignoring their root cause. 'The irony is that the expressionless fancy fake facades of today's two-dimensional architecture, whether elegant classical modern, or whimsical post modern, fail to grapple with real values. The problem is drowned in superficial responses.'[17] Whether consciously or unconsciously striven for, the effect of the work of Stirling, Rogers and Foster has been to encourage the continued vigour of 'modern' architecture – that is, modern in the sense of an attitudinal stance, rather than a commitment to a particular style. All three have a long record of refusing to confine themselves to a single manner of architectural expression.

Stirling's exploration of different structural

and constructional methods is well known. Foster is equally difficult to pin down to preconceived solutions and off-the-peg answers to problems. It is true that he has shown a preference for taut, sleek surfaces that suppress extraneous detail – which, according to Arthur Drexler, the director of the Museum of Modern Art's architecture department, is the authentic mark of a modernist. But even this has to be reassessed in the light of the Hongkong and Shanghai Bank, which has a new depth and solidity to it. It has more than simple skin.

Looked at dispassionately, it is hard to see very much in common between the undulating walls of the Willis, Faber and Dumas building, and the geometric precision of the Sainsbury Centre, except in the underlying assumption, namely that large, open interior spaces have a capacity to ennoble a building provided that they are of sufficient scale. The Nîmes Médiathèque, an arts centre which is a provincial town's riposte to the Beaubourg, seems to be a new departure again, with its explorations toward a solution that for once has Foster countenancing the retention of an existing facade to face his new building.

Equally, although the Beaubourg does have much in common with the Lloyd's building, in its passion for legibility, and its attempt to integrate itself into the texture of its surroundings, it is a different composition – a large box as opposed to a central volume

Foster's Modern Art Glass factory, built in 1973 in Thamesmead in Kent. The steel portal-frame structure is very much like standard industrial buildings of the period, but distinction is provided by the unusually refined profiled metal cladding and the all-glass end walls.

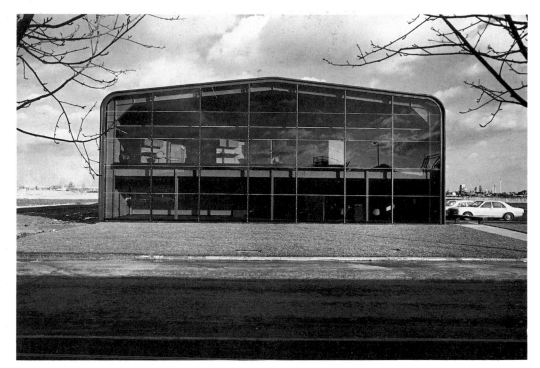

surrounded by towers. Fascinatingly, Rogers at the start of the 1980s seemed to be evolving a quite different aesthetic, so far demonstrated only in two unbuilt projects – the National Gallery extension of 1982 in London (see pages 113–116), and the Whittington Avenue office development in the City of London of 1983 (see page 134). Both schemes exhibit a crystallizing of Rogers's interest in the expressionist modernism of Erich Mendelsohn, an architect who had worked with Rogers's tutor at Yale, Chermayeff.

What Stirling, Rogers and Foster share in different degrees, and this is what distinguishes them as 'modern', is their search for an architecture of depth and meaning beyond the fleetingly fashionable. They combine this with a residual belief in the positive power of science and design – admittedly in different measure. For Rogers, the belief that design can be used to intervene positively to improve the quality of life is of the greatest importance. Architecture is a tool that can be used in the way it was used at the Beaubourg to bring an area of Paris to life, and in the way that Rogers hoped to use it at the National Gallery and at Coin Street to supplement the stock of traffic roundabouts that constitute the majority of London's public spaces with something rather more congenial. For Foster, technology is both a passion in itself and a means to an end: using high performance materials in a building in an appropriate way

makes better ecological and economic sense in the industrial context. Foster is fond of comparing the communications satellite with the undersea cable that it replaces. The latter requires the use of many tons of precious copper, and involves a long and costly cable-laying process, as well as the prospect of considerable maintenance. The high tech satellite solution to communication does away with all these, and offers extra capacity (the initial cost, of course, is immensely higher).

Stirling's work is perhaps the most personally centred of the three. He is an architect who works as an artist. As such, his sensibilities are open and tuned to the possibilities of change, which allows for a fractured view of design that can contain apparent inconsistencies within it. He acknowledges a descent from the vision of Le Corbusier, even if he is prepared to work with a more formal palette. But if there is any doubt that he is a modernist, then look again at Stuttgart's Staatsgalerie. The only fault that Colin Rowe, Stirling's one-time tutor, could find with the building was that it has no 'face'. It is perfectly correct to say that the gallery has no single identifying element. It is a composition of visually distinct elements, each allowed to express itself and all linked by a circulation route. Hiding these behind a facade would have been the most unmodern thing that Stirling could have done.

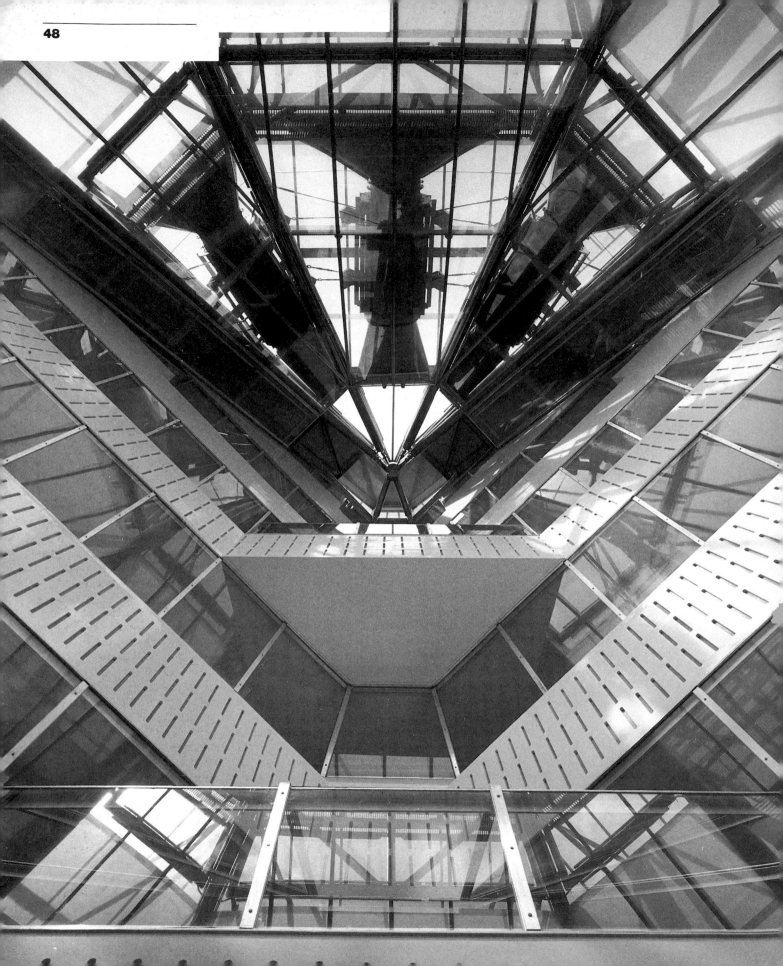

The machine aesthetic

At Cambridge Stirling pursued the idea of making a building like a machine: the double-skin glass roof of the History Faculty Building is intended to keep the interior cool in summer by the use of extractor fans mounted at the top to create a steady flow of fresh air through the building. The system has not, however, been without technical problems.

There are signs that the twentieth century has at last come to terms with at least the presence of the machine, if not necessarily with all its consequences. It is hardly surprising that the railway stations, factories and grain silos of the last half of the nineteenth century exercised such a powerful hold on the imaginations of architects of the modern movement. They were after all the instruments by which an irreversible transformation of the world was taking place. And it is equally unsurprising that aircraft, motorcars and now space vehicles have continued to fascinate architects. In terms of the resources and effort lavished on their development and production, motorcars are truly the cathedrals of the twentieth century, as Barthes somewhat provocatively observed.

Yet it is today taken so much for granted that a once miraculous but now commonplace piece of electrical equipment – a Japanese taperecorder for instance – will function well, that there is no longer any need for its designers to style it in such a way that it *looks* efficient and technocratic. Instead such products are increasingly styled as playful toys. Pastel colours, highly tactile controls and eccentric typography have taken the place of brushed aluminium, aggressive textured knobs and an unnecessary profusion of dials, all once used to bring home the message to consumers that they were indeed acquiring a piece of precision equipment. But that reassurance is no longer

necessary – indeed, to increasingly sophisticated consumers, highly attuned to the visual language of design at both conscious and unconscious levels, it may actually be counterproductive.

An obsession with the machine is a feature of modernism, from the Italian futurists' intoxication with power stations and aircraft to Le Corbusier's vision of the house as 'a machine for living'. A distinction needs to be made between buildings treated as machines and those which drew on machine-like forms for their inspiration. It is possible to see the enthusiasm of the architectural avant-garde of the 1920s and 1930s for machine-like precision, for the costly simplicity of unadorned geometry, and for industrial imagery, as an attempt to create the impression of a mechanistic architecture, appropriate to an industrial and machine-dominated age, without actually achieving its substance. Notoriously, the machine-like purity of form of the 1920s was achieved by the most laborious and costly handicraft techniques. Such buildings have subsequently required heavy expenditure on their maintenance to preserve their original pristine quality.

But while practicality was undoubtedly sacrificed to ideology, in the use of stucco as a surface material for example, it would be wrong to neglect either the power that genuine technological innovation has had in shaping

The Beaubourg's escalator provides the best free view in Paris, and attracts far more visitors than ever actually visit the museums inside. It is here that the building looks most machine-like.

The cranes that top the Lloyd's building are there for window cleaning purposes, but they also add to the impression that Rogers desires to give of the building as a continuing process, seemingly capable of erecting or extending itself.

architectural expression, or the poetic potential of the machine as a source of architectural imagery. Substance and image have of course continually played on each other. Even the most businesslike of machinery, that developed for warfare, is, consciously or not, under the influence of the imagery imparted to it by its designer.

So it is that the hand-made, one-off modern movement houses served as prototypes for forms of expression that later emerged from the use of genuinely advanced technological methods. Here again it is possible to make a comparison with the car industry, where the exotic hand-made high performance competition vehicle serves as a testbed for innovations that later reach mass-produced family saloon cars.

In fact, one of the greatest philosophical difficulties that has faced modernist architects has been an obsession with mass production and industrialization. Time and time again, the building industry has been characterized as primitive and incompetent in its reluctance to turn itself into a factory-based version of a car or aircraft plant. Because of the high degree of hand-labour involved, building remains a costly process, and the economies of scale of other industries have never been successfully transferred to the building site. The limited experiments that have taken place with such methods have usually been more in the nature of expensive prototypes than actual realizations. Building an office by hand to look as if it is made by a machine is inevitably much more costly and problematic than making a virtue of the imperfections of manual production techniques. These are issues that have formed an important part of the careers of Stirling, Rogers and Foster. All three have on occasion struggled to make use of the supposed benefits of mechanized building. But equally all three have also been aware of the purely visual potential of what has been called the 'poetry of equipment'.

Kenneth Frampton has used this phrase of the Maison de Verre, the house (with a surgery attached) that the decorator Pierre Chareau carved out of a nineteenth-century apartment house in Paris (1928-32) with the assistance of Bernard Bijvoet. With its glass-brick walls that suffuse the interior with non-directional light, and its delight in the tailoring of industrial materials such as steel I-beams, perforated steel and studded rubber to the specifications of domestic life, the house has exerted a strong influence, particularly on Stirling and Rogers.

Its elaboration of mechanical parts – for window opening, for hygiene, for bookshelves – makes a ritual out of the everyday tasks of life. By using materials that give them a machine-like quality, the house has the paradoxical effect of celebrating the tasks rather than diminishing them.

Rogers visited the Maison de Verre in 1959, at a time when it was still little known in Britain, and wrote an early appreciation of it (for *Domus*, 1966). Stirling also made a visit in 1959, in the company of Colin Rowe. He was moved afterwards to declare that 'the Chareau house started where Le Corbusier's houses stopped', that 'the Corb houses thereafter seemed like mere shells', and that 'after all, it was the internal environment mechanisms which were important, and the external shells were stylistically unnecessary'.[1] It would be wrong to draw too many direct parallels with Stirling's own work. There can be no doubt that the power of the image of the machine has been a recurring theme in his buildings, but, with few exceptions, such as his passing weakness for fibreglass – not a particularly high technology material – Stirling's enthusiasm for the machine has generally been limited to an appreciation of the nostalgic power of the abandoned, technologically outmoded machines of the nineteenth century, such as the steamship, rather than the anaemic world of microchips, injection-moulded plastics and machinery free of moving parts.

The romance of the machine has not stopped simply at creating buildings that look like machines, or which celebrate their imagery. There is also a continuing tradition of buildings conceived as functioning machines, with moving parts and components that respond actively to external stimulus. Thus the History Faculty Building at Cambridge is not only an evocation of a Victorian reading room; its double-skin glass roof has active louvres and a polished steel exhaust extractor fan mounted at the apex of the roof which turn the building's skin from passive to active. In a mechanical sense, the building has come alive. By contrast, Stirling's Leicester and Oxford buildings simply evoke the aesthetic of a Victorian power station by an elaboration of handrails, clay tiles and glazed bricks, materials meant to last, and the deployment of toy-like evocations of ships' funnels.

Similar echoes find their way even into the most avowedly classical of Stirling and Wilford's buildings, such as the Staatsgalerie, with its two overscaled bulbous vents

reminiscent of the Beaubourg centre, and its glass and steel constructivist canopies. Although Stirling finds these enjoyable and useful elements to deploy in his buildings, there is always an edge of irony, a distancing. In the same way that Leon Krier's drawings are full of unthreatening technology – electric trams not motor cars, airships not Boeings – Stirling likes his technology nostalgic. An exception in Stirling's case must be made for the second phase of his work at Runcorn New Town. Here Stirling has used not the precast concrete of his first buildings in Runcorn, but brightly coloured ribbed fibreglass cladding concealing a timber-frame structure, adopted porthole-like circular windows, and made much of pylon-supported service distribution systems that occasionally give the place the air of a chemical plant.

Rogers and Foster's relationship with the machine is of a rather different kind. Rogers's admiration for the Maison de Verre has been conditioned by the mood of the Architectural Association at the time of his graduation. Peter Cook, Warren Chalk, Ron Herron and Dennis Crompton among others were establishing Archigram, mixing futurism, an obsession with the burgeoning American rocket industry, and English eccentricity in roughly equal measures to establish a movement that although it built nothing fascinated the avant-garde in Japan and Italy. Projects like Peter Cook's Plug-In City, and Ron Herron's disturbing but powerful drawings of a walking city, clearly have had a strong impact on Rogers's thinking, as has Cedric Price's Fun Palace project. Stirling has

been content to use the image of the machine as one element among many in his collages, in the same way that Paolozzi works with elements of science fiction and pop imagery, but Rogers's buildings are closer actually to being machines.

In describing the Beaubourg as a giant Meccano set, Rogers makes this quite clear. Seen in this way, the Beaubourg becomes a machine whose purpose is to create social interaction within the city. It is a changeable, adaptable and playful machine, which is open and populist rather than closed and private. But Rogers's machines are not artless affairs: they are carefully designed, their static and moving parts composed for aesthetic effect. Charles Jencks alleges that Rogers is aware of the Beaubourg's echoing of the paired columns and tripartite facade of the Louvre, and Rogers himself has frequently compared his design for the Lloyd's building in London, with its expressed towers and inflected silhouette, to Street's law courts in the Strand.

To admit that it is a self-conscious aesthetic composition is not to invalidate a machine's claims to being taken seriously. Think about the pride which the Victorian locomotive engineers took in displaying connecting rods on their steam engines, and the care with which they composed the layout of the pipework across their boilers. The same amount of care has been lavished on the colour-coded pipes of the rue du Renard facade of the Beaubourg (see page 28), and on the intricate, almost expressionistic array of silver ductwork on both sides of the Lloyd's atrium. For Rogers, the essence of architecture

Stirling and Wilford built two housing developments at Runcorn New Town near Liverpool between 1967 and 1977. The first of them, shown here, uses a prefabricated concrete panel system, and is arranged around a series of squares, intended to provide a link with the urban tradition of British housing that includes the Georgian squares of Bath and Edinburgh. The sheer numbers – this group consists of 1500 dwellings – and the coarseness of the materials at their disposal have not made the comparison particularly flattering to Stirling and Wilford.

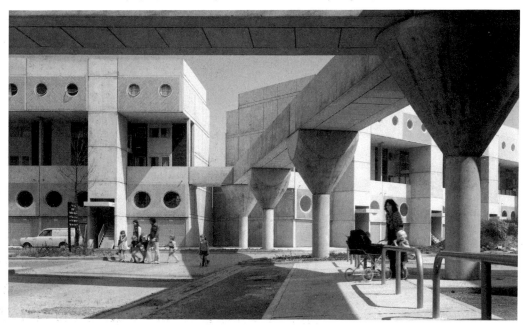

is legibility. He composes facades in which there is no ambiguity of purpose, and in which each element is designed to display clearly its function, the means by which it is connected to every other piece, and its relationship to the whole.

To an extent, this approach has amounted to a form of technological ornament in some of Rogers's buildings. It has echoes of Rogers's enthusiasm for the work of Louis Kahn, with his concept of served and servant spaces. Indeed, Kahn's Richards Medical Research Building in Philadelphia, with its expressed brickwork ducts, provides a paradigm for Lloyd's, even though it is expressed in an entirely different architectural vocabulary. At another level, its legibility is a restatement of Rogers's espousal of ideas first put forward by the metabolists, who view architecture in terms of product life cycles, as well as by Nicolaas Habraken. Structure will normally long outlast services, so why not express the services as different elements within the building, frankly admitting the possibility that one day they will be removed and upgraded?

Fundamentally, however, Rogers has an optimistic faith in the positive power of technology, and an uncomplicated enjoyment of its forms, textures and materials. For example, at his plant for Inmos, the British government funded microprocessor factory in South Wales, there are practical justifications for the cable-stayed mast structure, for it provides column-free spaces in the clean rooms within the factory. But the decision to suspend its two decks of containerized airhandling and services equipment above the plant (for they could have been concealed inside the building) makes it clear that the image is equally important. Certainly, there are logical technical grounds for such an arrangement, but given the fact that building Inmos was conceived as a deliberate act of government policy aimed at industrial regeneration, the idea of celebrating its technological content visibly seems entirely appropriate (see the illustrations on pages 58 and 59).

Of all three architects, it is Norman Foster who has probably come closest to achieving the modern movement dream of treating architecture as an industrial process. In the case of the Hongkong and Shanghai Bank in particular, the sheer scale of the building and its geographical remoteness have allowed Foster to treat the project exactly in the way that a new car would be developed. Each element – cladding, structure, internal fittings, service modules – has been prototyped, tested, and then designed for production on assembly lines with the help of subcontractors before being shipped for site assembly. The bank is genuinely high technology architecture. As Foster once said of the Willis, Faber and Dumas building, there is nothing particularly advanced about using glass and concrete in a building. But for the bank he has worked with engineers to develop completely new chemical treatments for fire proofing and anti-corrosion. Always an enthusiast for the transference of technological innovation from one sphere to another, Foster

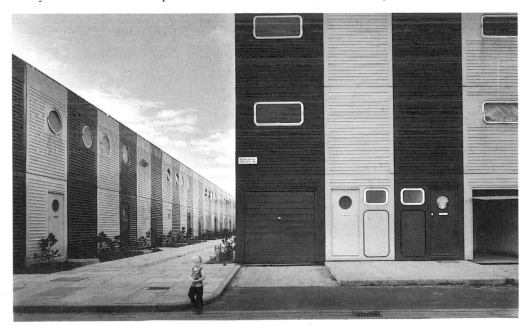

Stirling and Wilford's second scheme at Runcorn: 250 houses no more than three floors high, all with gardens and arranged in terraces. As always, Stirling's choice of finish for the fibreglass cladding favours strong contrasts of colour, in this case silver with either green, pink or blue.

Right *For the Olivetti training school at Haslemere (1969-72), Stirling and Wilford used fibreglass as cladding material – then a technology still in its infancy. The capacity to mould it and give it two-directional curves allowed the architects to create a building with a highly finished, machine-like quality.*

Opposite *The Olivetti training school stands in the grounds of an arts-and-crafts country house, and is attached to it by this tapering glass link that burrows its way into the centre of the school's two classroom blocks (see the plans on pages 88 and 90).*

has drawn on aircraft, fast cars and spacecraft for both the substance and the image of the Hongkong and Shangai Bank. Aluminium honeycomb floor-panels in the building are derived from those used for airliners, and the suspension mast structure is based on bridge technology.

Paradoxically, Foster's buildings remain essentially dependent on craftsmanship, a fact of which he is well aware. But it is craftsmanship of the order that is found in the modelling of car body-shell moulds in wood before die stamping tools can be made. To Foster this is a far more rational way of proceeding than reliance on a diminishing number of traditionally skilled building workers to labour in the rain and mud of the old-style building site. With the exception of the Hongkong and Shanghai Bank, whose foundations were in part dug by Chinese work gangs using only hand tools, Foster's buildings are fabricated by white-coated technicians, and are subject to inspection, quality control and continual evaluation. 'High technology is not an end in itself', he has written. 'Rather it is a means to social goals and wider possibilities. High technology buildings are handcrafted with the same care as bricks and mortar, or timber. Handcrafted care is the factor which makes a building loved by its users, and by those who look at it. Materials have changed however, and quality control no longer comes from site based crafts.'[2]

It might be added that the image of perfection that Foster pursues is one that removes all traces of the randomness and individuality of handwork. He aspires to smoothness, perfection, minimal thickness, and elegant, slim jointing. Foster's office had an association with Buckminster Fuller from 1968 until Fuller's death in 1983, shortly after the guru of the geodesic dome had delivered an address at the ceremony to award Foster's Royal Gold Medal for Architecture. It is possible to see the storey-high washrooms of the Hongkong and Shanghai Bank, which were prefabricated in Japan, and fitted out right down to the taps and mirrors before being shipped across the sea to be lifted into position by crane, as the conclusion of a process that began with Fuller's Dymaxion bathroom of 1937, or even with the prefabricated cast-iron of the Victorians. But the bank's electrically controlled sun-scoops – arrays of computer-controlled mirrors that track the sun in carefully measured steps throughout the day, to light the building's central atrium – go a step further toward creating a mechanically active building (see below, pages 157–158).

The emergence of high tech as a fleetingly fashionable decorating style in the 1970s did somewhat complicate the picture. High tech became a label that seriously embarrassed some architects – although not Stirling, who is still happy to refer to elements of Stuttgart as 'high

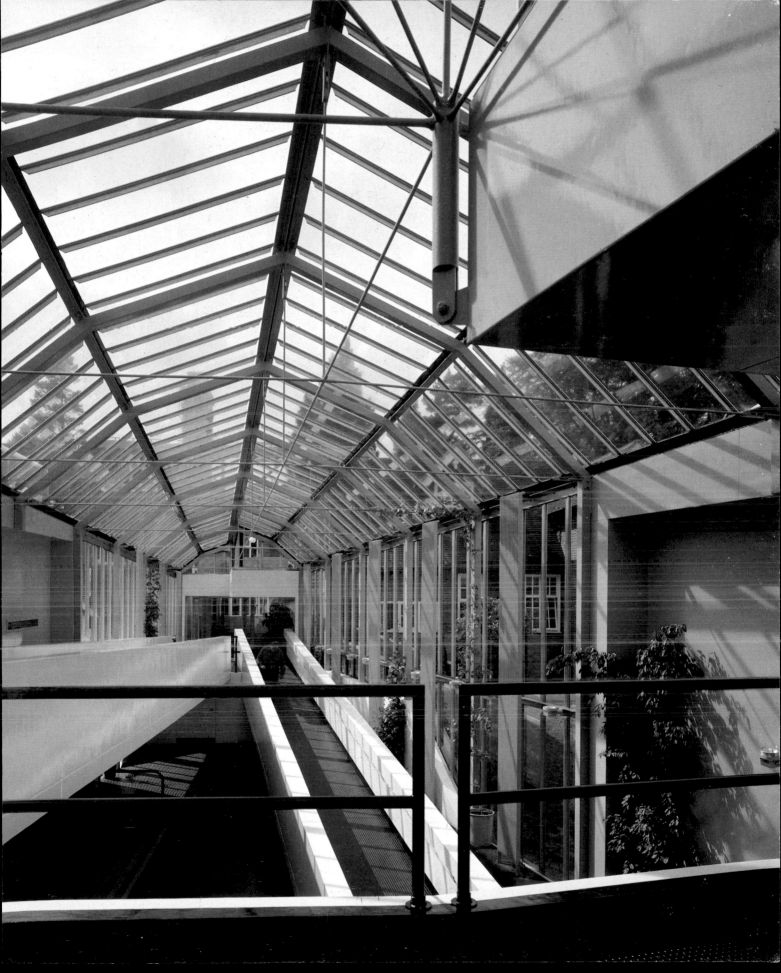

Left *Stirling's fascination with vivid colour schemes and glossy, sensuous shapes came to a head at the Olivetti training school. The lecture theatre's electrically operated partition walls and bare light bulbs could have come from the set of a pop-art movie. Another Stirling trademark is the use of conically topped columns (compare, for example, page 166).*

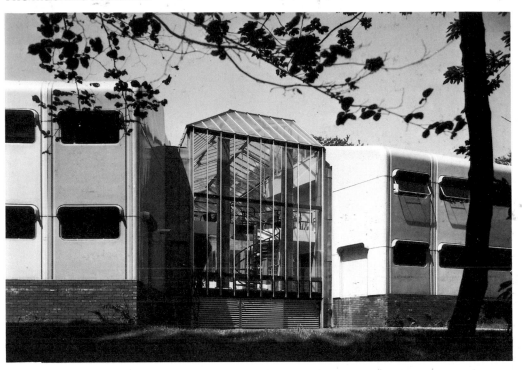

Right *The exterior of the two classroom blocks at the Olivetti training school, with the glazed connecting link in the centre.*

tech'. The enthusiasm for high tech, as evidenced by a rash of buildings that used exposed space frames, dangling curly cables and perforated metal mullions, has been described by some as evidence of a nostalgia for Britain's past engineering greatness, and therefore to be condemned. There may perhaps be some justice in this. But unless architects, in collaboration with the engineers on whom the achievements of Rogers and Foster, and also of Stirling in his Leicester days, have depended, continue in a determination to push materials to their limits, and extract more and more performance from them – genuine high technology if you will – then stagnation will very shortly be the only option. The ability to do anything else will have disappeared.

Yet, in the years since the 1960s, technology has been getting an increasingly bad name in Britain. Innovation is questioned, especially in view of the failures of system building. Such a view is short-sighted. It is illogical to reject innovation when even apparently traditional materials are produced by high technology methods. 'Slates' today are generally factory-pressed products that mix asbestos or other mineral fibres with cement. Bricks are very different in composition and appearance from the handmade products of the past, and the skill to manipulate them is fast vanishing.

When Stirling first used glass-reinforced polyester moulded panels as a cladding

material, for Olivetti's Haslemere training centre, it was a substance still in its infancy. On the surface it appeared to be exactly the kind of material appropriate to an era full of technological promise. It was after all made in factories, and could be used to create large numbers of lightweight easily portable panels by simple repetitive methods. It was easy to erect, and reduced the building process to a matter of the installation of a lightweight steel frame and the attachment to it of storey-height panels that could be detailed to have windows or doors pre-fitted. Most attractive of all to some designers, it allowed buildings to become even more like sleek pieces of machinery than Bauhaus stucco had done. It allowed rounded corners and double curves to be moulded without difficulty, contributing to the visual impression that the building itself was some kind of machine, profiled to slip easily out of the mould used to stamp it from plastic or steel. Such an explanation is often cited as being behind Stirling's use of fibreglass at Haslemere, where two classroom wings are contained in a cranked low block sitting at the end of a glass conservatory linking Stirling's buildings to Edward Cullinan's conversion of an Edwardian country house into a residential block for Olivetti. It has been suggested that Stirling was attempting to echo the sculptural panache of Olivetti's moulded-plastics business machines. In truth the moulding of fibreglass panels for

Left and below Built with government backing in 1982, Rogers's factory for Inmos at Newport in Gwent *has a deliberately technological air, highly appropriate for a prestige scientific project intended to give Britain a silicon-wafer manufacturing capacity. The essence of the factory is the maintenance of the working areas inside as surgically clean, column-free open spaces. Accordingly the structure and services are all on the outside. A series of double masts defines a central corridor, and from these steel cables are extended to support a series of open steel trusses.*

buildings is primitive compared with the automated injection moulding used to create the casing of a typewriter, or the body of an electronic calculator. Strands of glass are messily positioned, often by hand, within the mould, then resin is introduced into the mixture – more a do-it-yourself technique than an industrial process. A more persuasive explanation for the imagery of Olivetti is the notion of it as a striped Edwardian marquee, pitched in the grounds of a country house. The image would have been clearer still had Stirling been permitted to use the vividly contrasting green and blue he originally had in mind for the panels, rather than the cream and buff he was forced to settle for by the planners. Yet there is still a glossy sensuousness in the Olivetti building, especially in the multipurpose lecture theatre. Its mechanically retractable partition walls bring to mind an image of the 1960s that is like something from an art film by Roger Vadim, all push-button modernity and bare light bulbs.

The Cambridge History Faculty Building, with its retractable window-cleaning cranes, hints at another of the recurring themes of the machine aesthetic: the idea of the building working as a continuous process. Peter Cook's Plug-In City is made up of buildings that seem to be self-sustaining, each equipped with a permanent tower crane that allows the building to erect itself. The drawings of Foster's unbuilt Hammersmith Centre include two similar cranes, apparently equally permanent, whose function remains enigmatic. Such features have actually been realized for the Hongkong and

Shanghai Bank and for Lloyd's. Both Foster and Rogers have lavished more attention on, and accorded more prominence to, the window-cleaning and maintenance systems than could be justified on narrowly functional grounds. Lloyd's has its blue tower crane gantries, the Hongkong and Shanghai Bank its maintenance cranes suggestive of star-ship gunports, both tributes to the idea of the building as an unfinished process, with an appearance of being capable of adding to or extending itself.

In different ways both the Beaubourg and the Sainsbury Centre exhibit similar tendencies. The Sainsbury Centre's structure, a series of welded steel tubes formed into deep trusses, each spanning 110 feet, is static enough, but the building itself has a skin that is capable of a high degree of response to external stimuli. It is clad with a system of vacuum-formed aluminium panels. Each panel has a moulded aluminium outer skin, and an inner layer of foam, a composition which allows the panel to be moulded in a manner normally reserved for the plastics industry, and which in addition provides a high level of thermal insulation. There are three different panels: a glazed version, a solid aluminium panel, and a louvred variant. Each is held in position with just six bolts, and can be swapped with any other panel on walls or roof in about five minutes, providing the possibility of changing the building's facade. In fact this is not a feature which has so far been put to much use (nor is it ever likely to be), but it does allow for an extreme elegance in detailing and conception:

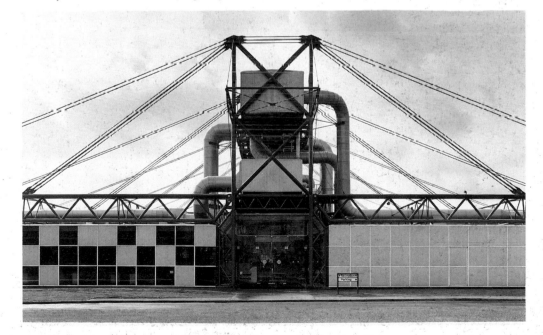

Left *At the Sainsbury Centre Foster uses electrically operated Venetian blinds to protect the all-glass walls from direct sunshine. The building was designed without airconditioning, so as to keep operating costs as low as possible.* Right *Only the most tenuous of links, a glass-walled walkway, ties the Sainsbury Centre to its concrete neighbours on the University of East Anglia campus. Rather than approach the building head on, it slides up at an oblique angle in an informal – and by implication 'anti-elitist' – way.*

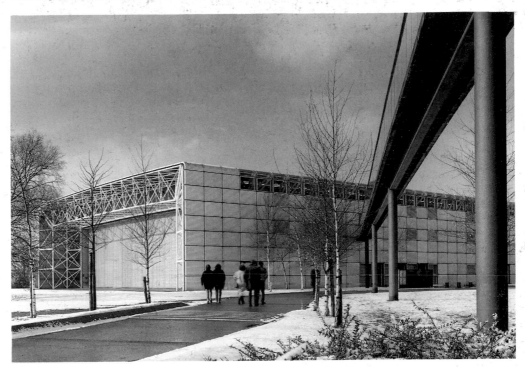

A detailed diagram of one of the steel-tube supports for the Sainsbury Centre's glazed panels.

the joints between each panel are sealed with neoprene gaskets of a profile that allows them also to function as rainwater channels, eliminating conventional gutters and downspouts

An even more machine-like aspect of the Sainsbury Centre is the way in which its cross section is conceived as a seamless double-skin profile, within which are contained the servicing distribution systems and the structural and environmental controls, very much in the way that an outwardly sleek section of aircraft wing is actually packed full of structural spars, fuel tanks and hydraulic control lines. Within the Centre's roof, a space eight feet deep, with room for an access catwalk, are adjustable lighting gantries, tuneable to cater for different exhibition layouts below, and two layers of aluminium louvres. The outer layer is controlled by photosensitive cells which allow the building to close up protectively against bright sunshine, to help prevent the build-up of a greenhouse heating effect. The second layer of louvres is motorized, allowing it to be adjusted as required. Within the walls, also made up of two skins eight feet apart, is the air-distribution equipment, which draws in fresh air from the outside through circular air-intakes, and expels it through exhausts in the louvred cladding panels. The Sainsbury Centre is reticent about all these details. The impression made by the outside is of a taut

metallic skin; on the inside the visual complexity of the roof makes it disappear into a diffuse layer of brightness (see pages 101–104).

The Beaubourg is rather different. Rather than conceal its working parts with an elegant skin, it puts them on show. It is possible to see even the most private of mechanical functions displayed on the outside: the movements up and down of the lift counter-balances are visible, and colour coding identifies which pipes are handling electrical services, and which are spiriting away foul water. It is this difference that has led some critics to call Foster a classicist in his use of high tech themes, in contrast with Rogers's 'gothic' spirit.

Rogers's muscular use of structural components certainly gives this claim some justification. There is an elaboration of braces and beams emerging from the main building envelope of many of Rogers's buildings in a way that does indeed suggest a gothic tendency. But 'romantic' might be a better description for the way in which Rogers uses structures and services to create picturesque silhouettes. There is, however, purpose in Rogers's pursuit of technology which goes beyond aesthetics. Hence the use of glass-reinforced cement cladding panels for the Universal Oil Products factory in Tadworth, and of specially formulated triple glazing on the Lloyd's building, a material developed both to save energy and to make the most of available light.

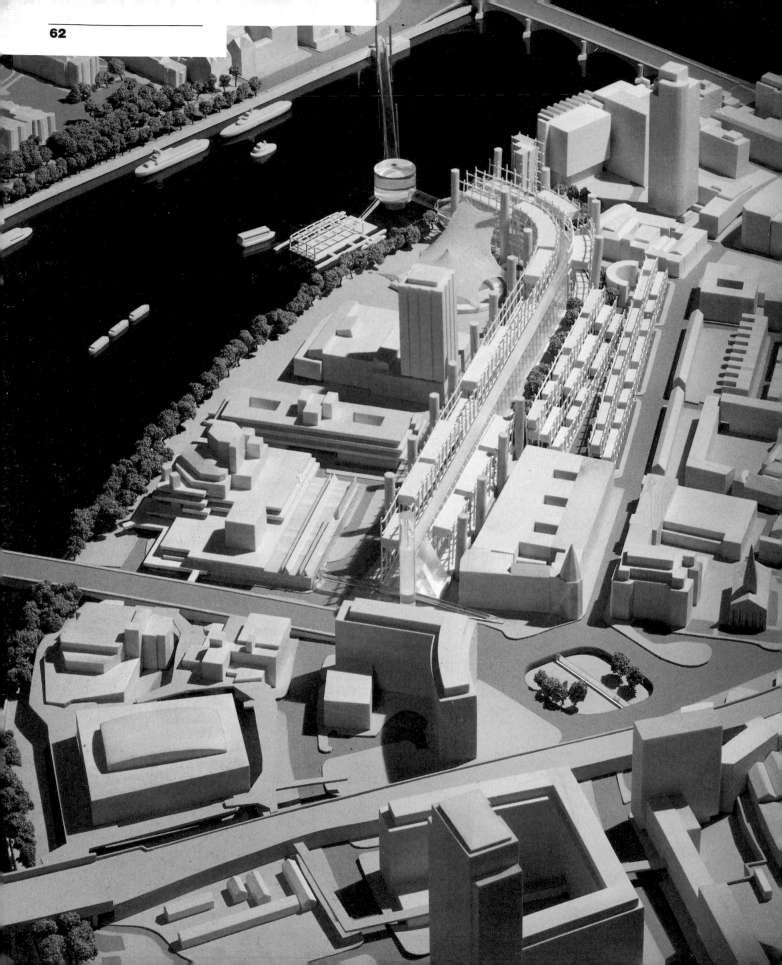

Architecture as a political art

It is a measure of the significance with which society still invests architecture that it is so often the subject of bitter and protracted conflict. With a very few exceptions, art in the last decades of the twentieth century is not the battlefield that it was in the nineteenth. Faced by agnosticism and indifference, it has become a marginalized activity. It is hard now to imagine the climate in which Napoleon III felt the need to intervene in the affairs of the French Academy to allow a salon des refusés, to which Paris's citizens flocked – for the most part without much comprehension – to see the works of Manet.

Architecture on the other hand still has the power to inspire passions of that order, in both professional debate and public controversy. The tens of thousands who in 1982 came, futilely as it turned out, to cast their votes for one or other of the original seven schemes in the National Gallery extension competition, the intervention of the heir to the throne in that same argument, and the violence of the language with which architecture is discussed in print, all point to the continued significance that it still has. This is not to say that conflict is necessarily associated with architecture's relative importance and quality. But its presence does suggest that architecture is considered a subject worth expending effort, energy and money on, even among those who have no direct part in it other than as consumers.

This is partly because consideration of architecture offers people the opportunity, real or apparent, to take part in the shaping of their environment. While the purely architectural aspects of new urban developments may not ultimately have the determinant force of such intangible abstractions as land values, planning policies and economic programmes, they are the most immediately obvious aspects, and they do provide a chance for at least the semblance of participation in the process. So it is that local authorities have been eager to exercise a power which, strictly speaking, they do not have – aesthetic control. And so it is that the architectural trappings of unpopular aspects of twentieth-century life – materials such as concrete, 'slab' tower blocks and so on – have taken on a symbolic scapegoat role for the ills that they represent.

For those who take a more pragmatic view of development than the architectural profession – the politicians, the pension fund investment managers and the developers – architecture's symbolic role has often provided a convenient diversion of attention from their own activities. Yet architects themselves have deliberately emphasized this role. They have consistently presented their work as at least a ticket to an architectural utopia, if not actually a weapon in the class struggle.

The irony of this has of course been that by the end of the 1970s architects were finding

themselves attacked on exactly the opposite grounds: not, as in the 1930s, that they were agents of Bolshevism, but that they were capitalist tools. The most personally damaging phase in Rogers's career has been the abortive Coin Street development, planned as the large-scale rebuilding of London's long-derelict south bank. Most of the fourteen-acre site had been used for nothing more than car parking since the Festival of Britain buildings were cleared from it. Much of the land was owned by the Greater London Council, which put forward a succession of radically different plans for its future, each depending on the political complexion of the controlling group of councillors. The Conservatives at one stage gave their blessing to a skyscraper hotel that would have erupted from immediately behind the National Theatre. Their Labour successors attempted to re-zone the land for low density housing. The succeeding Conservative administration reversed that policy and put the council's land holdings up for auction. Four developers expressed an interest, all backing their cash offers with architectural schemes drawn up by a variety of undistinguished commercial practices. At the last moment one of them, Greycoat Estates, dismissed their original architects and brought in Rogers to produce a new scheme worthy, they claimed, of the metropolitan importance of the site.

This was an early example of the increasingly common calculation by developers that a conspicuous commitment to architectural quality might not only smooth the path of planning applications, but could also make property more desirable to potential tenants. The three other developers dropped out, leaving the field clear for Greycoat until an unprecedentedly well-organized and vociferous campaign of opposition erupted from the streets just inland of the derelict Coin Street sites. These campaigners and their leftist supporters claimed that Rogers was allowing himself to be used as a fig leaf for a piece of brutal commercial greed. Coin Street was, they declared, the last remaining large site in central London that could be used economically for public housing, and they set about drawing up their own alternative to Rogers's design.

Although Rogers's direct involvement in political activity has been limited to such symbolic gestures as marching to Aldermaston, and to instituting a system within his partnership that limits partners' salaries to a given multiple of the lowest-paid employee, his speeches have frequently sought to present architecture as a political activity. In 1976 he told the RIBA that 'we stand at a watershed in world history. The issue being the validity and acceptability to the majority of the world's inhabitants of the present social and economic system, which allows two-thirds of the world's population to suffer from malnutrition and homelessness.' Rogers went further, refusing to confine himself to ritualized expressions of well-meaning concern: 'The question is, whether a new order is viable, based on our ability to carry out a social revolution which in the short term will threaten our present living standards, for the forces of the market place that have traditionally been kind to us, are blind and merciless to the majority who are weak. If this is utopian day dreaming, and we reject the idea of a new social and economic order, based on limiting the total hold of the few manipulating everything in their own interest, then we must accept the aftermath, which is starvation, destruction and death.'[1]

Rogers followed these remarks with some harsh words about the way, as he saw it, the large architectural practices had all the work, and those such as James Stirling's – and presumably his own – were starved of opportunities because of their tendency to upset the status quo. 'It is tragic that, in spite of our best intentions, we architects inevitably strengthen the existing system, whilst paying lip service to society's needs, for our living is gained by service to the present system. The sole possible aim of the successful architect becomes to improve the financial return of the client who pays him, thereby bringing himself personal wealth, power, and further work, while closing his mind to the non-paying public. How can we then consider ourselves to be autonomous professionals working for the good of the people?'[2]

The rhetoric of Rogers's previous commitments to socialism – he had even quoted Marcuse at the hapless members of the RIBA – ought to have put him on the side of the mainly leftwing activists who had mobilized against the Coin Street scheme even before his appointment. But in fact Rogers consented to act for Greycoat, not without misgivings and arguments within his office. The dispute really came down to whether the Coin Street site was one of importance to the whole capital, and was therefore appropriate for development on an urban scale, or whether it was simply another housing site. Rogers concluded that the former was the case. But he also saw sufficient space and scope within the fourteen-acre site to

This drawing shows the riverfront elevation of the Coin Street scheme, where the offices would have risen to a 15-storey block. Similarities to the Lloyd's building are immediately obvious: see page 179, for example.

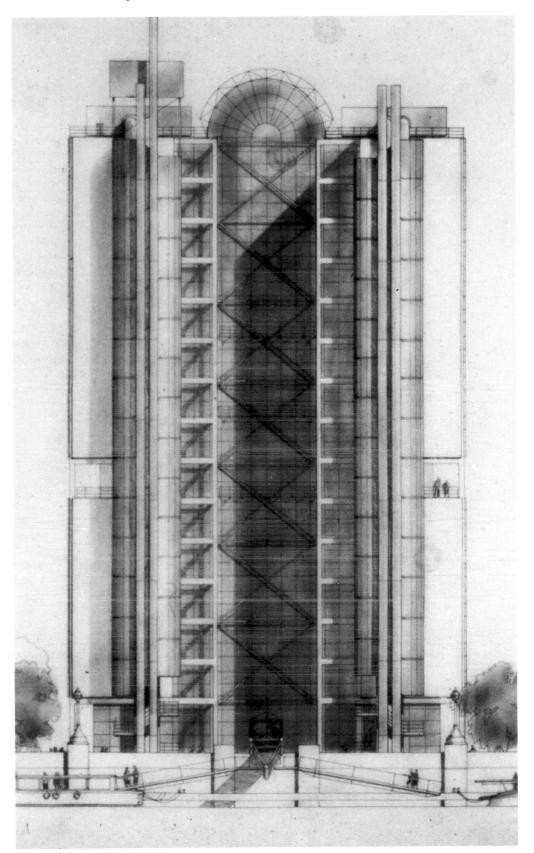

Below *The essence of the argument over Coin Street was its significance to central London. Was this just another housing site, or was it a chance to respond to the metropolitan scale of its surroundings? Rogers's view was that there was room for both new housing and the offices his clients needed. This drawing shows the view from the south. Houses are in the foreground; the glass-roofed atrium runs parallel to the river before turning north to culminate in the building seen on page 65 and visible here halfway between two existing towerblocks.*

include both the housing that the protestors were calling for and the offices which Greycoat needed to fund the development. From this point on, rational argument tended to become overwhelmed by the symbolic content of the debate. Coin Street became a set-piece battle in which all the redevelopment failures and the fortunes made in the 1973 property boom went on trial, regardless of the actual merits or demerits of what Rogers was proposing. In this battle, modernism, which had in the 1920s been given its greatest opportunities by the progressive town councils of Germany, was now being castigated by those who might once have been its supporters and adopted by their political foes.

Rogers concluded, in company with the Royal Fine Art Commission, that Coin Street, caught in a twist of the Thames between Westminster and St Paul's, was a site of national importance. It was a rare opportunity to put into practice on a large scale his ideas about urbanism and what it had to offer to life in a city which had few functioning public spaces. As

Rogers said at the time, 'the site lies within a few minutes walk of Waterloo Station, and its quarter of a million passengers each day, the second largest office development in London at the Shell Centre, the Houses of Parliament, Trafalgar Square, St Paul's, and is on the bank of London's largest unused amenity space: the Thames. It is our belief that an open-ended flexible infrastructure, capable of fostering a wide range of local and metropolitan activities is needed if a 24-hour life for young and old in all walks of life is to be encouraged on the South Bank. The aim of the planning concept is to make a major linking and pulling magnet out of the Coin Street development to link it to the rest of London.'[3]

To this end Rogers proposed a complex made up of nearly 1 million square feet of offices, 200,000 square feet of housing, 185,000 square feet of shops, restaurants and other entertainment facilities, workshops, and an open-air amphitheatre for public performances. He planned the scheme around a continuous covered pedestrian route, stretching

Right *The Coin Street development would have included a series of terraces of low-cost public housing at a lower level than the office buildings. Rogers later modified the somewhat monolithic character of the offices as shown in this model by grouping them in clusters interrupted by open spaces, thus countering charges that they would have formed a continuous wall cutting off the domestic hinterland of the site from the river.*

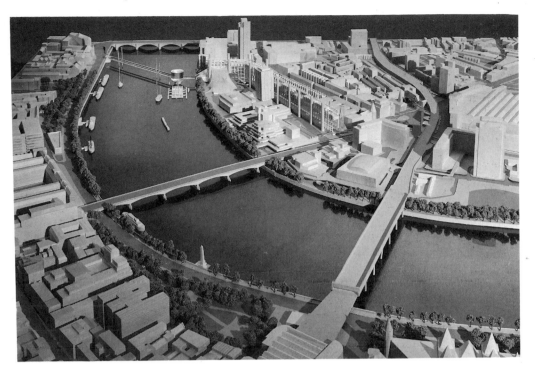

from Waterloo Station in a gentle curve toward the river, where a new footbridge would have linked the development with the north bank of the Thames – indeed designs for bridges across the Thames have fascinated Rogers ever since, and form a major element in his Royal Academy exhibition display of 1986. The office blocks were to have been grouped in three clumps along the pedestrian route – a pattern reminiscent of Foster and Rogers's earliest collaboration as students at Yale. By enclosing the route on both sides and roofing it over, Rogers planned to create a vaulted *galleria,* complete (in his drawings at least) with pavement cafés and shops at ground level. At intervals, this walkway would have opened out into pavilions to provide a pitch for street entertainers – the buskers, sword swallowers and the like that have become almost as much a symbol of the Beaubourg as the multicoloured plumbing. Although the design was never fully detailed, it is clear that the section and profile of the office blocks, stepping up to a maximum of fifteen floors adjacent to the river, would have been very close to that of the Lloyd's building. Of the 12.6 acre site, only 3 percent would have been utilized at ground level for offices.

On the other side, the Coin Street Action Group proposed a housing development clothed in the all-purpose brick 'vernacular' of the 1970s. This plan was drawn up by the Greater London Council's own architects once the Conservatives had lost control shortly after committing the council to sell the land to Greycoat. After three separate public inquiries, two High Court cases, one appearance in the Court of Appeal, and innumerable demonstrations, Rogers got his planning permission. But in the event, the developers backing the project never had the chance to exercise their option to buy the site from the now bitterly hostile Labour-controlled GLC because of legal technicalities, and so they sold out their holdings.

It was a curious defeat. The most often repeated arguments by the opposition to Rogers's plan was that there was no money to build the offices Greycoat wanted, and no demand for the space within them. But within two years of the final abandonment of the project, a consortium of banks so desperate for the type of space that Coin Street would have offered embarked on building a far larger office complex in Dockland. Judging by the planning decisions that followed Coin Street, it seems that those developments which take a lower profile, and do not even attempt to include a

commitment to urban values, are much better received than those which do.

Rogers passionately defends his Coin Street design as stemming from his convictions about planning policy, especially his belief in responsibility to a wider public. However, his opponents portrayed him in a very different way. But the strongest message from the affair is surely that Rogers is wrong to say that architecture is necessarily bound up with ideology. There is a difference between architecture itself and the symbolic role it can be made to play.

Although architecture is not politics, it is not only architects who seek to treat it as if it were. James Stirling is the most firmly apolitical of architects. Indeed he once remarked that he had abandoned his town planning studies in the early 1950s because the course concentrated on the national and regional issues, 'which to me seemed only to have political solutions'.[4] But there is no doubt that a political dimension certainly did enter the argument over the fate of Stirling and Wilford's Cambridge University History Faculty Building.

To understand the controversy that has surrounded this building, it is first necessary to consider the changing political complexion of Britain in the years since its completion in 1967. This period has marked a wholesale shift in the terms by which British public life is conducted. The liberal consensus of the 1960s evaporated, to be replaced by the policies of successively more radical Conservative governments. As the years went by, it became clear that Britain was going through more than the periodic swings of its two-party system. The whole centre of gravity of the system had been moved toward the right, and Neil Kinnock's Labour Party found itself forced to follow. The shift took place not just in the narrowly political sphere, but in the broader cultural one as well. As, for instance, all political parties moved to embrace the idea of home ownership, so public subsidy for the arts came to be joined by commercial sponsorship. And in the universities, social sciences, highly favoured in the climate of the 1960s, were eclipsed by more narrowly technocratic and commercial subjects.

None of these changes took place by accident. In the 1960s, when the Conservative Party found itself for a time displaced from its self-appointed role as the natural party of government, and its traditional political and cultural values seemed outmoded and reactionary, groups of policy strategists both inside the party and on its fringes began to

address themselves to the battle for regaining power. The strategy they adopted was to build up, bit by bit, an alternative position on a number of issues which had, on the face of it, no direct relevance to day-to-day politics, but which taken together allowed for the growth of a renewed cultural conservatism that paved the way for a political revival in their fortunes.

In this one or two academics played a key role, with activities ranging from the Black Paper on Education to the *Salisbury Review*, a journal self-avowedly devoted to informing Conservative policy. A natural target for the New Right was architecture. Mounting an attack on the face of Britain's development in the 1960s could harness public nostalgia and revulsion. It also reawakened echoes from the 1930s of those who sought to present modern architecture as a cosmopolitan conspiracy. Central in this attempt was the architectural historian David Watkin, a Fellow of Peterhouse, Cambridge, and a former student of Sir Nikolaus Pevsner. His brilliantly forensic book *Morality and Architecture* (1977) set out to demolish the pedigree that Pevsner had established for modernism in Britain. It opened the way to a reappraisal of such figures as Lutyens whom Pevsner had completely ignored, and in the process set the agenda for an architecture that would for Watkin and his circle prove more congenial than what they saw as the muddleheaded collectivism and technophilia of modernism.

The tone of Watkin's book is set early on when he writes that Sir Leslie Martin's Centre for Land Use and Built Form at Cambridge University had a title that 'indicated clearly enough a belief that architecture as an art involving taste, imagination and scholarship should finally be abolished, and replaced by a scientifically plotted Utopia in which tamed collectivist man with all his wants defined by technology and gratified by computerised planning would contentedly take his appointed place as in some gigantic rationalistically constructed beehive.'[5] Watkin, who went on to recommend for further reading on the centre an article by Roger Scruton entitled 'The Architecture of Stalinism', appears to have focused a good deal of his hostility on Stirling. Indeed, *Morality and Architecture* is prefaced by Stirling's remark that he left Liverpool School of Architecture with a deep conviction of the moral rightness of the new architecture.

Stirling's History Faculty Building is of course on Watkin's doorstep in Cambridge, and it has attracted the ferocity of other figures with whom Watkin has been associated, particularly Gavin Stamp and Scruton. The latter, the editor of the *Salisbury Review*, has propounded the desirability of a return to classical forms in architecture and has used his column in *The Times* to attack modern architecture in the most intemperate language. Yet Scruton has not always found it easy to persuade the political party he supports of the rightness of his views.

The History Faculty Building at Cambridge was a subject of controversy even before it was finished in 1967. Its technical capabilities and uncompromising aesthetics have been hotly debated ever since, both within the university and outside it.

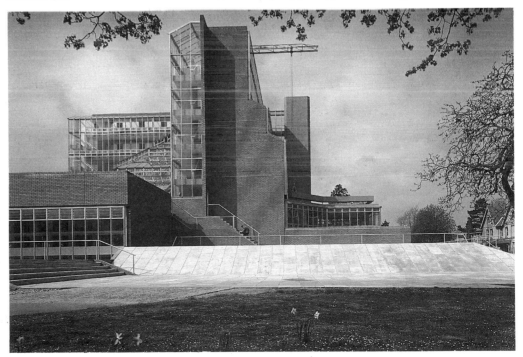

Margaret Thatcher showed dangerous signs of approving the Mies van der Rohe plan for Mansion House Square before the scheme was finally rejected by her environment minister.

This then was the climate in which Cambridge came close in 1985 to holding a poll of its resident MAs to determine whether or not the History Faculty Building, then just eighteen years old, should be demolished. By that time, the world had become only too used to a steady stream of troublesome teenage buildings coming to violent ends through dynamite as a result of defects in their construction or their unsuitability for the task for which they were designed. But the destruction of Stirling's building would have had much wider historical significance than the elimination of a high-rise slum in Liverpool or Glasgow. Even before the building had begun to demonstrate any technical failings, Stirling's design was debated in the university Senate. Stirling recounts that debate, in which, he claims, one professor began his address by saying 'this building is like no other building that I have learned to love', and calling for a return to the orders. In the course of the speech, however, he slipped in a description of the library which caught Stirling's fancy: 'You come to the desk, and realise that you are in an Edwardian hotel. Either you go up to your room, or you pass beyond, into the tea lounge, with the light coming from above, and no doubt a palm court orchestra playing.' According to Stirling, 'this is an apt description, in a strange way.'[6]

The objections of Watkin and his colleagues on aesthetic grounds were given an important boost by the rapid physical deterioration of the building. Tiles and bricks began to drop off at such an alarming rate that by 1985 they had all been stripped off, for fear of injuring passers-by. Their absence exposed black tar patches and bald concrete, providing valuable ammunition for a group within the university which disliked both the building and the direction that the faculty itself was taking in its studies. That there were technical shortcomings cannot be denied – some were undoubtedly exacerbated by the complete lack of routine maintenance. Whether builder or architect was responsible for these shortcomings has never been satisfactorily determined. Perhaps they were simply the price that eventually had to be paid for Stirling's brave attempts to make silk purses out of sow's ears by using crude industrial materials 'out of context', as Stirling once put it, to rescue low-budget buildings from banality in the straitened climate of the times. The university did consider going to law, but it had left its action too late.

In any event, these niceties did not concern those who scented the chance to demolish what others regarded as the most distinguished modern building in Britain. The University Treasurer produced a report claiming that since repairs would cost £1.5 million against an alleged replacement cost of £2 million, the latter course might represent better value for money. The building's supporters, who included many people within the history faculty, counter-attacked, claiming that a disinformation campaign was in progress. They put forward a case arguing that it would have been impossible to build a structure anything like the size of the existing building for £2million. Experts advised this group that the cost of a replacement had been seriously underestimated: to build a full replacement would cost at least twice as much as the claimed figure. The building's supporters feared that the history faculty would end up with much smaller premises and argued convincingly that those pressing for demolition were motivated more by aesthetic prejudice than by practical considerations. In the end these arguments won the day. The building was spared, and a repair programme started.

Stirling is hardly the first important architect to have faced such difficulties. Lutyens's Castle Drogo has had to be substantially rebuilt because of serious water penetration problems. Sansovino was threatened with jail by the Venetians when the ceiling of his library fell in. Demolishing the History Faculty Building would have been just as much an act of vandalism as pulling down Castle Drogo. The difficulty for Stirling was that the modernism with which his Cambridge foes identified him has an image of technocratic perfection and machine-like precision, so that when things go wrong, the expectations that the aesthetic has aroused inevitably open the way for recrimination. The most curious aspect of the Cambridge affair of course is that Stirling is the least doctrinaire of modernists. He has never suffered from the collectivist fantasy of those who saw architecture as an instrument of the welfare state. And he shares with David Watkin a passion for the flamboyant work of Thomas Hope.

Le Corbusier ambiguously postulated in *Vers une architecture* (1923) that 'It is a question of building which is at the root of the social unrest of today: architecture or revolution.'[7] He concluded that revolution can be avoided. It is hard not to find that conclusion echoed in the boundless technocratic self-confidence of Norman Foster. Shortly after he had started

Stirling stands between the two glass skins that form the roof of the Cambridge History Faculty Building. This deep space was created to avoid the occurrence of a greenhouse heating effect in the interior.

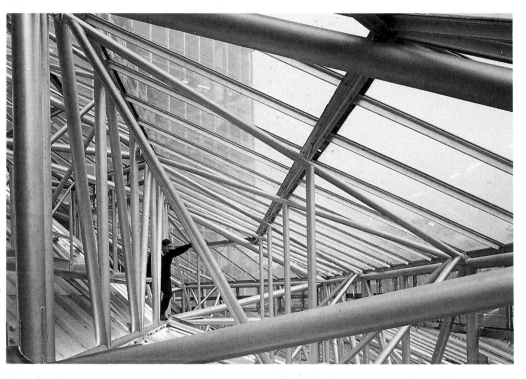

Foster Associates, in partnership with Wendy Foster (and later Michael Hopkins), Foster gave an address at the RIBA in which he spoke at length of his approach to architecture. Its language is more revealing than its content. 'Our approach,' he said, 'is largely determined by the nature of each assignment, and our background. The crash programme is a very familiar situation, and we have evolved techniques which allow it to be reconciled with cost and quality control. This has led us to a network sequencing of the briefing, design and construction phases, rather than the more usual linear sequence.'[8] What Foster is saying is that no problem is beyond solution, and that patient research, management techniques and a disciplined, rational approach can always be constructed, which will, like a well-oiled machine, produce the best of all possible solutions, provided it is fed the correct data.

A graphic demonstration of the Foster approach is in the November 1972 issue of *Architectural Design,* in which the work of the fledgling Foster Associates was published. The central square of a regular grid of pictures showing Foster projects was left blank. Instead of showing a building, there was a simple typographic message: 'Berco: research eliminated the need for a new building which was originally predicted by the client. Considerable savings of cost and time were achieved by a more efficient space utilisation,

the redistribution of activities and the improving of our client's premises.'[9] It is the perfect image of the architect as technocrat – dispensing politically neutral solutions to problems which no matter how apparently intractable are all, eventually, susceptible to reason.

Foster's intention has been to use design as a social instrument by improving working conditions within factories and offices. Consciously or unconsciously, he has adopted the view that since science is value-free (a view which is, of course, open to argument), architecture, which he treats as a science, is equally value-free, neutral and without rhetorical content.

During the course of his career, Foster has had to face up to the realization that such clear-cut distinctions cannot always be drawn. One revealing gesture in this direction was the note that he scrawled across a corner of one of the preparatory drawings in his competition-winning entry for an arts centre in Nîmes adjoining the remarkably well preserved Roman temple in the centre of the city, the Maison Carrée. 'No diagonals in structure, must *not* look industrial' he wrote. The extent to which Foster's sanguine view of the positive power of science will be borne out cannot yet be judged. As Britain's relative economic position has continued to decline through the 1980s, it is one shared by disturbingly few of his fellow countrymen.

Working methods

A detail of Foster's warehouse for Renault at Swindon (1983), showing a joint in one of the structural masts and part of a fire-escape.

One persistent attitude that Rogers and Foster share in their working methods on both the drawing board and the building site, and which differentiates them from more conventional architectural practices in Britain, is the way in which their designs are in a sense always provisional until they have actually been executed. Both architects have a way of working that seems very much as if they were searching for an idealized image that they have had of a particular building, progressing through option after option until they find a practical way of matching up to their original image.

Thus the earliest schemes drawn up for the Beaubourg or the Hongkong and Shanghai Bank, while they may diagrammatically resemble the end result, are entirely different in detail. The process by which the first version is transformed into the final one is complex and, despite Foster's attempts to systematize it, often confused and erratic, involving the detailed pursuit of design tributaries that prove ultimately to be dead ends. For example, Foster spent some time trying to come up with a means of fireprotecting the steelwork of the Hongkong and Shanghai Bank so that he would not be forced to hide it within an elegant aluminium casing. Ultimately he decided that it was not possible in the time that he had. Similarly Rogers originally envisaged the Lloyd's atrium as a steel structure until the building control authorities insisted otherwise.

But without these processes, buildings like Rogers's and Foster's would not be possible. The extent to which they are prepared to go in this process of invention that is an integral part of their methods of design is a peculiarly English characteristic. It is also partly a result of the distinctive structuring of the profession in Britain, where architects retain far more responsibility for the transformation of their design ideas into reality than is the case in many other countries. In Britain, once the design of a building has been approved by the client, it is the architect's responsibility to turn his early drawings into detailed working versions which will form the basis of a building contract. The architect will normally then supervise the work of the builder who has successfully tendered for the job.

Elsewhere in the world, it is much more common to find a division between architects who design and those who oversee the building process. In France this division is achieved through the bureaux d'études. Architects produce a scheme design, usually relying on small-scale elevations, plans and sections only, with no more than a notional specification. These are then passed on to a bureau d'études, a specialized office which works this information up into a form from which builders can price for bidding for a contract, and then use to put up the building. For architects this means that there is no need to maintain large-scale

offices; many are able to carry out major projects with just a couple of assistants. But it also means that the individual 'handwriting' of an architect is reduced. The bureaux develop their own standard details for doors, glazing systems and so on, and it is these which go a long way toward determining the character of the building.

A similar system prevails in Germany. In America it is common to find the largest architectural practices, which can have several hundred employees, carrying out a function similar to the bureaux as 'executive architects', cooperating with 'design architects' who produce the building concept and aesthetic treatment, and may be responsible for the detail of perhaps the cladding, but who often leave interior details to the executive architect. In America, and in Europe outside Britain, there is also a greater reliance on the expertise of the specialist manufacturer for the design and installation of high-finish proprietary products such as curtain walls, structural steelwork and so on.

One result of these differences is that buildings can be completed far more quickly than is normal in Britain. And, within a narrow repertoire of materials, a much higher standard of finish can be taken for granted. On the other hand, there is much less readiness to experiment outside these norms. Solutions to common problems are entirely standardized, and there is little or no scope for the architect to invent new solutions unless the scale of the project is very large, because the building industry is not geared up to tackling small, intricate work.

In Britain the reverse is the case. Standardized products are not of a particularly high standard, and the building industry is not very good at installing them, but there are fabricators and builders with craft skills of high quality who excel at carrying out one-off

solutions. One example of this is the difficulty that Rogers had in constructing the PA Technology office building at Princeton. The general contractor there had to recruit retired welders to work on the exposed steel structure fabrication that had presented no difficulties for the diagrammatically very similar Inmos plant in Newport.

In Britain, while the general-level architect is content to rely on relatively undemanding solutions, basic structural frames, and cladding products that require a minimum of specialized expertise, the system has allowed both Rogers and Foster, and a number of other similarly disposed architects, including Stirling in the early part of his career, to develop a very high level of inventiveness and ingenuity. For both Rogers and Foster, the initial design of a building tends to be a diagram, almost an agenda for discussion, rather than a final design, even though that is often how it is presented. Thereafter teams within each office are detailed to investigate all the technical options available for realizing particular areas of the building. Specialist consultants also have to be involved right from the start. Without them the high level of technical sophistication that Rogers and Foster both aspire to would be impossible to achieve.

It was open to Foster for example to work within the standard procedures of the Hong Kong building industry for his bank tower there. By using a conventional concrete frame, he could have erected it much more quickly and easily, but it would not have been the same building. Foster's objectives depended for their realization on techniques and products that are not commonly available, and which required a world-wide search for suppliers and fabricators. Instead of concrete, he chose to use a steel structure, one that relies on suspension trusses to support the office floors. At the time he

Apart from housing spare parts for Renault's national chain of dealers, the Swindon building (shown here in section) has an exhibition space, offices, and a dining room for the staff who work there.

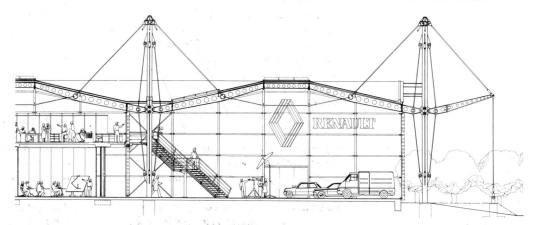

The Renault building is designed to be easily extended: the shorter of the two long side walls can be simply unbolted, and two more bays added on. This drawing shows the building in its present state.

Overleaf Foster's warehouse for Renault was conceived by the company as a deliberate act of image building. They asked for more than a simple shed and Foster gave them what they wanted: a forest of steel trees finished in yellow, the Renault house colour, and an immaculate aluminium skin.

designed the original diagram neither Foster nor anybody else knew, or could know, exactly how such a building could be built, nor exactly how the building itself would actually look once the practicalities had been worked out.

It was the same with the original Piano + Rogers design for the Beaubourg. A building with the 150-feet clear spans from the front to back that it postulated was at the very edge of the achievable. However, having been designed initially with the participation of Ted Happold and Peter Rice, engineers with Ove Arup, the structure was more than a speculation. It had a logic, but nobody knew how it would be built, still less if it would be possible to devise a method of fireprotection for the steelwork which would not compromise the aesthetic conception. Despite the precedent of the moveable floors in Jean Prouvé's Maison du Peuple in Clichy, nobody had ever attempted them on the scale envisaged by Piano + Rogers. In the event the floors proved impossible to perfect in the time available. But virtually all the other technologically difficult parts of the building were achieved, thanks almost entirely to the close collaboration between Piano + Rogers and the engineer Peter Rice of Ove Arup, the man who had earlier played an important role in the building of the Sydney Opera House. It was Arup also who made possible Rogers's rapid translation of the Lloyd's building from steel to concrete when the technical difficulties associated with fireproofing exposed steel proved insoluble.

Ideologically, Rogers would have preferred to use steel because it is a material more suited to prefabrication. Instead he resorted to a concrete structure tailored with the precision of steel.

Apart from this crucial dependence on engineers, the approach of Foster and Rogers is underpinned by a willingness and ability to extract from manufacturers performance that is often beyond the limit of what is normally considered possible, by becoming involved in the factory manufacturing process. The scale of such operations can vary – from the sophisticated anti-sun glass developed for the Willis, Faber and Dumas building, to Rogers's development of a simple cladding system for the Inmos plant at Newport capable of being made by a modest local glazing firm to meet a political demand of the client for extensive use of locally made materials.

Although James Stirling is not generally perceived as an architect with the same commitment to research and invention, he has always similarly refused to allow the limitations of conventional solutions and conventional applications of materials to stand in his way. Speaking of the stepped glass profile of the Cambridge History Faculty Building, which would have been impossible to realize if he had accepted the restraints of normal window-cleaning techniques, Stirling explains how he asked a specialist contractor to invent a completely new cleaning gantry, equipped with telescopic arms, 'so that the men in the window cleaning boat could travel up and down, but also

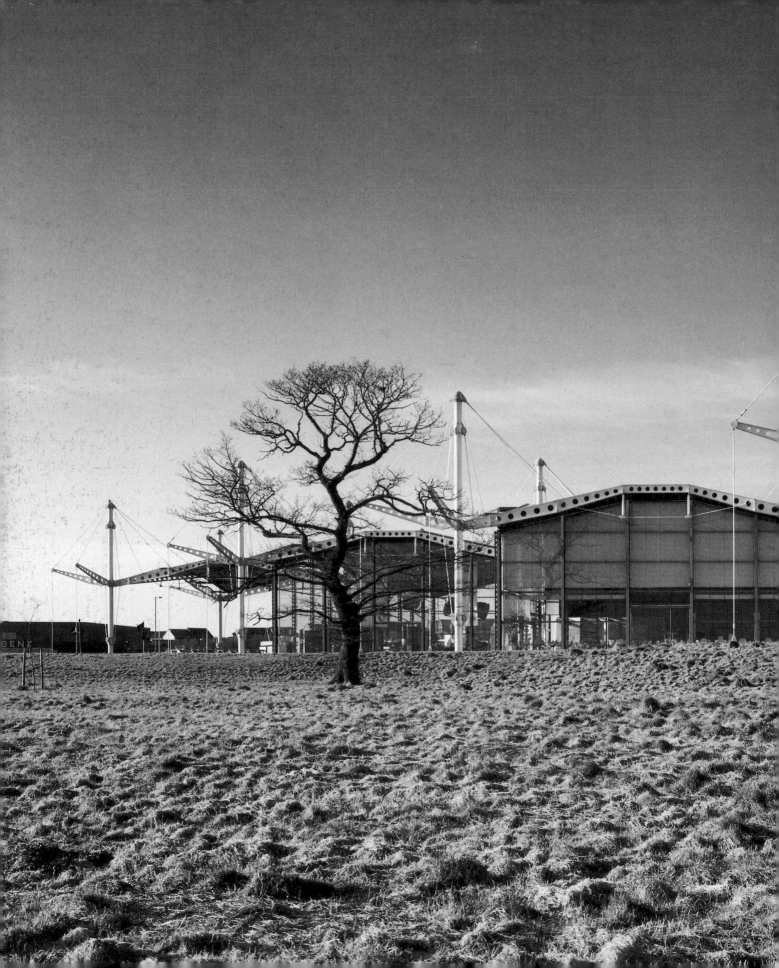

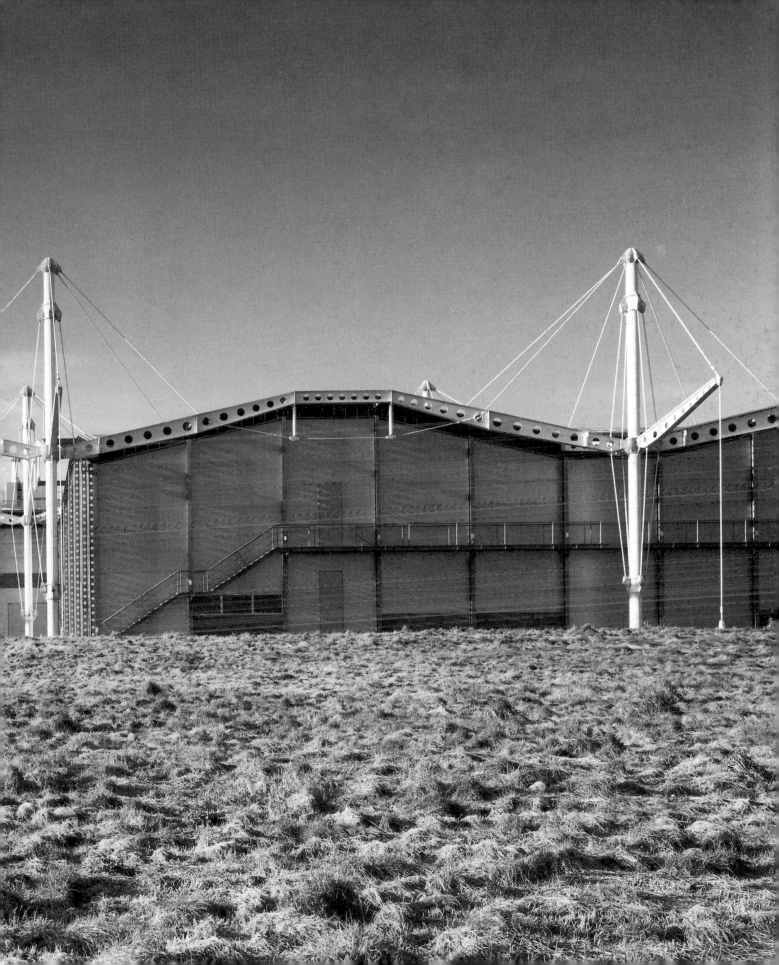

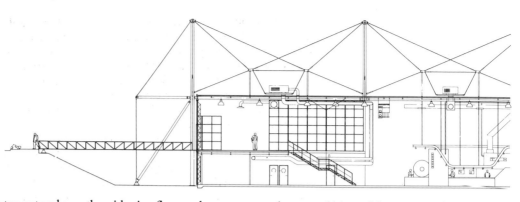

The Fleetguard factory at Quimper in France (1980) was the first of Rogers's designs for factories to make use of a structure supported by exterior cables. Compare, for instance, the Inmos factory (pages 58-59) and the PA Technology Building at Princeton (pages 81-84), both of 1982. The motif has since been widely imitated.

step out and over the widening floors at lower levels'. Then he went on to outline a commitment to first principles solutions that has much in common with Rogers and Foster, although neither has ever stated it more lucidly: 'It is always necessary to trace back to the source the inhibiting factors, in this case the window cleaning, and then change them, in order to achieve a supra-rational solution.'[1] It is the same spirit which drove Foster at the Sainsbury Centre to the length of installing the locks in the all-glass doors of the dons' offices in the floor, to avoid compromising the doors' visual purity.

Stirling once said that 'it is the unique responsibility of the architect to raise the human spirit by the quality of the environment which he creates, whether it is a room, a building, or a town.'[2] However, he runs an office which maintains a studiedly fusty air. Housed in a crowded and scruffy London terraced house, it maintains a modest number of assistants who work at traditional drawing boards. There is not a computer or a prototype workshop anywhere to be seen. Nor is there any pretence at democracy by presenting projects as the working of an anonymous team. Stirling and his longstanding partner Michael Wilford are the architects; their employees are the assistants – although their role in each project is scrupulously credited, whether the assistant was Leon Krier, who worked with Stirling on the entry for the Derby Assembly Room competition, or Quinlan Terry, who assisted in the Stirling and Gowan old people's home at Blackheath of 1960.

Architectural design to Stirling is ostensibly a straightforward process. It is a matter of information gathering, briefing, research, and then of the synthesis of alternatives. 'For this I have a staff (nowadays it's called a team)' he once drily observed. 'But an actual decision, as to what is correct or not, has to be my responsibility.'[3] That said, Stirling has always shown himself ready to absorb the ideas of

others – and his work has remained remarkably free of any sign of hardening arteries.

'I think every building must have at least two ideas in it.' In 1965 Stirling talked at length about the design of his buildings for Leicester and Cambridge in a way that clearly still has a great deal of relevance for his work today: 'In modifying and even rejecting principles on which the new architecture was founded, it is necessary to replace them with working rules and methods which are realistic in a situation of low cost and expediency. . . . Glass buildings are, I think, appropriate to the English climate. It is seldom too hot, or too cold for them. I think of glass rather like polythene, to be pushed in and out, enveloping the shape of the rooms [within] which are considered as always having an ideal shape according to their use. It is necessary to maintain the shape of the rooms at their most functional without compromise by forcing them into an overall construction. Designing a building, one compiles these various room shapes to become the complete assembly. This can then be covered with a membrane of glass, not structurally a difficult thing to do.'[4] If one thinks about buildings like the Clore Gallery for the Tate or the Stuttgart Staatsgalerie, it is possible to see the same accretive technique still at work, although without the wrapping. Instead the different volumes are given different characters by various forms of surface treatment.

Stirling used to talk about using such materials as industrial patent glazing, engineering brick and so on 'out of context', as a tactic for low-budget building. Foster has a similar enthusiasm for transfer technology – that is, the adoption of techniques originally developed for quite different purposes, and applying them to the generally more backward technology of building. Thus when Foster returned to Swindon in 1983 to build a warehouse for Renault with a distinctive masted roof, and was faced by an apparently

insurmountable jointing problem at the fascia where a wall met the roof, he resorted to using neoprene-coated nylon fabric originally developed for Hovercraft skirts, and held it in place with the ties normally used for the heavy-duty covers of truck trailers. And in one of his earliest buildings, the Olsen terminal at Millwall, recycled baggage conveyors of the type used at airports made a similar non-scheduled appearance.

Foster's buildings depend on a quite exceptional determination to expend effort on getting each component tailored to perfection for the purpose – visual and technical – to which it will be put. Rather than order window systems off-the-peg, Foster will design his own, with the aim of squeezing extra performance out of the process. As Foster has remarked, very few building components come off the shelf. 'The building industry is not like the automobile industry in that sense. If you order a lot of components for a building, the chances are that someone will have to go away and make them. Now if you have a thorough grasp of production processes, you should be able to design something better. Much of our work centres around a deep concern with how a building is made, with craftsmanship and tender loving care.'[5]

To this end, Foster developed, in conjunction with an American manufacturer, a tailor-made cladding and glazing system for the Hongkong and Shanghai Bank that required the establishment of special production lines. In the same way, the bank has a unique airconditioning system that both distributes fresh air, and later extracts it through the floor. Airconditioning is usually installed in the ceiling, but Foster believed that this was unreliable and created more difficulties when alterations are required – another example of tracing things back to the source. In order to be able to talk to manufacturers on equal terms in such enterprises, Foster maintains a permanent staff of model-builders producing mock-ups and prototypes, often at full scale, for study and evaluation within the office.

The same techniques are used to develop the form of the buildings themselves. The basement of Foster's Great Portland Street office is full of large-scale models showing projects in their context, and also models of details. At one stage, Foster contemplated using a herringbone structural system for the Hongkong and Shanghai Bank, with the tower's floors suspended from rows of steel tubes inclined at an angle of 45° to the vertical, and his office was dotted with a pattern of inclined tubes simulating the working conditions that would prevail in such an interior. Foster designs out the surprises, exactly in the way that a car manufacturer would build a maquette of a new car before committing himself to full production. The parallel can be still further extended. Very few cars are ever launched on the basis of a single design idea. Different options are modelled up in great detail, and then evaluated against each other. This is how Foster works too, and it is a method that is not without distinguished architectural precedents. It also reflects Foster's reluctance to commit himself to a design. Time and again one can see Foster's designs developing from their original conceptions into quite different forms when actually built. Large-scale schemes, like the Hammersmith Centre (see below, pages 117–119), and the Hongkong and Shanghai Bank, go through dozens of different phases, each of them modelled and prototyped in great detail.

Stirling and Foster both have a considerable graphic facility (Stirling and Wilford favour a curious worm's eye view of their buildings, the axonometric from below, to which some critics have ascribed much of the power of their buildings' spatial composition), whereas Rogers has never had this fluency – indeed, apart from conceptual sketches, he rarely draws at all. His role in practice was once described by a former assistant as that of a master chef – tasting and blending ingredients prepared by others, but indispensable as an inspiration, and as the visionary behind the whole enterprise.

One aspect in which Rogers and Foster do differ decisively from Stirling and Wilford – apart from such predictable details as the number of computers that the first two maintain in their offices – is their determined attachment to the notion of modernizing the building process. Stirling and Wilford at Stuttgart were happy to adopt the most traditional of building materials, stone, and to apply it in a manner that looks, even if it is not, fairly traditional. The only way that Foster has used stone so far is in the form of a laminate – the banking-hall floor of the Hongkong and Shanghai Bank is surfaced with a 2mm-thick sliver of black marble, glued to the aluminium tiles which form the subfloor. Both Rogers and Foster developed early in their careers a violent aversion to the conventional building process, which, as they saw it, is muddy, inefficient, inexact and for the builders themselves a cold, wet and unpleasant task. Rogers seems to have been particularly affected by the experience he had with a house designed

Opposite, below and overleaf *The PA Technology building at Princeton (designed in 1982), by Rogers. Steel details recall the Beaubourg Centre, and the plan resembles that of the Inmos factory (see pages 58-59). However, its colour scheme and more compact proportions give it a look which is quite different from Inmos, underlining the fact that this is not a factory, but a workshop and office building. The external structure of the building has to cope with servicing requirements far more modest than those of the Inmos factory, but the ducts and airhandling equipment nevertheless make an impressive show. The welding skills needed to realize this complex structure were hard to find in the USA, for they had been rendered nearly obsolete by increasing standardization in the American construction industry.*

in the early days of Team 4, when he arrived on the building site to discover the workforce installing not the bituminous felt damp-proof membrane that he had specified, but a layer of newspaper painted black.

From that day on, he and Foster have both been determined to make the maximum use of prefabricated components. From the frustration of finding it impossible to supervise semi-skilled workers on the site, from labouring long and hard to produce pitifully few buildings painfully slowly, Rogers came up with a strategy, much influenced by the approach of Charles Eames in America, for designing low-maintenance, prefabricated buildings with simple dry joints.

It is not simply the methods which architects adopt that provide an oblique but powerful influence on their work. The very manner in which architects obtain commissions is also an important but insufficiently discussed factor. Stirling and James Gowan left Lyons, Israel and Ellis in 1956 to set up their own architectural practice on the strength of a commission from the parent of one of Stirling's students at the Architectural Association to build the Ham Common housing development (see above, page 11). It was the first of many examples of the way in which post-war British architects of a certain kind have had to rely for work on commissions from within the architectural world. It was Sir Leslie Martin who recommended Stirling and Gowan for the Leicester University Engineering Building, and Stirling himself who was later to include Richard Rogers and Norman Foster in their Team 4 days on the shortlist that he drew up for Peter Parker's consideration of possible architects for the Reliance Controls factory in Swindon. Later, it was Gordon Graham in his term as the president of the Royal Institute of British Architects who helped to secure the Lloyd's and Hong Kong commissions for

Rogers and Foster respectively and who was instrumental in Rogers's involvement in the Coin Street scheme. In one sense this could be seen as a self-perpetuation of a professional taste system. In the British context however, in which the vast majority of architectural work is commissioned for reasons quite other than aesthetics, it is nothing more sinister than a survival mechanism for the minority of the profession who see architecture as an art.

With a conspicuous lack of patrons in the traditional sense, the only alternative to date for talented younger architects has been the competition system – widely used in Germany and in France, and from which all three architects have benefited enormously. This again, however, amounts to the perpetuation of the introverted attitudes of the architectural world, since it is so often architects themselves who are the most important jurors in major competitions. At least the Europeans have found that architectural competitions are a reasonably satisfactory method of allocating work that has given France and Germany a large number of handsome buildings. As well as Rogers's success in the Beaubourg competition, Foster won the commissions for the Leichtathletikhalle in Frankfurt and for the Médiathèque in Nîmes as the result of competitions (Stirling was one of the judges for the latter competition), and Stirling and Wilford scored victories at Stuttgart and Berlin (the Wissenschaftszentrum). The British experience of architectural competitions is not an encouraging one. There are many examples of client and competition-winner falling out, or of elaborate competitions won by one architect which have resulted in quite another being appointed.

The most significant development on the British scene, however, is the growing interest of commercial clients in architecture. At one

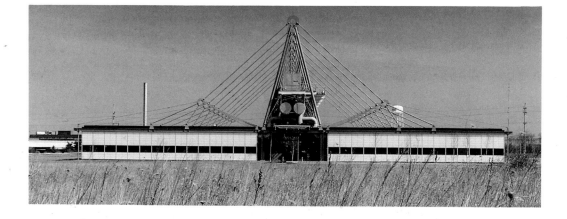

PA Technology had previously used Rogers to design their buildings in England (see pages 94-95) and the experience gained there convinced them that a flexible, easily extended building of the type proposed by Rogers at Princeton would be essential to meet their potentially rapid growth in the USA. This is a view down the building's central corridor.

time the higher-education sector was practically the only outlet for the talent of the British architectural avant-garde, but now the picture has changed decisively. At least part of the credit for that shift must be attributed to the brief period (1979-81) that Michael Heseltine spent in office as Secretary of State for the Environment during Margaret Thatcher's first government. In a remarkable speech to a conference of the RIBA in Newcastle, he pursued what was clearly a strong personal enthusiasm that he was determined to turn into government policy: 'Future generations will judge the quality of our contribution by the quality of the architecture that we leave behind.'[6] He warned against the kind of short-term expediency in redevelopment schemes that Stirling has called 'rip-off architecture' and Foster has dubbed 'hit and run architecture'. 'Long after the day-to-day political battles are forgotten the buildings will remain', said Heseltine. And he went on to attack the financiers and public authority committees for 'encouraging grey solutions which produce buildings without flair or imagination'.[7] Heseltine backed his words with a programme of architectural competitions for government buildings and by making it clear to developers that their chances of a sympathetic hearing would be much improved if they employed architects of quality.

All this came at about the time that Britain as a whole was experiencing greatly increased design consciousness. In the same way that Sir Henry Cole had argued in the 1850s for design as the means of rescue of British manufacturers from their continental competitors, the example of designer entrepreneurs such as Sir Terence Conran, and the collapse of the British manufacturing sector, brought about a much greater awareness of the potential of design in the commercial world, and this awareness spread into architecture. All this, together with the fact that companies were again becoming aware of the potential benefits to their image of employing recognized architects, helps to explain why it was that at the end of the 1980s, after several lean years, all three firms found themselves with major commissions. Stirling was asked to prepare plans for the redevelopment of the Mansion House site originally assembled by the millionaire property developer Peter Palumbo in order to build the aborted Mies van der Rohe tower; Rogers was working for the Saatchi brothers in New York, and had commissions for the design of a financial trading floor in the City of London, for the headquarters of a chemical company near London and for a hifi factory in Glasgow; and, in the aftermath of the completion of the Hongkong and Shanghai Bank, Foster was working on large-scale public commissions – the stillborn BBC radio headquarters, and the third London airport, at Stansted.

Right and overleaf Foster's sports hall in Frankfurt was designed in 1981, when it won an architectural competition for the project, but the decision to build it was not taken until 1986. Half buried in the ground, the structure is integrated seamlessly into the glass roof. The sections overleaf make clear its diagrammatic resemblance to the Sainsbury Centre.

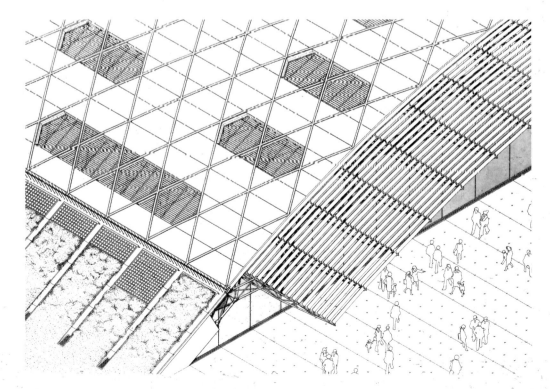

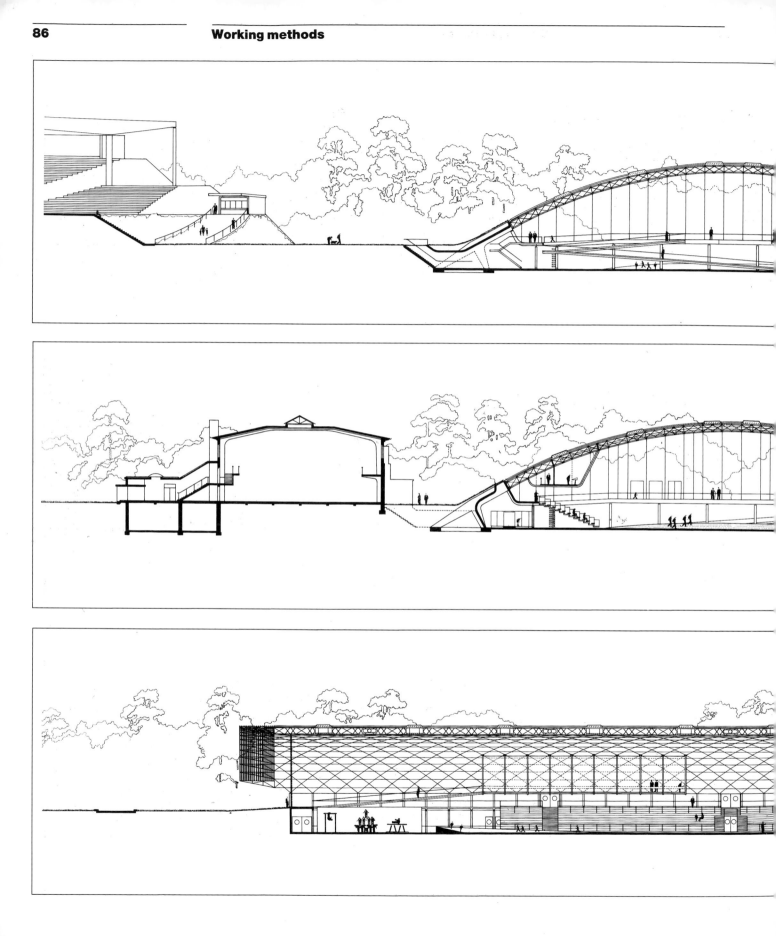

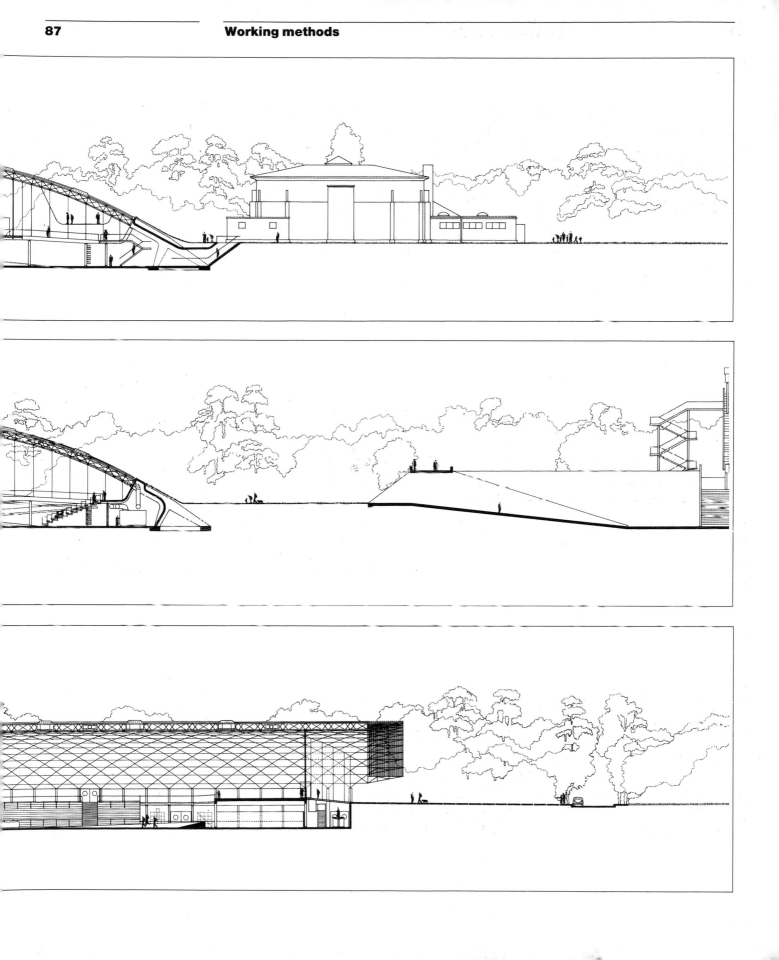

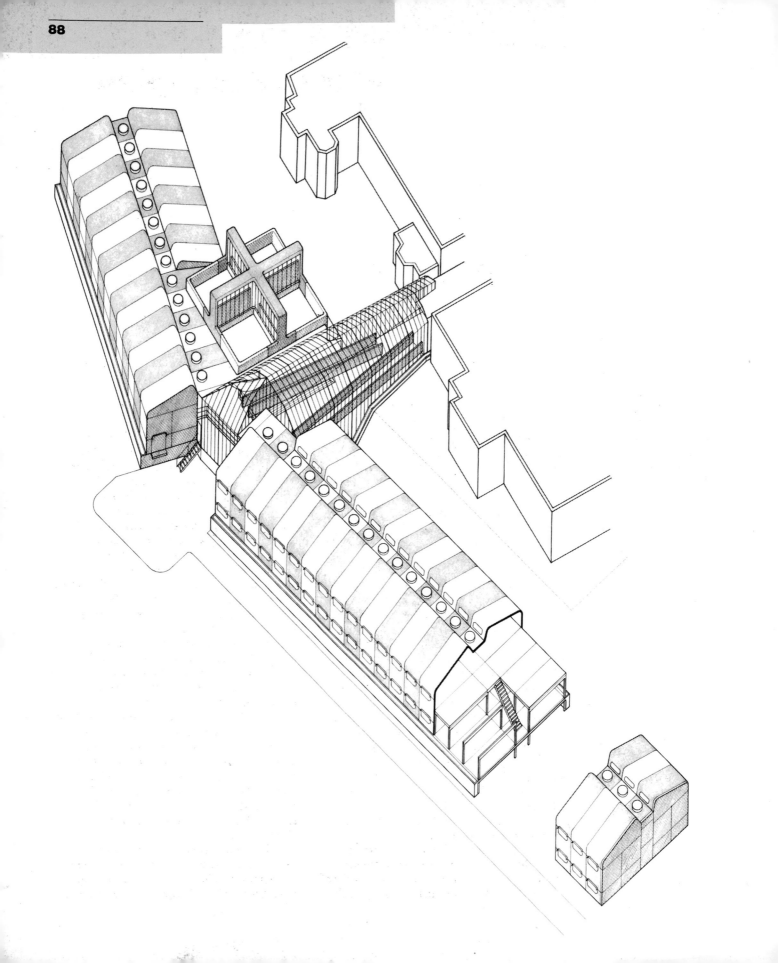

Plan and non-plan

The elements of Stirling's Olivetti building – lecture theatre, circulation space and classroom blocks – all register as discrete, even disparate, components.

Perhaps the most significant difference between the approach of James Stirling on the one hand, and that of Norman Foster and Richard Rogers on the other, is in the way that they work with space. For Stirling and Wilford, architecture is an art with an underlying order, a matter, Stirling himself has said, of tackling first the design of each individual room, and then that of the circulation routes that link one room with another. Equally at issue is the way in which Stirling and Wilford control space in, around, and through their buildings. It might be added that for Stirling architecture is a performing art. That is, his buildings become fully explicable to the spectator only by a promenade through them. They are in fact presented in such a way that each space within them becomes one of a sequence of events. In negotiating the routes that Stirling devises, the visitor is exposed to a variety of different spatial effects orchestrated to evoke a response through a combination of confinement and release. Hence Stirling's quite out of the ordinary enthusiasm for ramps and staircases which is displayed everywhere, from the Tate to the Olivetti building, and his addiction to axonometric and isometric projections, which make the most of the primacy of the plan (see, for example, page 19).

Stirling evidently prefers spatial complexity to simplicity, ambiguity and collision to clarity and articulation. In a sense this is the opposite of the way in which Foster and Rogers approach space. They both have a tendency to regard their buildings as no more, and no less, than containers, in which the larger gesture is more important than the subtler gradations of individual incidents. While Stirling and Wilford's approach to the plan, with some exceptions, notably the architecture school extension at Rice University, ensures that it is allowed to register on the exterior of their buildings, Foster and Rogers place more emphasis on the sensuous qualities of the skin of a building – tense and taut in Foster's case, articulated in Rogers's – freeing it from any inflection from the interior.

There are a number of possible explanations for this difference. The first might lie in the predilection for indeterminacy of that generation of English modernists who, like Foster and Rogers, came under the spell of Paxton and Eames. From this source stems their prejudice against regarding buildings as massive, heavy volumes, equipped with thick, heavy walls that demand an accommodation from their occupants, rather than offering one. Stirling of course was also influenced by Paxton, but took rather a different lesson from him, adopting his inventiveness rather than his planning.

But twentieth-century visionaries such as Buckminster Fuller, and their followers, among whom must certainly be numbered Norman Foster, if not Richard Rogers, seized on the

Stirling's technique of 'collaging' the floor plans of his buildings by juxtaposing components, seen most conspicuously at the Stuttgart Staatsgalerie, can already be glimpsed at Olivetti, where the regular geometry of the two classroom wings collides with the open plan of the square lecture theatre and the glass link with the main building.

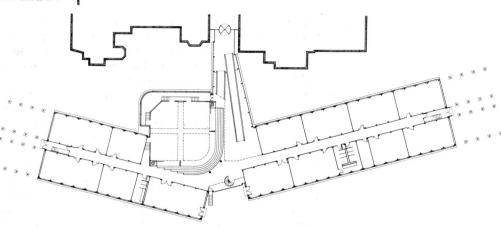

technological optimism of the Paxton tradition. They created a view of buildings as enabling mechanisms, reduced in one celebrated image of the 1960s, Fuller's plan to build a bubble over Manhattan to keep smog and pollution at bay, to the most minimal of all possible shells, a transparent bubble of heat and light that could keep its occupants comfortable in even the most hostile of environments. Allied with this view is a mistrust of the pursuit of an architectural goal that involves a finite, ideal object, closed to all possibilities of further development. This attitude comes in part from the capital made in the 1960s by those theorists who believed in the necessity of developing an approach to architecture that would be able to respond to the demands of rapid social and technological change.

In the midst of a period of unprecedented growth in the world's economies during the 1960s, architects continually found themselves having to contemplate the construction of buildings that would in the course of a very few years have to meet changing requirements that they could only guess at. It was then that the idea evolved of conceiving of buildings as highly responsive systems that could be extended or altered to cope with any future demands to allow for a need for extra space or for the introduction of additional technical equipment. Although there were those who oversold this point, it was certainly a real one. It is only necessary to look, for example, at the way in which mainframe computers have shrunk in size leaving the elaborate, highly serviced computer rooms that were built in many office blocks of the 1960s redundant, or, conversely, how the extra space needed for telecommunications cables in offices has come to demand deeper floor voids, to see that technological change does directly affect buildings and the way in which they are used.

In its most extreme, almost futurist, form, as

expounded by Cedric Price, this view questioned the ability of *any* new building to meet the changing demands of its occupants, in view of the time lag between planning and construction. More mildly expressed, this view percolated even as far as those architects engaged in the design of housing, which many suggested ought to be just as capable of metamorphosing to respond to expanding and shrinking households as a factory adjusts to the need to increase production. The point was not simply that the uses to which buildings would be put would change, but that their technological content was likely to change also. Traditionally buildings depended for environmental control solely on passive means: massive walls that permanently provided the necessary insulation to cope with extremes of temperature and appropriate cross sections that could be used to ensure adequate ventilation. But the increasingly rapid introduction of active methods of environmental control, such as airconditioning and artificial light, is a new phenomenon, and one that has accounted for an ever increasing percentage of the total cost of a building. In some extreme cases, such as for example Rogers's Inmos microprocessor manufacturing plant at Newport, where the conditions of cleanliness required by the silicon wafer processing production lines are highly demanding, the mechanical servicing of the building, and the equipment within it, actually account for a larger part of the total budget than the architectural shell itself.

Yet all these components have comparatively short lifespans, becoming either obsolete or worn out in a far shorter period than the expected lifespan of the fabric of the building. Despite the view of those who argue that all non-traditional buildings tend to be wasteful of energy (thinking, for instance, of the extensive use of glass), the evidence is rather that

appropriately applied technology in such buildings can actually make them more energy efficient than so-called 'traditional' methods of construction. The response to all this was codified at the start of the 1970s with the formulation by the RIBA of the slogan 'long life, loose fit'. In essence this postulated that the best chance of addressing the problems of growth and change satisfactorily was to avoid definitive fixed plans. The idea was that buildings might appropriately be considered as voluminous overcoats – presumably mass-produced – rather than as bespoke and tailormade.

In part this approach stemmed from many architects' growing experience of the potential of creatively recycling redundant buildings to uses not originally envisaged by their designers. From this position much else flowed. It was assumed more and more that *any* type of building, or rather any function associated with a particular building type, could be accommodated satisfactorily within the same sort of space – typically a large undifferentiated interior, possibly equipped with devices for temporary partitioning and for readily relocating doors and windows in the external walls. A similar tendency overtook the domestic interior in the 1960s. The passion for converting industrial loft space and turning old factories into large single-space studio homes quickly spilled over into the planning of more traditional dwellings also.

The use of the non-plan, as it could be described, was reinforced by the way in which offices and factories have tended to become more and more like each other. This is not simply a question of architectural rhetoric: the investment of large corporations in electronic equipment, resulting in the blurring of the distinctions between production line and desk jobs, and the demand for better shopfloor working conditions, have ensured that both offices and factories by the mid-1980s tend to be well-lit and well-carpeted wide open spaces. Similarly, shopping centres, art galleries and museums all began to experience the same convergence on a single building type.

For Rogers and Foster this convergence had certain ideological and practical advantages. They could regard the idea of an interior stripped of the hierarchical ordering of space represented by solid walls and cellular rooms as being more democratic than the alternative, in the sense in which Foster has spoken of the creation of workplaces that put an end to the distinctions between managers and managed. Pragmatically also, open plans have certain advantages for some architects. When working within the economic constraints of a low budget, the concentration of design effort and resources on the creation of a single, relatively generously proportioned space allows for a more memorable image than is possible with the restricted space of cellular buildings.

There are objections which can be raised to the reductionism of this approach however. The most powerful of these is the suggestion that by reducing all types of building – cultural, industrial, domestic or civic – to the same order of open and indeterminate space, one is also destroying part of the essential richness and differentiation of life. Behind this argument is

For Foster, formal planning was not an issue in his proposals for IBM's advance headquarters building at Cosham. The idea was simply to provide a container to house the building's activities in any configuration that expediency demanded. The structure on the roof houses airconditioning. For a photograph of the finished building, see page 46.

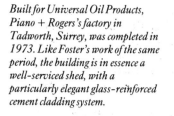

Built for Universal Oil Products, Piano + Rogers's factory in Tadworth, Surrey, was completed in 1973. Like Foster's work of the same period, the building is in essence a well-serviced shed, with a particularly elegant glass-reinforced cement cladding system.

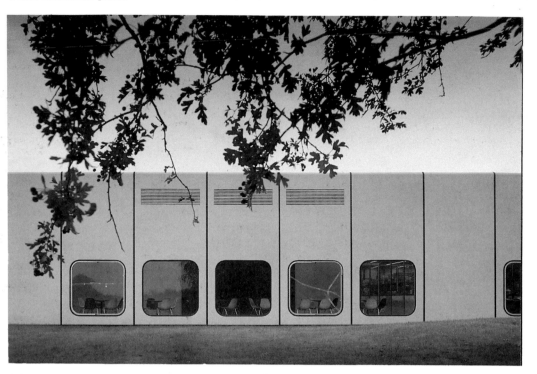

the belief that certain building types have, over time, acquired an intrinsic meaning associated with their use, and can in themselves express a message – of culture or faith as much as of wealth or prestige. If this really is so, then when a city is deprived of these meanings, it faces the danger of becoming as culturally impoverished as China was in the days of Mao, when the conformity of universal baggy green clothing was deliberately adopted. Although this argument may convincingly warn of the danger of a real coarsening of the quality of life, it should be remembered that many of the meanings supposedly conveyed by buildings are of very recent origin. And there is no reason to believe that new meanings for particular forms are not continually being invented.

An equally fundamental problem is that indeterminacy may in many cases be illusory rather than real. Often it is more a rhetorical then a genuinely useful device. Team 4's Reliance Controls factory in Swindon, for example, has had its original elegance, supposedly a poetic expression of lightweight, easily reordered construction, seriously compromised by the later insertion of ill-considered and mundane off-the-peg windows. The non-loadbearing walls of the factory made this readily possible, but the refined aesthetic, although providing the appearance of flexibility, did not in fact permit change to be accommodated comfortably. Equally, the clear-

span open floors of the Beaubourg, yawning to the horizon in each direction and providing space the size of many cricket pitches, entirely free of columns, have not been judged suitable by some observers for the display of the centre's permanent collection of art. Indeed it was precisely because of these doubts that the Italian designer Gae Aulenti was commissioned to install new walls on the fourth floor of the Beaubourg that would impart a sense of solidity and permanence to the setting of the museum's early modern pictures. Of course it might be pointed out that Piano + Rogers's original concept was well able to accommodate this change of attitude – a requirement of the brief in any case – and could do so equally well again should further changes in curatorial fashion take place in the future.

The indeterminate approach to planning is characterized by buildings such as Rogers's PA laboratory and research building at Melbourn, outside Cambridge, Foster's IBM offices at Cosham, and his Renault warehouse in Swindon. In each case site planning and the choice of structural system have been carried out in such a way as to allow for easy expansion of the building by unbolting a section of cladding and tacking on a new wing. At Cosham at least, IBM have made full use of this flexibility, moving the entrance at least three times, re-siting the canteen just as often, and turning the building from a pilot headquarters

Overleaf Initially designed by Piano + Rogers in 1975, PA Technology's laboratory at Melbourn in Hertfordshire was built in three phases, finally completed in 1983. The single-storey block of laboratories and workshops sits on top of a basement level which provides car parking and a sheltered zone for all the heavy servicing requirements of the upper level.

into a single department.

But although Rogers and Foster have elements in common in their approach, there is also room for differences of emphasis in the means by which they attempt to achieve their aims. Foster has in the past tended to suppress overt structural expression in the exterior of buildings such as the Willis, Faber and Dumas offices, the Sainsbury Centre or the IBM complex at Greenford Green. Until the Renault and Hong Kong buildings, he attempted instead to synthesize the skins of his buildings with the structure. Rogers on the other hand has preferred to express structure and enclosure as distinct and clearly different elements. Since the earliest of his industrial projects with Team 4, Rogers has tended to approach architecture in terms of layering. He has devised ever more sophisticated cladding systems that allow for simple fixings, while also increasing the finesse of the structural systems which support them.

Rogers has taken the freeing of space within his buildings to a planned extreme, removing not just permanent partitions and defined circulation routes, but also banishing virtually all other fixed obstructions, such as lifts, staircases and lavatories, to beyond the primary building envelope. As a result his buildings generally have deep plans which make an efficient use of energy and space, with a correspondingly low proportion of external wall to floor area. Externally, the buildings are distinguished by the visual complexity of their servicing elements – the circulation towers and

the ducts that mark Lloyd's as much as they do the Beaubourg. If cellular enclosed spaces are a functional necessity, they are housed in simple, uninflected modular rectangles which are generally located within the depths of the building's interior and leave no trace on the elevations. Similarly, Rogers prefers to regularize the overall plan into simple rectangles, suppressing all formal incidents except for the expression of services and structure. Apparently of more interest to Rogers than the plan is the cross section of a building. Double-height spaces have occurred frequently, beginning with the interpenetrating volumes of the Team 4 designed house in Cornwall (see above, pages 16–17), which was followed by Rogers's own house in Chelsea, where, under the spell of Chareau, he has carved out a huge galleried living area which spreads across the width of two terraced houses and the height of two conventional floors. Similarly, Rogers has chosen to respond to the intricacies of the Lloyd's building's use in its cross section rather than in its floor plan.

In his early houses of the 1970s, such as the building for his parents in Wimbledon, bedrooms are differentiated from the single-volume living spaces only by sliding partitions. And within the Beaubourg every partition is demountable, from the *Bürolandschaft* room dividers in the administrative spaces (little more than furniture which can be repositioned in minutes), and the hanging museum partitions – now superseded by Gae Aulenti's more permanent walls – that might have taken an hour

After the London docks closed, Foster's Olsen building was taken over by the London Dockland Development Corporation, and became the seat of its attempt to regenerate the whole area. See also page 29.

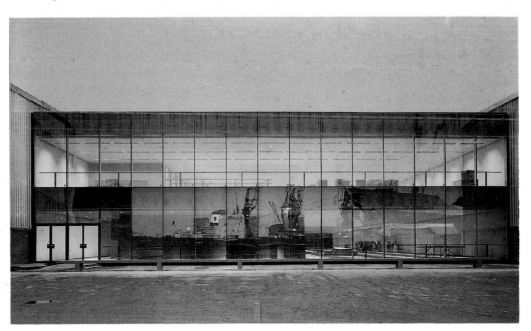

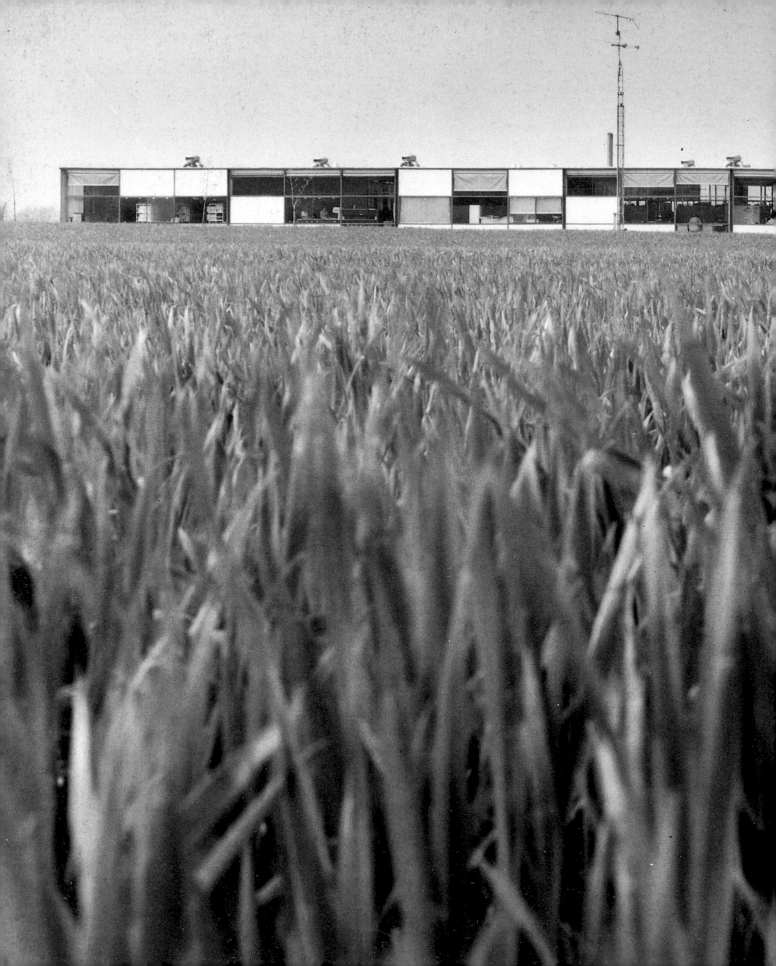

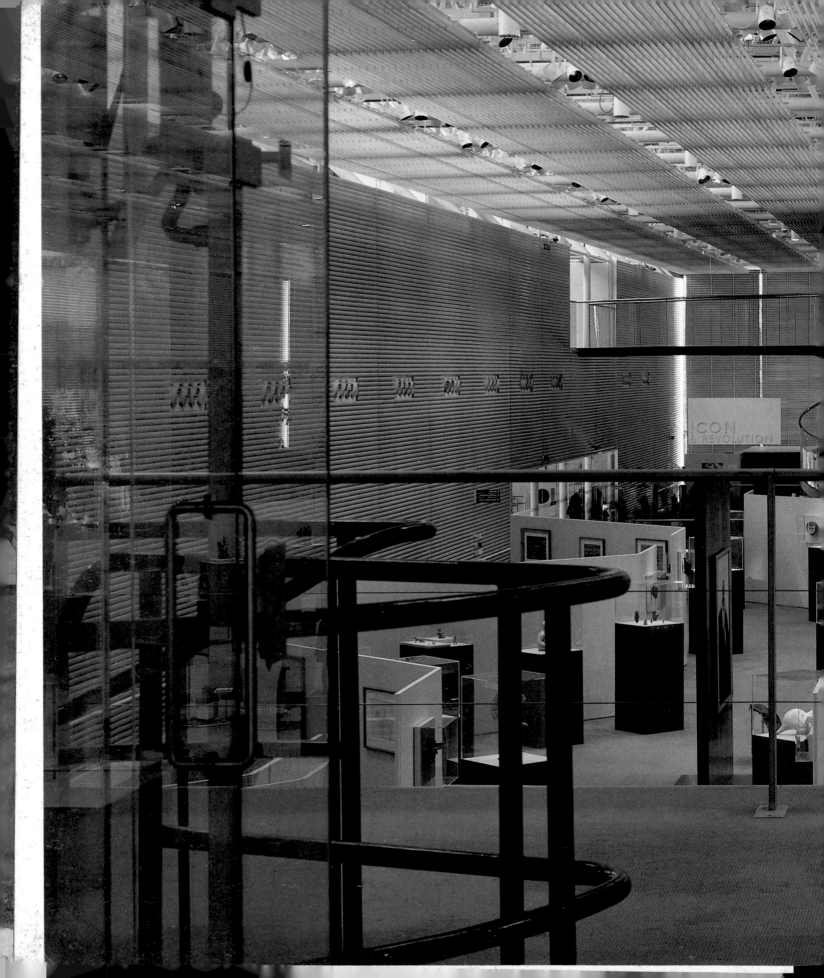

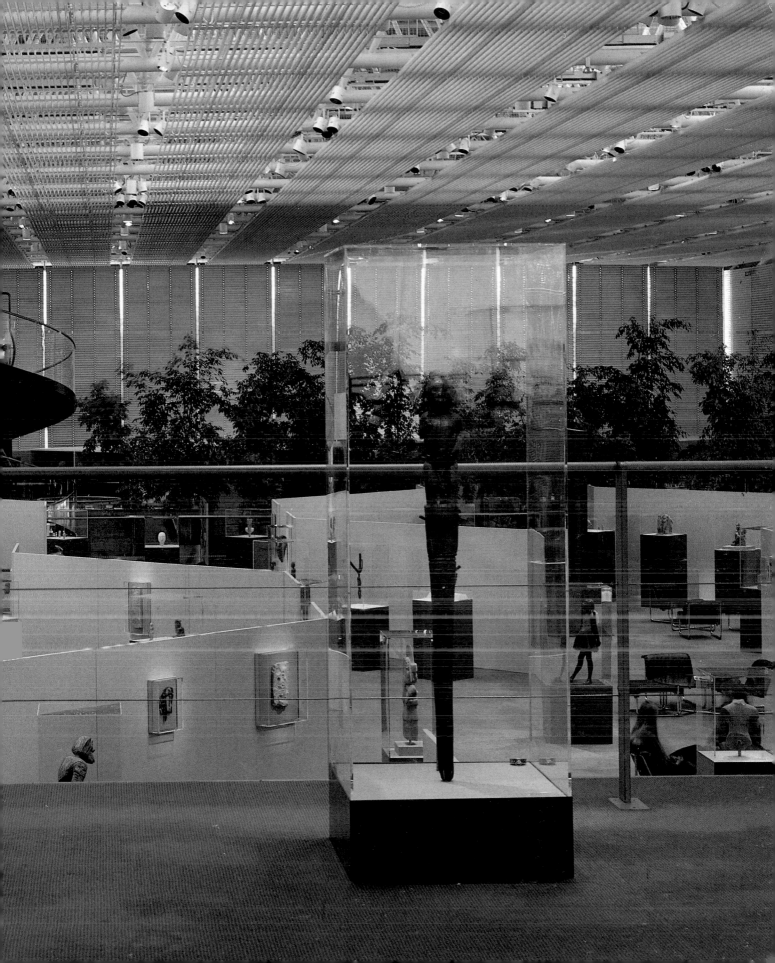

Left *By stopping the glazed end wall of the Sainsbury Centre short by a full structural bay, Foster reveals the complexity and precision of the welded steel work, painted white to contrast with the gleaming aluminium cladding.* Right *The high-level walkway linking the Sainsbury Centre with the rest of the University of East Anglia campus descends precipitously into the public part of the building by means of a glass-walled spiral staircase. Separated from it by unobtrusive low glass screens and turnstiles are the two exhibition spaces, one for temporary shows, the other for the permanent collection.*

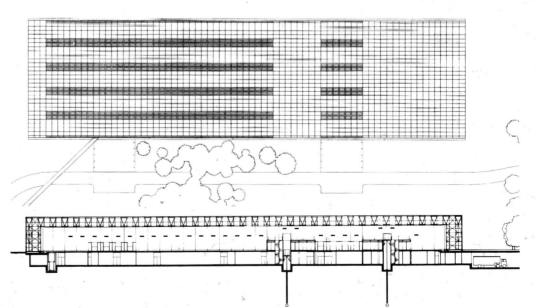

The Sainsbury Centre's roof (above) uses cladding components exactly like those of the walls. Any glazed panel can be swapped with any solid panel in a matter of a few hours should changing requirements demand it. Only service vehicles have the chance to enter the Sainsbury Centre head-on, by means of an access road into the basement (below); pedestrians have less exalted angles of approach.

something altogether too tentative about the glazed link to the rest of the campus, which comes sidling up with ingratiating diffidence at an oblique angle. It is only the service vehicles, admitted into the basement of the centre by means of an axially positioned access ramp, who are allowed to approach it with anything like ceremony.

From the way in which Stirling has described the process of designing the Engineering Building at Leicester – where, as he tells it, each

newly appointed member of the academic staff added his own highly specific requests for a space dedicated to his own research specialisation – it is clear that he was forced, at least at some stages, to regard the overall identity of the building as secondary to the individual rooms and spaces within it. This was, perhaps, an example of the legacy of the functionalist tradition. But even so, Stirling acknowledged that such an approach was not without its difficulties, particularly when, as at

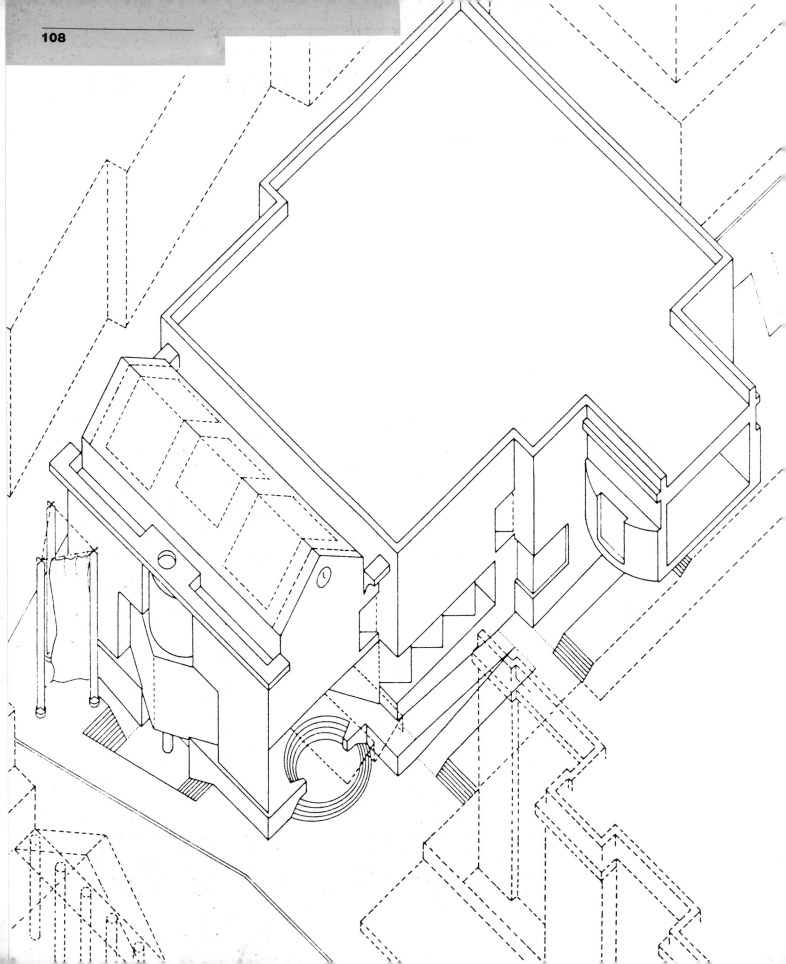

Building in the city

The idea that there is something badly wrong with the world's cities is hardly a new one. Urban malaise has been central to architectural polemics from Pugin to Ebenezer Howard and from Jane Jacobs to Oscar Newman. But what makes the present outpouring of public and professional distress so acute is that the focus of concern is not the chaos and squalor of the raw unfettered growth of the industrial revolution, the cholera and congestion that so worried the Victorians, but the failure of the prescriptions that were put forward to remedy them. The disease and much of the deprivation may have been eliminated, but the received wisdom of the present day is that the remedies of the early modernists are at least as bad, if not actually worse, than the disease.

With a passion that verges on the distress of Pugin's *Contrasts*, Leon Krier, one of today's most influential urban theorists, refuses to build at all, in protest at what he sees as the barbarism of the modern world. 'The destruction which now ravages the European cities cannot be stopped by fragmented interventions. Only a global project for reconstruction could in time make it possible to save a millennial culture of cities', he declaims.[1] Krier, a Luxembourg born architect and planner who has been close to both James Stirling and Michael Graves, turned away from any attempt to build after working with Stirling on the design of the Siemens computer centre in Munich (1969) and a submission for the competition for Derby's new

civic centre (1970), both projects that remained unrealized.

According to Krier, cities are Europe's greatest contribution to Western civilization, yet they are being wiped out in what he calls a 'holocaust', fuelled in equal measure by modern town planning policies and capitalism. 'Considering the magnitude of destruction and the theoretical confusion which agitates even the most enlightened professionals, I understood that building today can only mean a greater or smaller degree of collaboration in this process of the self-destruction of civilized society.'[2] To Krier the core of the problem is in modernist town planners' dogmatic insistence on zoning cities by function, thus disintegrating the connections between home, work and leisure, coupled with the more generalized malevolence of industrialization. There are few apologists for the planning policies of the 1950s and 1960s, which saw the wholesale destruction of existing cities in the interests of commercial and public redevelopment. The urban motorway, barrack-like suburbs, isolated new towns and brutalized historic town centres are all the product of the policies first adopted in the 1920s.

The most clearly enunciated statement of modernist town-planning aims is contained in the charter of Athens, a document drawn up in 1933 by CIAM (Congrès Internationaux d'Architecture Moderne), a caucus of modern architects and planners. Although its principles

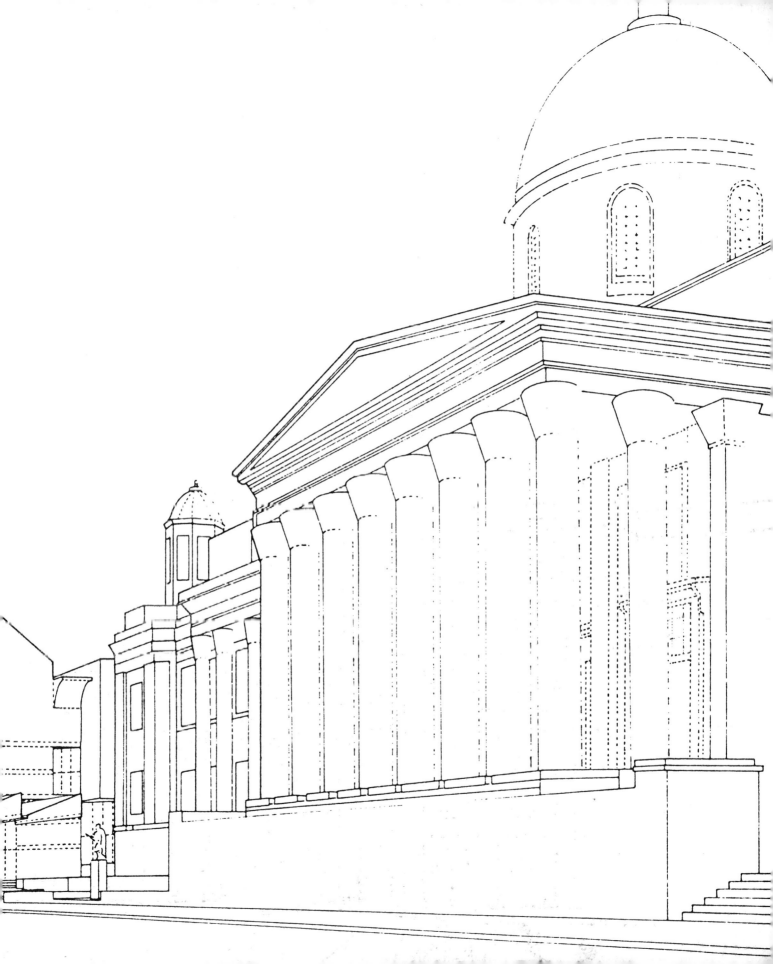

were motivated by the highest moral concerns –
'On both the spiritual and material planes, the
city must ensure individual liberty, and the
advantages of collective action' – its
prescriptions have, to say the least, been
counterproductive.

One key passage in the charter called for city
zoning 'that takes account of the functions [of
urban life] – housing, work, and recreation –
that will bring order to urban territory. Traffic,
the fourth function, must have only one aim: to
bring the other three usefully into
communication.'[3] The CIAM signatories were
under no misapprehension as to the significance
of their words. If adopted, 'great
transformations are inevitable', they said.
Although the tone of the charter of Athens is
mild enough, Walter Gropius was later to issue
an altogether more chilling call that 'all existing
cities should be relieved of congestion and high
blood pressure by those who cannot
permanently be employed. Resettled around
small industries in townships, these people
would regain their productive capacity and
purchasing power.'[4] Checkerboard patterns of
sixty-storey blocks of flats set in parkland
provided visual realizations of what a CIAM-
planned city would be like.

To counter all this – the bastardized results
of which can now be seen in and around
practically any city in the developed world –
Krier drew up an equally precise formulation:
'A city can only be reconstructed in the form of
streets, squares and urban quarters. The
quarters must integrate all functions of urban
life in areas which cannot exceed 35 hectares
and 15,000 inhabitants. The streets and squares
must present a familiar character.'[5] This is a
view of the city that totally ignores the effect of
the motor car. While all sides in the present
architectural debate, including Stirling, Rogers
and Foster, would endorse – up to a point at
least – Krier's dismay at the shape that cities

have taken, none of them would go as far in their
remedies. Indeed, for all his populist appeals to
the spirit of 'common sense', there is little
evidence that Krier's view of the future of cities
would find much favour with the public either.
As a sentimental evocation of a non-existent
past they are powerful enough. But given the
choice, it seems that consumers, unaided by
CIAM propaganda, are flocking to patronize
huge out-of-town shopping malls rather than
frequent the remnants of the *quartiers* that Krier
regards so fondly.

For Stirling, Rogers and Foster, and any
other architects who have not forsworn active
participation, the problem of building within the
city is one of the most intractable facing
contemporary architecture, a problem
surrounded not just by violent polemic, but also
by powerful vested interests and political
conflict. At the heart of the dilemma are two key
factors: one is the lack of identity of modernist
schemes – their large scale and their unfamiliar
character – and the other is the modern legacy
of architecture conceived as the freestanding
object in space. It is the resolution of these
factors which has been the principal concern of
the present generation of modernists.

For Rogers, the most serious urban problem
of the last fifty years has been the erosion of
what he calls the public realm, those parts of the
city in which public life traditionally took place –
squares, malls, markets and streets – which have
given way to isolated buildings, cut off from one
another by traffic, parking and aimless, unused
open space. The difficulties are caused,
according to Rogers, not by the aesthetic
expression of modernism, but by the poorly
planned use of the motor car, and 'the absence
of continuity of form'. By this Rogers means that
the scale of new spaces and buildings should
enable them to link into the existing city,
increasing connections rather than shunning
them. According to Rogers, new buildings

*Despite the use of a historical
vocabulary, extending as far as
keystones in the basement storey,
Stirling and Wilford's design for the
National Gallery is still clearly
modernist in its sensibility. This view
shows the facade on Pall Mall; the
gallery's main building is on the
right.*

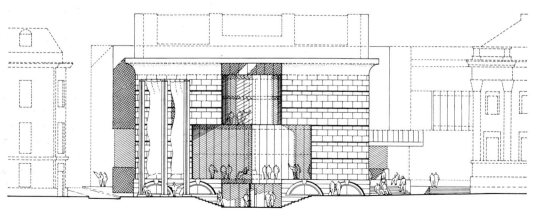

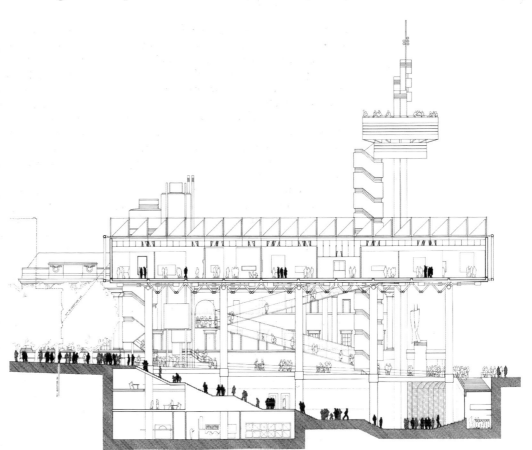

Rogers's 1982 design for the National Gallery in London had a completely different brief from Stirling and Wilford's. He had to incorporate commercial offices to pay for the gallery space – shown here at the top level, with natural light from above. At the lowest level, a pedestrian arcade links Trafalgar Square with Leicester Square.

Overleaf Rogers used different materials to express the two different aspects of his National Gallery extension. At the top the galleries would have been housed in a stone-faced box. The offices below would have had a metal cladding. The tower on the right was an attempt to respond to the vertical elements of Trafalgar Square, particularly the spire of St Martin-in-the-Fields.

which encourage this continuity of form need not necessarily imitate existing architectural forms. He takes the position that imitation may be appropriate, but in some circumstances a frankly modernist expression may be equally valid, provided that it exhibits the continuity which Rogers sees as the vital issue.

The National Gallery extension competition entry that Rogers submitted in 1982 is perhaps the most conspicuous example among his works of the latter approach. The notoriety that this particular scheme acquired has tended to obscure discussion of the real essence of the design, which did not lie in the startling technological imagery in which it was expressed. The key element that Rogers had identified, and which none of the other entrants to the competition had even attempted to address, was the role that the building could play in linking two of central London's most important urban spaces, Trafalgar Square and Leicester Square.

Traffic routes and the form of the buildings in the area have conspired to isolate these two potential magnets from each other, turning Trafalgar Square into a roundabout, cut off from the surrounding streets by heavy and constant traffic. The square is reduced to a

purely symbolic role and comes into its own on one or two special occasions only: large demonstrations, and on New Year's Eve. Leicester Square, though pedestrianized, is an equally cheerless place, claustrophobic and somewhat aimless. Rogers's most brilliant stroke was to identify the potential of the site as a catalyst to end this isolation and transform the way in which central London is perceived. Considered together the two spaces could be far more successful than the sum of each in isolation. He proposed closing to traffic two short streets behind the gallery which link it to Leicester Square, so forming a clearly defined pedestrian route that would have ducked beneath the new building, and then on down into a shop-lined mall that would have burrowed beneath the road ringing Trafalgar Square and opened up into it. The finale of the route from Leicester Square would have been a spectacular view of Nelson's Column, suddenly revealed as pedestrians emerged into the sunshine from the constraint of the mall. This was the way in which Rogers saw the extension maintaining 'continuity of form' with the existing urban environment – as far as he was concerned a more fundamental issue than the

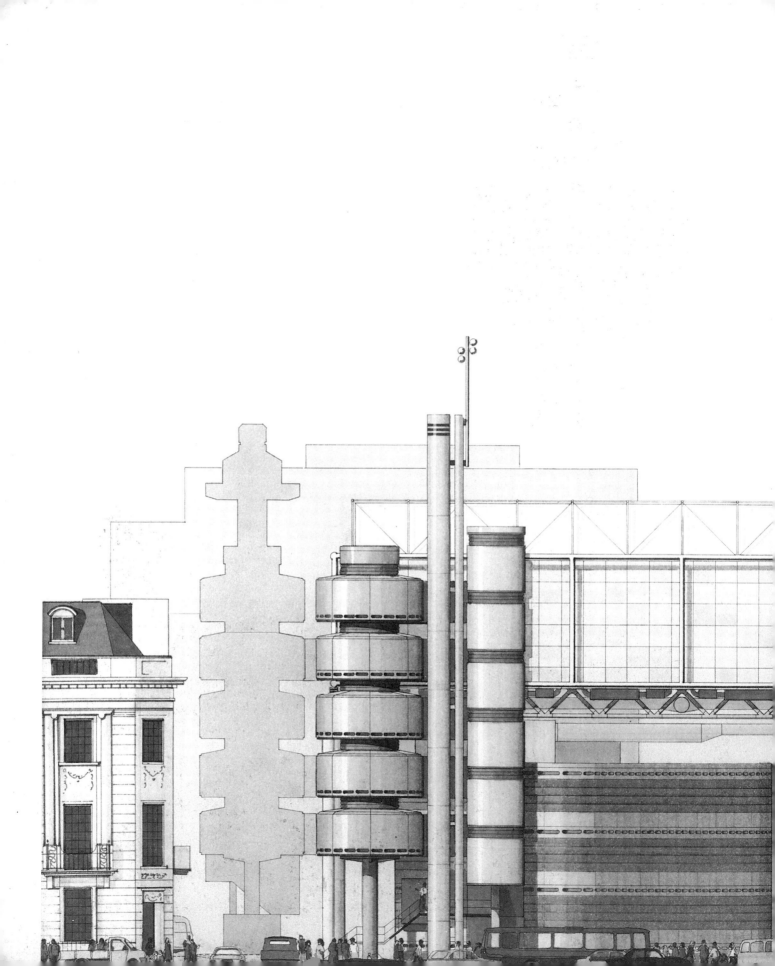

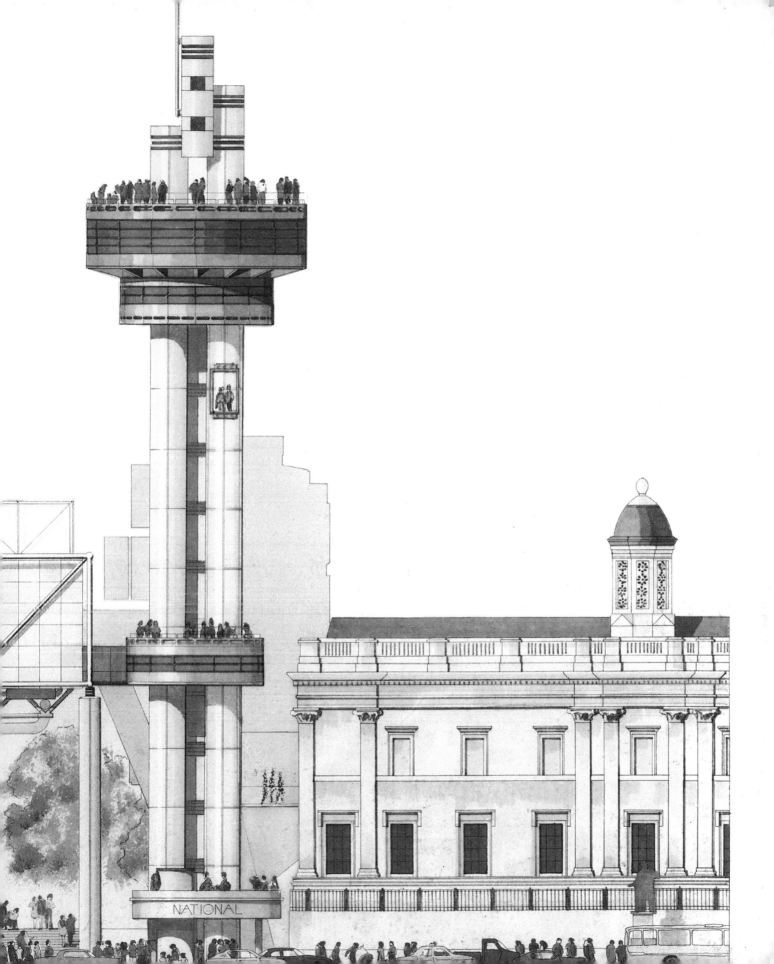

NATIONAL

Right and far right The competition for an extension to the National Gallery in 1982 presented contestants with the difficulty of combining commercial office space with galleries to display Renaissance art. Rogers's design, shortlisted and exhibited in the gallery, had startling aspects – particularly the dramatic tower, influenced by expressionist architecture – but, as this model shows, it also proposed an imaginative reordering of pedestrian routes in and around Trafalgar Square, including the creation of a mall beneath the new extension and the surrounding roads.

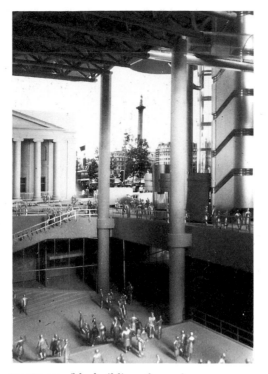

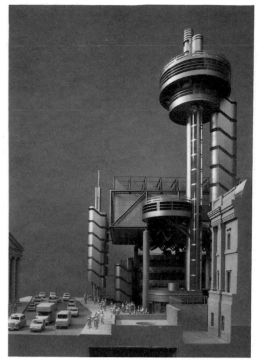

treatment of the buildings themselves.

In a deliberate act of bravado, Rogers proposed as part of the extension a tower which would have been of a scale to match the spire of St Martin-in-the-Fields on the opposite side of the gallery. This would have plugged what is at present a visually very leaky corner of the square, as well as providing a high-level restaurant with a superb view. By this device, Rogers attempted not only to symbolize the importance of the gallery, but also to restate confidence in architecture in the midst of an exceptionally timid and uncertain period. In the public poll that the National Gallery conducted at the time, Rogers's entry scored the highest number of votes both as the most popular and as the least popular of the schemes. With its metallic cladding and its streamlined curves curiously reminiscent of Mendelsohn's work from the 1930s it conspicuously broke the visual consensus of buildings within the square, which are all masonry faced and vaguely classical – even Herbert Baker's South Africa House, despite its elephant's head keystones.

In response to this criticism, Rogers maintains that it is not materials or the style of adjoining buildings that create harmony, but the relationship of the buildings' form to each other and to the movement of people between them. As evidence he cites the Piazza della Signoria in Florence, with all its bold irregularity still a profoundly harmonious space. The other

criticism levelled at Rogers was that his design did not have a character appropriate to the display of a collection of early Italian paintings. Implicit in the first line of attack was the notion that nothing but some form of classicism would be suitable – an unlikely hypothesis, especially given the questionable, but essential, inclusion within the competition brief of commercial office space, so that the whole development could be paid for without burdening the public purse. Rogers came to grips with the symbolic challenges that this presented by adopting two different aesthetic systems for offices and gallery: smooth skin for the offices, visually suppressed below a masonry box containing the gallery itself, which was held within an exposed structural frame.

In terms of aesthetic expression, though not in underlying planning principles, Rogers adopted exactly the opposite approach with his submission in response to the Royal Opera House's search for an architect to plan an upgrading of its existing Covent Garden facilities. Here too, a cultural institution was in the position of trying to pay for an extension by means of a commercial development. But the Opera House, warned off by the fiasco of the National Gallery competition – which had produced a traumatic split between museum trustees and competition judges – adopted a different selection procedure. Instead of a competition, they held a series of interviews in

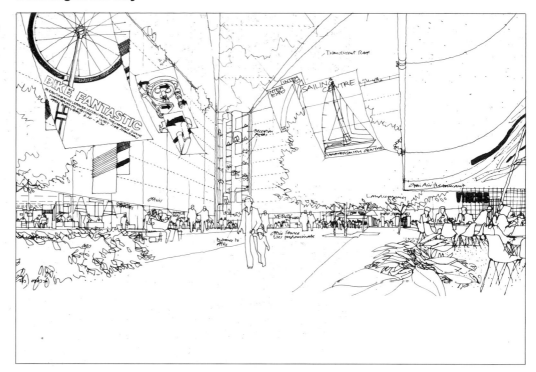

Foster's scheme for the Hammersmith Centre (1977) would have produced a civilized enclave within the traffic-choked roads and grim post-war developments of west London. The drawing above shows the interior of the public atrium, which is surrounded by a ring of shops and restaurants with offices above. The roof is a translucent plastic membrane. The section below shows how this atrium – the size of Trafalgar Square – is built over a new bus garage and underground station.

which a number of architects were invited to develop their approach to the problem. What Rogers suggested was a stone-by-stone reconstruction of the facades that Inigo Jones designed for the Covent Garden piazza, behind which would be a battery of spatial pyrotechnics (*gallerias*, vaults and so on), by now a recognizable part of his repertoire.

By the middle of the 1980s, Norman Foster's realized city centre projects were limited to two: the Willis, Faber and Dumas headquarters in Ipswich, and the tower for the Hongkong and Shanghai Banking Corporation — very different solutions for very different problems. The Willis, Faber and Dumas building was in effect a modification of the modern movement view of

the building as isolated object. The undulating facade hugs the pavement and is fragmented into faceted planes, which, thanks to the careful choice of materials, avoid the brashness of most mirror glass, and offer instead a gentler reflection of the surroundings. Of course the idea of smooth black glass is alien to the tradition of Ipswich tiled buildings, but the offices are still completely at home, mediating between the concrete of the nearby speculative office slabs, and the still surviving medieval streets. The Hongkong and Shanghai Bank is a very different conception. It is deliberately conceived as a landmark – a skill which, oddly, modernism has found difficult, despite its predilection for green-field sites. Here Foster

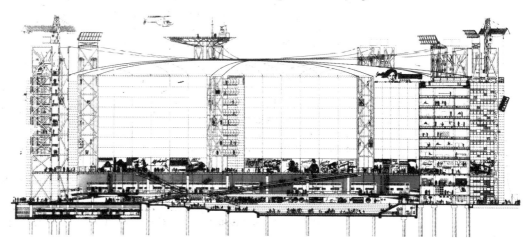

Regents Park

Euston Road

Marylebone Road

Park Crescent

Portland Place

British Telecom Tower

Cavendish Square

Oxford Street

Oxford Street

Oxford Circus

Regent Street

examined, and rejected immediately, the idea of going for simple height. He chose instead to respond to the diagrammatic remains of a formally planned series of urban spaces, for once aligning his building directly across their axis, rather than avoiding the issue with geometric evasions (see pages 149–155).

More significant for the future, however, has been a series of projects that have so far remained unbuilt – and one, the Nîmes Médiathèque, which seems finally to be going ahead. Of these, the saddest loss to London is Foster Associates' plan for Hammersmith, a development projected for London Transport which would have included a new underground station and bus garages, as well as a ring of offices surrounding a large, enclosed public space. London Transport's existing facilities in Hammersmith are all housed on one large island site, surrounded by heavily used roads. Foster tried to take what was probably the last chance to breathe life into the desert of crude new offices and hotels that the once pleasant suburb of Hammersmith had become. 'We saw it as more than just another commercial development,' said Foster at the time. 'I wanted to look beyond immediate expediency which just produces hit and run architecture.'[6]

His design had to juggle three sharply conflicting demands: commercial viability, the difficult technical requirements of building over railway lines, and the social needs of the local community. Foster's solution was to create a striking hybrid space, something between a shopping mall and one of the more flamboyant landscaped American hotel lobbies. He put the office slabs around the edge of the site. They sit on top of the bus garage roof, which becomes the floor of a huge open space the size of Trafalgar Square. A translucent plastic bubble stretched between the roofs of the offices and supported by tension cables would have sheltered the area from the weather. The resulting semi-indoor public space would have been equipped with a range of social amenities: an ice rink, exhibition and concert areas, shops and cafés. From the outside, the scheme would have had the glassy elegance of the Willis, Faber and Dumas building, albeit on a larger scale. The offices would have risen to twelve floors, punctuated at four points by towers containing air-handling equipment to service the public space within.

In its own way, the Hammersmith scheme is as original an urban invention as the Milan Galleria. It accepts not only elements of twentieth-century life that Krier is so disgusted

by – offices, motor cars, technology – but also a barbarously maimed site attractive to developers only by its very favourable position astride the main transport routes between Heathrow airport and central London. But it transforms them into what could have been a highly civilized environment. Unlike the private atria of American hotels, Foster's centre would have been a genuinely public space, and, thanks to the translucent fibreglass Teflon-coated material covering it, would also have been sunlit during the day.

Sadly, the scheme, originally drawn up for London Transport, was handed over to a commercial developer, who despite having had no previous experience of development in Britain, began asking for changes from Foster: the incorporation of brick facades, for example, and fewer amenities. Foster prepared a range of cost options, showing how the scheme could be realized with different levels of spending, but refused to allow his original concept to be diluted out of existence. Eventually the developers decided to appoint another firm of architects, who produced a numbingly banal design.

Foster's design for the BBC radio broadcasting headquarters was his first scheme for a major building on an important urban site – at the focus of Adam's and Nash's Portland Place. The urban problem here was an all too common one: the BBC's radio broadcasters had long resisted suggestions that they join the steady flow of institutions that have been quitting city centre sites for low-cost flat suburban industrial estates. Yet the corporation's original Broadcasting House had become hopelessly obsolete, constant maintenance was interrupting live broadcasts (banging was often audible on the air), conditions were cramped and equipment was out of date. However, during World War II, the BBC had acquired the Langham Hotel, a High Victorian brick pile designed by John Giles in 1864. The BBC decided to use this site to build itself a new broadcasting centre, leaving only administrative functions in the old building. A limited competition was held, on the lines of the Lloyd's and Hongkong and Shanghai Bank selection procedures, in which Foster was chosen in preference to Richard Rogers and the post-modernist Terry Farrell, among others.

It was, Foster admitted, 'the most complex and challenging project we have ever tackled; the most complex, both in technical terms and in urban terms.'[7] The building that he designed responded to a complicated number of different

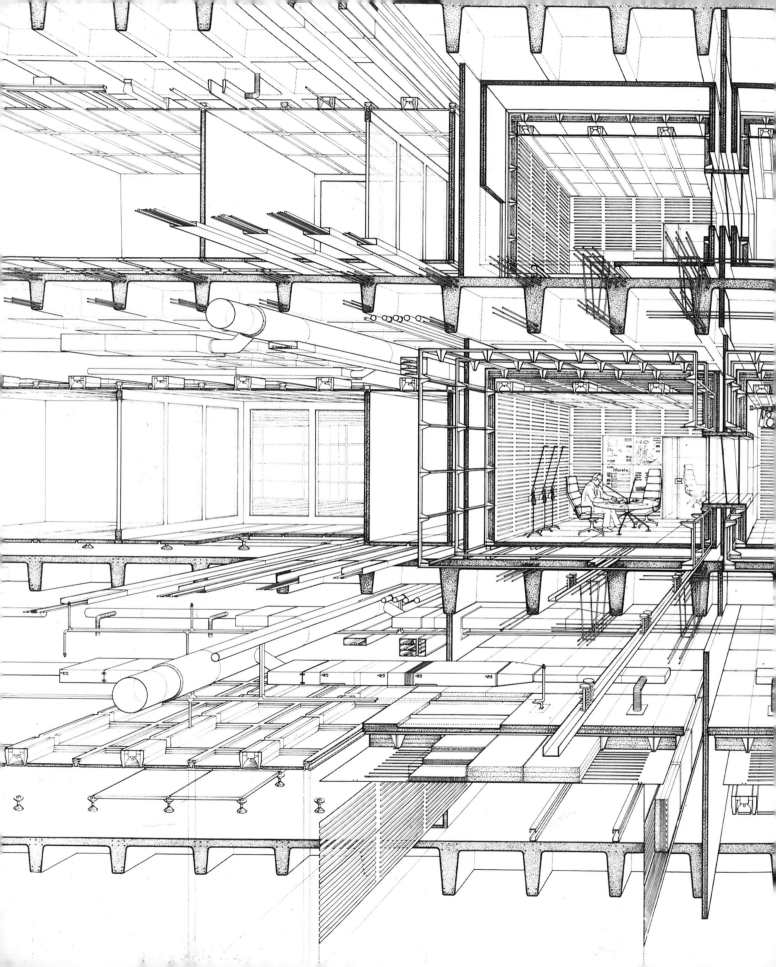

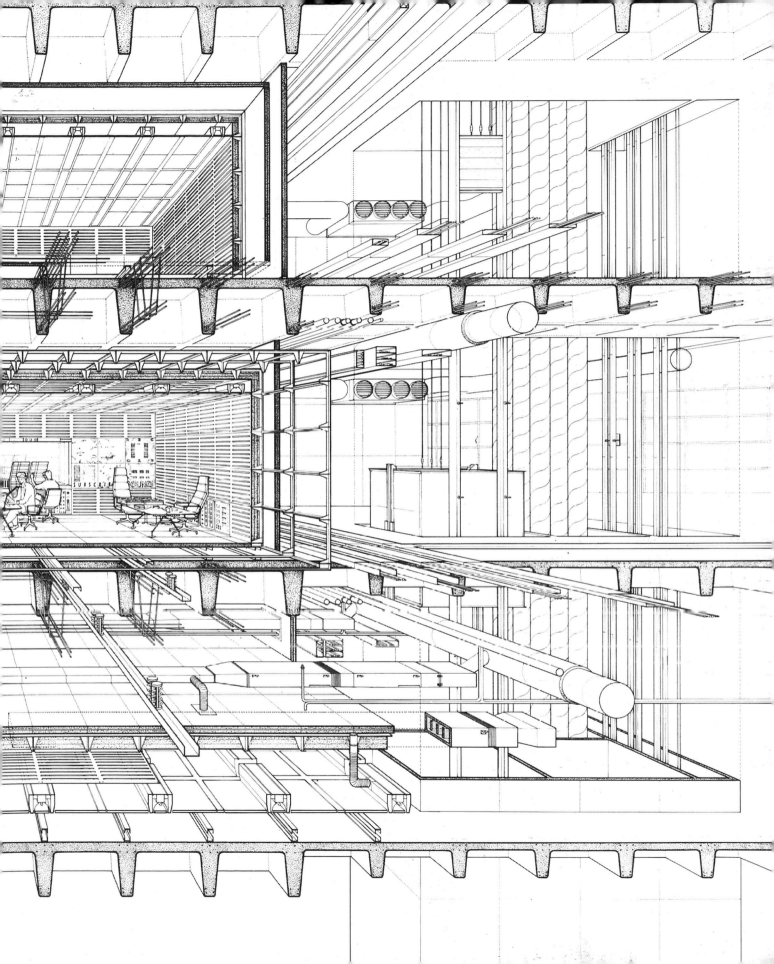

The elevation of the proposed BBC building on Cavendish Place, where the realization of Foster's plans would have entailed the destruction of a row of Georgian buildings.

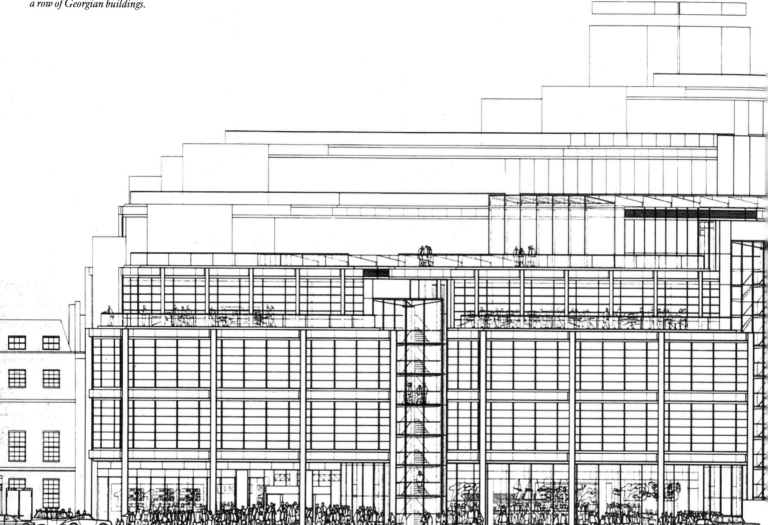

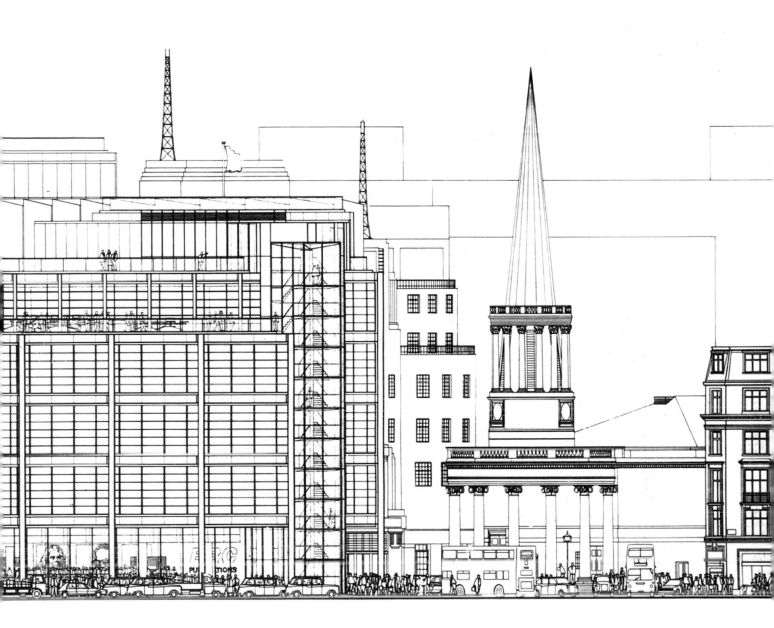

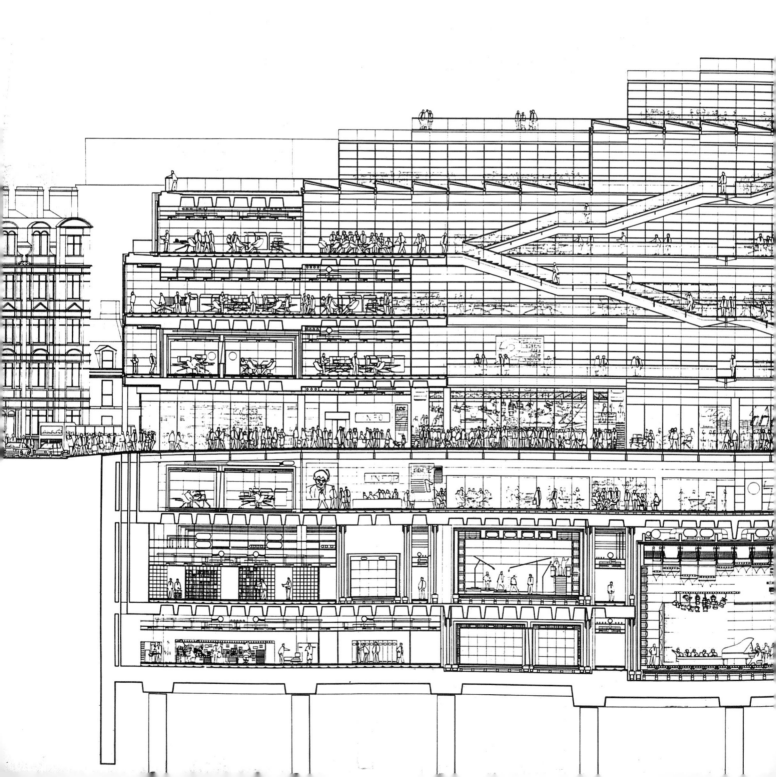

A section through Foster's proposed building for the BBC, showing escalators hung around the central atrium that forms part of a public route which cuts diagonally through the centre. Nash's All Souls is on the far right, next to the old Broadcasting House.

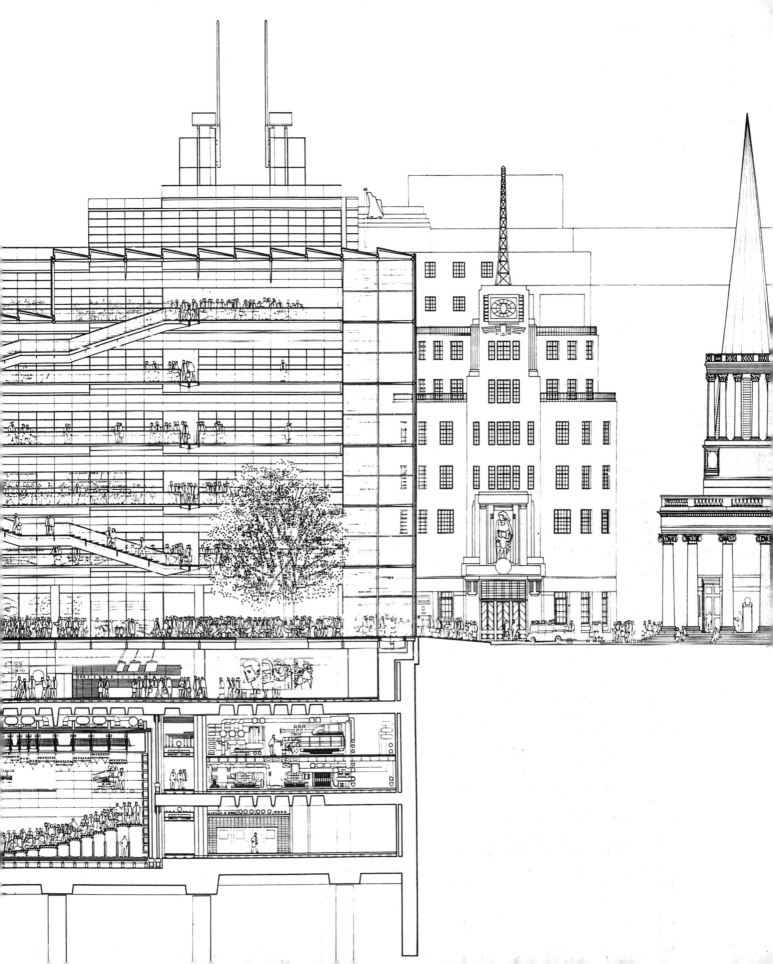

This cross section of the proposed
BBC building, looking towards the
existing Broadcasting House in
Langham Place, is at right angles to
that on pages 124-125. All Souls' is
visible through the transparent walls
of the public atrium.

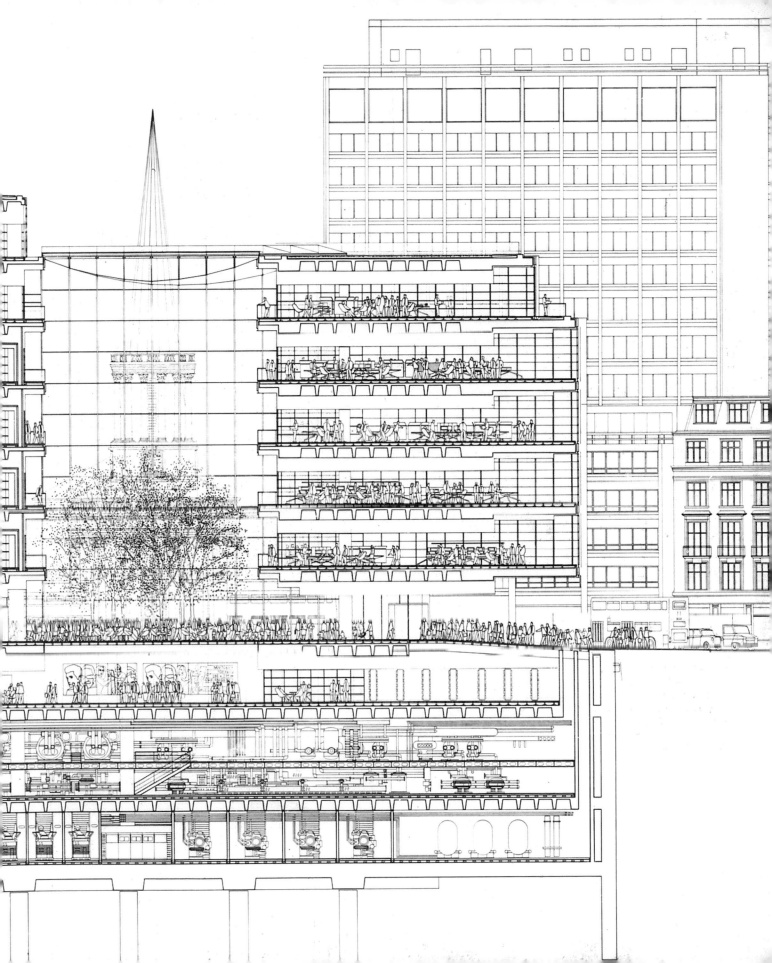

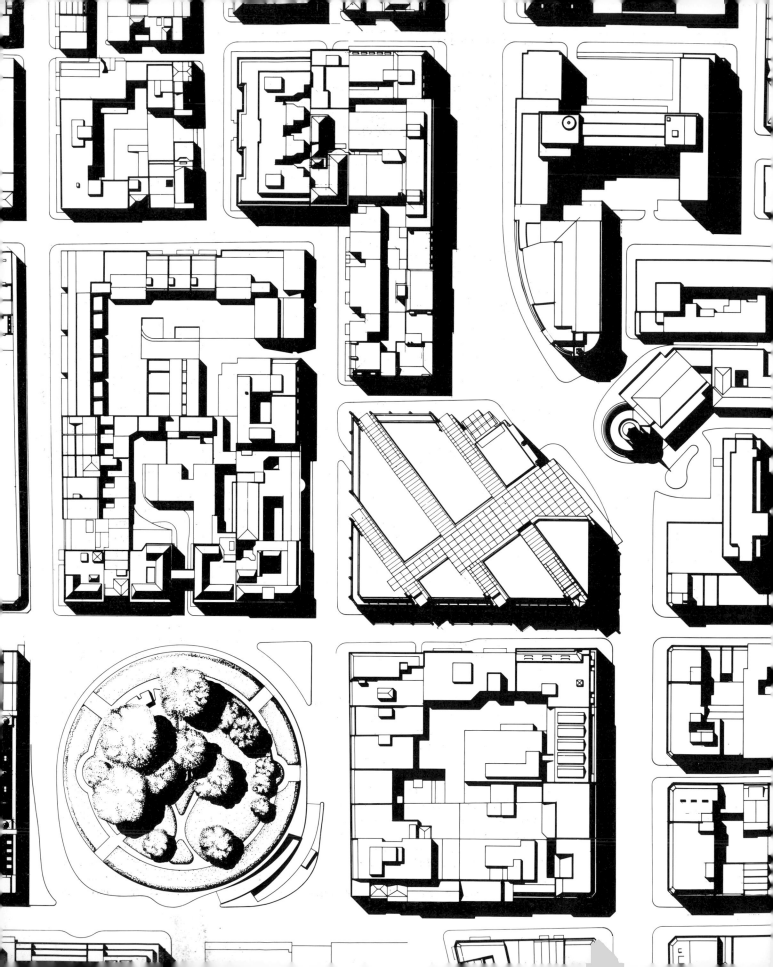

Left *Foster's BBC building not only had to close the vista of Portland Place, a great urban setpiece, it also had to turn a corner, face a square, and form one side of a terraced street.*

Right *A plan of the proposed BBC building. The high sound insulation and security requirements of the broadcasting studios form the fixed elements in the open-plan floors. Circulation between the floors would have relied on escalators, always Foster's preferred alternative to lifts.*

influences. Its facade to Portland Place would have been aimed at relating formally to its setting, while the Regent Street frontage would have been much more fragmented. 'There is an extraordinary variety of scales and views and atmospheres', said Foster, 'urban bustle in Regent Street, professional calm in Portland Place.'[8]

Foster spent nearly two years on the project. He painstakingly researched the technical demands of a broadcasting station and developed a strategy to deal with the urban issues. 'Imagine a site which appears to sit at one end of a triumphal way, but in fact turns a corner',[9] he remarked. For an architect who had made a career of studiously avoiding or ducking formality, preferring generalized spaces and solutions to particularized ones, Nash's Portland Place was indeed a challenge. The eventual design was a powerful piece of planning based around a public route from Portland Place into Cavendish Square, with a blurring of the public and private activities of broadcasting. At the centre of the new building would have been a semi-public atrium, with glass-walled studios and a broadcasting museum.

Foster's basement offices filled up with huge study models of the area, while he addressed the political problems of coming to terms with a conservationist lobby that was already mobilizing to stop the demolition of the Langham Hotel. But at the same time the BBC began to find itself under growing pressure from a government bent on resisting demands for an increased licence fee and it was criticized for the political stance some people thought it was adopting on certain issues.

Just as Foster was about to unveil the design in public in order to make a formal planning application, the BBC chief executives began negotiations to buy an alternative site for new radio buildings at White City. Whatever the buildings that the corporation finally decides to erect there, the episode will have been a defeat for the quality of life in modern cities, as yet another of the capital's institutions shuns the city and a further step is taken toward the separation of functions into discrete zones.

If the buildings that established James Stirling's reputation and occupied much of the middle part of his career – at Leicester, Cambridge, Oxford, Haslemere and St Andrews – were very much variations on the traditional modernist theme of the isolated object, his work has subsequently become more

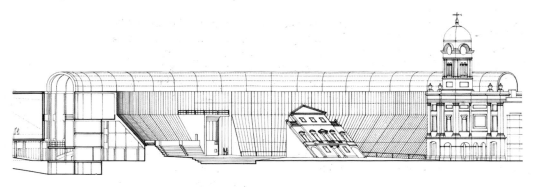

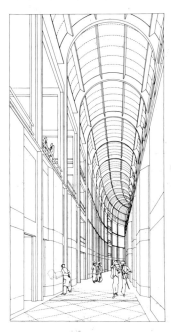

Top and above *Stirling's entry for the Derby Town Centre competition of 1970 proposed a complex scheme of urban surgery. In the drawing at the top, the Guildhall is on the right and behind it extends a semi-circular arcade of shops and offices (the interior of which is shown above). The facade of the old Assembly Room has been tilted backwards to form the roof of a bandstand, which faces onto an open arena.*

and more bound up with treating architecture as an urban art. Stirling and Wilford's three designs for German museums, at Dusseldorf, Cologne and Stuttgart, of which only the last has actually been built, are all attempts both to create buildings for and of those cities, and to develop a therapy to heal the traumas inflicted on so many European cities by war and post-war redevelopment. Stirling has attempted to use architecture to restore a lost sense of identity. The shift in emphasis provided the catalyst for an enrichment of his own work. But his interest in the city was hardly new, nor did it require him to abandon the enthusiasms of his youth. He had after all once defended Le Corbusier, 'frequently accused of being an internationalist', whereas to Stirling he was 'actually the most regionalist of architects': 'The difference between Paris and Marseilles is precisely the difference between the Pavillon Suisse and the Unité.'[10] In his famous comparison of Garches and Jaoul for the *Architectural Review*, Stirling had gone on in his only serious note of criticism to express his disquiet at what he then saw as the disturbingly peasant-like, anti-urban quality of the latter, just half-a-mile away from the Champs Elysées.

Stirling's attempts to work at a level beyond the individual building can be traced as far back as the village project of 1955, produced as a response to CIAM while he was still under the Team X umbrella. It was a theoretical study, sparked off, according to Stirling at the time, by driving through Cotswold villages and being disgusted to find that each had been despoiled by crude new housing schemes without any pattern and with nothing to offer in a place-making sense. Within a structural logic of parallel cross walls, Stirling devised a casual, apparently random and accretive pattern of public spaces in an attempt to provide a model that would give some coherence to the tidal wave of building threatening to engulf England.

Built in the grounds of a Georgian house, Stirling's housing scheme at Ham Common

hardly had a similar context to address (see page 11). The unsuccessful competition entry for Churchill College, Cambridge, was made of sterner stuff, a heroic restatement of the academic college, elevated to a ruthless and monumental scale that distressingly resurfaced in the squares of bleak housing for Runcorn (1967). It was not until the Derby Town Centre project, designed by Stirling with the assistance of Leon Krier as a competition entry in 1970, that the idea of architecture as a curative for modern urban ills became a central concern for Stirling. The nominal subject of the competition (won by a scheme by Sir Hugh Casson's practice, Casson and Conder) was the design of a new Assembly Room for the city. Stirling's entry was therefore disqualified for exceeding the terms of the brief. Yet it was an important attempt to recreate the kind of sense of civic space which had been lost in post-war redevelopment.

Stirling took his idea for a new Assembly Room – in fact a kind of multipurpose auditorium – and buried it within a series of boldly urban gestures: a two-level arcade, with shops on the ground floor and professional chambers above, grasps the Assembly Rooms, and at the same time creates by its sinuous crescents an outdoor arena ringed by stepped seating. The focus of this outdoor space was to have been a bandstand with a roof of sorts formed out of the recycled facade of the old Assembly Room building, tilted backwards at an angle of 45 degrees to the ground. The design also included a clutch of awkwardly ironic incidents – for instance, a giant statue of The Winged Victory (that clearly shows the hand of Krier) looms over the piazza, in tribute to Derby's largest employer, Rolls Royce.

As an addition to Derby's ravaged centre, Stirling's scheme would have had a powerful presence – assuming of course that all those shops in the Burlington Arcade of the north that Stirling proposed to build could have been let. It also provided a pointer toward the three

Right *The first of Stirling and Wilford's series of three entries for competitions to design West German museums was the unsuccessful 1975 project for the Northrhine Westphalia Museum in Dusseldorf. The buildings shaded black were already in existence. On the left is a cut-away diagram of the covered porch sheltering the turnstiles. The open-air central drum was to be a feature of the Stuttgart Staatsgalerie.*

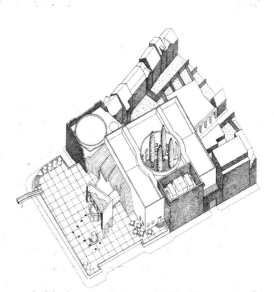

German competition designs of the mid-1970s. By this stage growing discontent with the shape of urban development was an important and permanent theme of Stirling's work. He felt particularly distressed at the fate of his native Liverpool, where whole areas of fine buildings had been levelled or left to rot, and the survivors huddled among the wreckage of an immeasurably coarsened city. West Germany's cities might not have been facing the economic problems of Liverpool, but they too had suffered badly, not just from war-time bombing, but also from traumatic post-war development. Stirling and Wilford's competition report for the Northrhine Westphalia museum for Dusseldorf speaks of their wish to 'achieve an architectural appearance that is as individual as the older buildings in contrast to the oversimplified appearance and overblown scale associated with modern architecture; the box, the slab. Our attitude to the surrounding urban context is to infill and preserve.'[11]

Like Stirling's glass and tile university buildings, the German competition designs, culminating in the building of the Stuttgart museum, can be seen as a trio exploring the same themes. Each is a collage of similar elements that invariably includes a drum – open to the sky in the case of Dusseldorf and Stuttgart, bridged over at Cologne – redolent, we must assume, of Schinkel or Asplund. In each case also, as a condition of the competition, a pedestrian route is included, eroding its way across the site like a stream eating through limestone.

At Dusseldorf, the state of Northrhine Westphalia allocated a site for a new museum of twentieth-century art on the Grabbeplatz, within the historic core of the city but occupied by a partly demolished gaunt Teutonic library

and a bleak open-air carpark. The library backed onto a wasteland of empty lots and backyards. Rather than demolish everything on the site, Stirling and Wilford chose to bury the bulk of their building behind existing facades and to recapture the Grabbeplatz for the city by banishing cars underground and creating a raised terrace above it, putting pedestrians safely above the surrounding busy roads. The museum's presence would have been announced by a porte cochère signalling both the entrance and the start of the pedestrian route across the site.

At Cologne, perhaps the most powerful of this series of designs, Stirling and Wilford had to come to grips with an astonishing urban paradox: Cologne's cathedral has been displaced from its long dominance of the Rhine by a mighty piece of Victorian engineering, the railway bridge that crosses the river on an alignment aimed directly at the cathedral spire, but swerves to one side shortly before reaching

Also designed in 1975, Stirling and Wilford's Wallraf-Richartz Museum in Cologne would have provided the city with two gateway pavilions, framing the twin spires of the cathedral and screening the clutter of railway lines that currently disfigures the approaches to the cathedral.

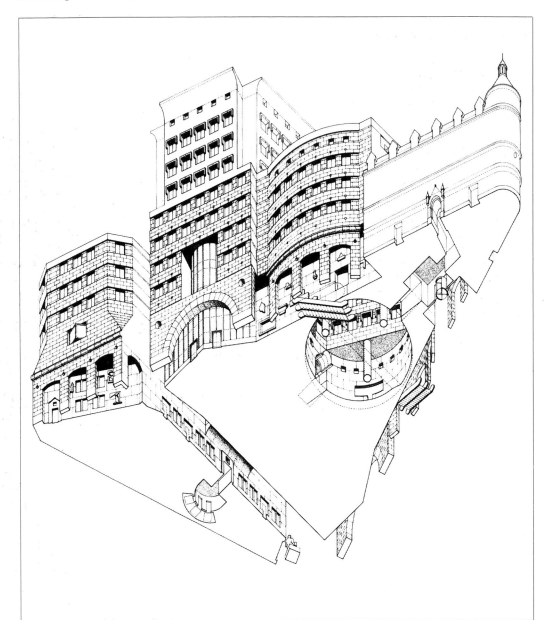

it, to bury itself in the station. The site for the new museum, immediately in front of the cathedral and stretching down towards the Rhine, gave Stirling and Wilford a remarkable opportunity to address this apparently insoluble urban problem. With fearless ambition, they created a pair of pavilions overlooking the Rhine which frame the cathedral and make a gateway for the city. A long low flanking gallery screens out the railway, and a network of escalators and bridges allows the museum to span the railway tracks: in all, a masterly piece of urban surgery, carried out in an austerely monumental style.

Stirling and Wilford's technique is not to orchestrate the theatrical attractions of

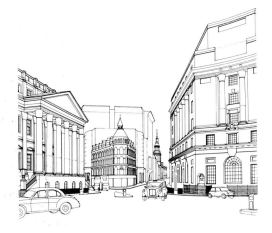

After failing to build a glass tower designed by Mies van der Rohe for the City of London, the property developer Peter Palumbo chose Stirling and Wilford to produce a new scheme for the site next to Mansion House. Existing street lines were to be respected and plans to create a new city square were dropped. In 1986 Stirling and Wilford unveiled two alternative designs. That on the right, *which rises to seven storeys, is only slightly higher than the present roof line, but involves the demolition of seven listed buildings on the site. That on the* left *preserves the only one of them with a real claim to architectural distinction, the Victorian Mappin & Webb building on the corner, but to compensate for this loss of space, the new block rises up to a 150-feet-high tower, to provide all the offices necessary to finance the redevelopment. Both schemes have banded stone facades and include arcades and a central drum.*

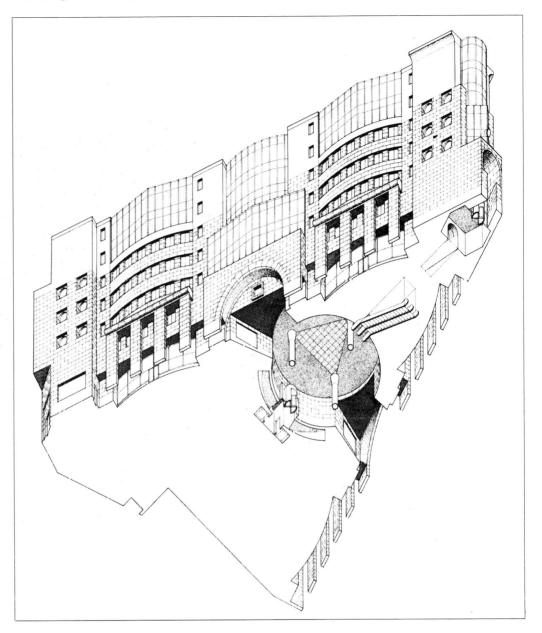

urbanism in the way that Rogers does – although their pedestrian routes may have an echo of the approach that Rogers adopted in linking Trafalgar Square and Leicester Square. What Stirling does instead is to create the formal architectural incidents that together make up an urban context. The question that might be asked is how much can one building ever provide a genuine substitute for the aggregated growth of the traditional city? But setting aside this reservation, Stirling and Wilford's German projects do seem to offer a model with much wider applications, one that was to come to fruition at last in the Stuttgart Staatsgalerie (see below, pages 159–175).

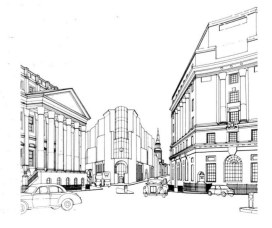

Living with the past

Rogers's 1983 design for an office building in the City of London was met with little enthusiasm by the planning authorities, who responded to this scheme by producing a picture of a Victorian block in Glasgow, and inviting him to try again. The details of the building were never worked out, but the preliminary drawings demonstrate the interest in 1920s expressionist architecture that was also apparent in Rogers's designs for the National Gallery (see pages 113-117).

Few generations have come to be as haunted by, or more ambivalent toward, their past as our own. And in Britain, with its apparently innate distaste for change, and its contempt for commerce and industry, this ambivalence is particularly pronounced. For the satisfaction of the apparently insatiable British nostalgia for the past is made possible only by the industrial spirit whose decline the economic historian Martin Wiener has so lucidly desribed in his book *English Culture and the Decline of the Industrial Spirit* (Cambridge, 1981).

From the coal miner who hates his pit, yet refuses to leave the village which it supports, to the successful first-generation industrialist whose immediate impulses on achieving financial security are to adopt the land-owning habits of a class which despises his enterprise, and to educate his children in their mores, Britain is in thrall to a process of decline that can in the long term only destroy rather than safeguard its civilized values. Given the pace of technologically induced changes, and their often disturbing consequences, it is hardly surprising that many attempt to isolate themselves from them. But this is not a realistic option. In the early years of this century, the declamatory posturing of the futurist wing of the modern movement was a deliberate attempt to create a climate open to the impact of industrialization. Although much of what the futurist Marinetti had to say sounds naive, he was at least prepared to address the changes that were inevitably overtaking European society, and to harness them. Yet, as accelerating economic decline threatens Britain, there are many who are content to ignore the realities behind this slide.

Combined with a natural reaction against the failure of modernism to deliver its utopian promises, this mistrust of change has reached a neurotic extreme in Britain, where the attitudes once voiced so lucidly by the American architectural historian Vincent Scully have come fully to life. 'Consider an empty site', he said. 'Today we are perfectly sure that it will be better empty, than with a new building on it. Consider an old building. We shudder when a new building is projected to replace it because we have good reason to suspect that it will be worse than the old.'[1] So violent has the reaction against the received wisdom of the last generation been that there is a general supposition that any new building will be inferior to any old one – in short, that any form of change should be resisted.

It is curious that though this view is now identified as specifically anti-modern, much of the most serious destruction of art-historically important architecture during this century has been carried out not by modernists at all, but by the traditionalist architects. They saw no reason not to carry on with the same self-confidence exhibited by their profession throughout

Left *The centrepiece of the Arthur M. Sackler Museum is a cascading series of stairs, lit from above, its walls an ambiguous mixture of the internal and external, adorned with architectural fragments from the museum's collection and finished in a more vividly coloured version of the two-tone banded brickwork of the outside walls.*

Right *The interior of the Rice architectural school is in deliberate contrast to the undemonstrative exterior. The free-floating mezzanines in the all-white double-height spaces are a reminder of Stirling's earliest designs, which were influenced by Le Corbusier.*

long way from the spurious adoption of an ersatz saccharine-sweet vernacular, as cosmetic and as superficial as the Festival of Britain style. Thus the National Gallery extension included a tower intended to match the spire of St Martin-in-the-Fields in height, and located in a precise relationship with Nelson's Column, the centre of the gallery's portico and the church. Equally, Rogers was prepared to take on an advocacy role for Save Britain's Heritage in their battle with the City of London authorities to retain the nineteenth-century structure of the old Billingsgate fishmarket when its original users had moved out to Dockland. Once that particular battle had been won, Rogers was actually called in to carry out the old market's conversion into a trading floor for an American bank.

For Stirling, responses to architectural history have manifested themselves in a variety of different ways. At Cambridge, the nearest neighbour to the History Faculty Building is Casson and Conder's picturesque stab at a medieval quadrangle, raised up on pilotis. The only other nearby buildings are the Edwardian suburban villas of West Road, so Stirling and Wilford saw nothing in the context to respond to. Accordingly they resorted to personal invention to give the building a form and an identity. But they took a very different view in 1979 when they secured the commission to design an extension to the school of architecture

at Rice University in Houston. At the start of the 1980s Houston was enjoying boomtown conditions. Profits from the oil price explosion were being channelled into property developments, causing the city's skyline to metamorphose twice within the course of a decade, pushing up first a crop of Mies-inspired glass boxes and slabs, and then the even more rapid and intimidating growth of a riot of still taller art deco skyscrapers.

Given that context, the civilized quadrangles of the Rice campus, laid out by Cram, Goodhue and Ferguson in a blend of Romanesque reminiscent of Ravenna, seemed to Stirling and Wilford like an urban asset well worth preserving. Indeed, his clients specified that the new buildings should adopt a palette of brick and stone that related closely to what was already there. Stirling and Wilford went further, faithfully adhering to the logic of Cram's plan and its stylistic expression. Hence their determinedly restrained approach. Their extension is an L-shaped addition to the original school building, positioned in such a way as to form a three-sided courtyard focused around a new garden. With its brick and stone elevations discreetly echoing the facades of the existing buildings, there is hardly a clue that it is anything other than at least a generation old. Only an off-set circular window set within a blind arch, and two curiously shaped pyramidal skylights suggest that anything new is going on.

Internally however, Stirling has not been afraid to adopt an entirely different approach. There is an almost surreal contrast between the white interior and the textured brick exterior. On the outside, Stirling has virtually denied himself all avenues for self-expression.

After completing their work at Rice University, Stirling and Wilford went on to design several more academic buildings in the United States. These projects often combined several functions in one structure – a theatre with conventional academic accommodation at Cornell University and an art gallery with teaching space and offices at Harvard. The first of this series, the Arthur M. Sackler Museum at Harvard, was designed in 1979 as an extension for the Fogg Museum on a site on the corner of Broadway and Quincy Street. Although considerably smaller than the Staatsgalerie in Stuttgart, it took almost as long to be built and was not finished until 1984, after a series of setbacks. Indeed at the end of 1986 the building was still not completed in the form which Stirling and Wilford had originally envisaged, but awaited the construction of a high-level bridge linking the new building with the Fogg Museum, on the other side of Broadway. The bridge would have had the same striped exterior as the rest of the museum and, like it, would have been embellished by one discordant stone-edged element, a giant circular window positioned at the mid point of the bridge's crossing over the street beneath, an echo of the Fogg Museum's main gateway in its Broadway facade. The bridge would itself contain two galleries as well as a lounge area looking out over the street.

The Arthur M. Sackler Museum occupies a prominent corner site on the edge of the historic Harvard Yard, immediately adjacent to the university's Gund Hall school of architecture and building, and close to Le Corbusier's Carpenter Center. Stirling has chosen to respond to the street frontages that form a thin border to the Harvard campus, which is made up of a number of landmark buildings loosely arranged in an open space. From the exterior, the museum presents a continuous brick wall that curves sharply at the corner between Quincy Street and Broadway and is interrupted by an apparently random pattern of windows punched through the two-tone banded brickwork. It has all Stirling's quirkiness and deliberately eschews any attempt to ingratiate itself by resorting to superficial charm – a quality that the writer Ian Nairn was once moved to describe, with approval, as

'bloodyminded'.

The critic Kenneth Frampton has criticized the museum's window pattern, reproaching Stirling for having created a deliberately shocking and disordered facade. In a letter to Stirling he wrote of 'not understanding the rather simple and even banal principle which determines the facade, namely every window is in the middle of its respective inner wall'. To Frampton this was an inadequate principle on which to design a building, since in his view, 'facades are representative, and there should be a disjunction between inner and outer order'. Stirling simply referred to his decision as a functional placement of windows according to the requirements of the rooms. But indeed there are few signs on the museum's exterior that this is a cultural building: amidst the collection of buildings all around it, Stirling has adopted a deliberately 'ordinary' image. Possibly to make amends for this artless character, the museum has a monumental entrance, a primitive but powerful stone-edged opening torn into the brickwork, flanked by circular pillars which may, or may not, one day carry Stirling and Wilford's projected linking bridge. Now they also act as air-intake ducts. The other main feature of the exterior is its colouring, but, as with so many of Stirling's attempts at polychromy, the final colour scheme is more subdued than was originally intended. Blue engineering bricks alternate with buff, whereas early studies were for a stronger shade of green, mixed with straw yellow.

The museum houses collections of oriental, ancient and Islamic art, and it can plausibly be argued that similarly exotic sources have provided the inspiration for the form of the entrance, and for the long, uninterrupted, almost stately progress of the main staircase inside. In addition to the galleries for the permanent collection, there is space for special exhibitions, offices, curatorial and service departments, storage, classrooms and library collections. In total there are 11,000 square feet of gallery space, which represents an increase of 75 percent for the Fogg's total display area. The plan is a large L-shape, with the classrooms and offices forming an outer layer wrapped around the galleries. In the basement, a turn in the staircase gives access to a 250-seat lecture theatre.

The galleries are arranged around a skylit central staircase that rises the full height of the building in a continuous straight flight. This is an impressive example of one of Stirling's repeated and reworked themes, one that

Right *The rear elevation of Stirling's Florey Building, a residential block for Queen's College, Oxford (1971), supported on protruding concrete A-frames. It presents a forbidding front to the city – the result of a decision to turn the building in the opposite direction, to face the river.*

appears at the Clore Gallery at the Tate, which Stirling and Wilford began shortly after the Sackler Museum (see pages 176–177). The walls of the staircase have been treated as an exterior with a banded coloured pattern that recalls the walls outside, and they are adorned with architectural fragments from the museum's collection, providing an effect faintly reminiscent of Sir John Soane's Museum in London (see page 140). As a complete building, the Sackler is a curious mixture of the ordinary and the exceptional, quiet on the outside, loud on the inside. It is an attempt to restore some sense of urbanity to America's streets, a quality which is so lacking even in the civilized enclave of Cambridge, Massachusetts.

The Florey Building, for Queen's College in Oxford, is outside the city's historical centre, positioned on the edge of an Elysian watermeadow with a view across a tributary of the Isis to the spires and towers of Magdalen College. But on the other side of the site, it is hemmed in by a scruffy slice of Victorian vernacular that conceals it from suburban Oxford to the south-east. Here Stirling spelt out his intention that the building, a residential block for undergraduates and senior members of the college, should be historically evocative, not in the sense of adopting a collegiate gothic, but by providing visual clues that would relate this new building to the context of academic life in the city. Thus the form of the Florey Building, wrapped around three sides of a courtyard, is a deliberate reference to the traditional academic cloister. Instead of a lawn reserved for fellows, there is a democratic tiled terrace, formed on the roof of a cafeteria that looks out over the river. In the centre is a toylike conceit, a mechanical air-extractor vent, one of Stirling's recurring ship motifs, this time presented as analogous to a founder's statue. On the street side of the building, a coupled pair of brick towers, containing stairs and a lift respectively, are intended to provide a recollection of the medieval gateways of the Oxford colleges. Such resonances have not by and large evoked much response among the building's residents. Many have complained of the lack of privacy of the all-glass window wall, and the choice of red tile has been criticized as inappropriate, given the limestone context of the bulk of the city's buildings.

Another attempt of this order was Stirling and Wilford's housing scheme at Runcorn New Town, planned in the years after 1967. Here they tried to evolve the layout from the traditional British manner of using repetitive

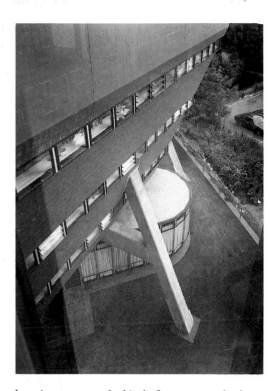

housing to create the kind of monumental urban spaces that distinguish Bath, Edinburgh and Bloomsbury. In fact the closest resemblance between this ideal and the prefabricated concrete panels of the reality was in Leon Krier's evocative drawings. This was, however, the project on which Stirling came closest to the position adopted by the Italian architect Aldo Rossi in his influential book *The Architecture of the City* (1966); both seek the fundamentals of building types and urban planning.

The word 'history' is frequently on Richard Rogers's lips. He co-opts the masters of the Renaissance to create a pedigree as a passionate response to charges that modernism has forgotten the lessons of the past: 'For the Modern Movement to continue to be valid, it must be capable of development and adaptation in response to new information and considerations. It must learn from the past. Serious mistakes, rooted in the revolutionary optimisms of the first part of the twentieth century, such as the belief that science could solve all problems, must be corrected. But it would be even more foolish to conclude that because science alone is not sufficient, it is not necessary either.'[2] But Rogers's view of the acceptance of history does not go so far as to adopt the reaction against modernism, which he claims is rooted 'in the belief that the aesthetic of architecture exists purely in its own right, and does not need other validation; in other words,

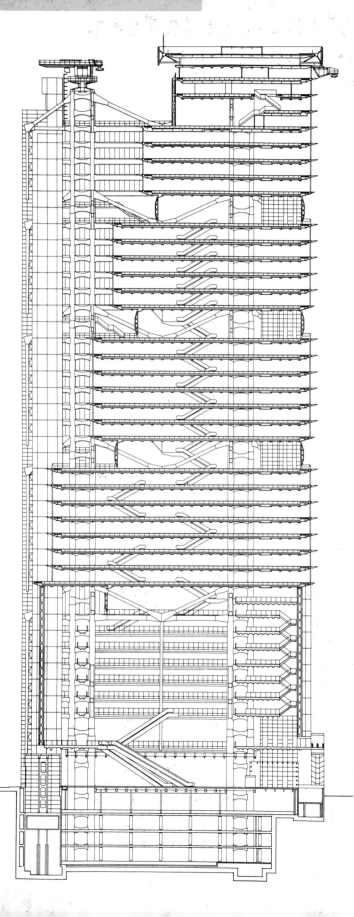

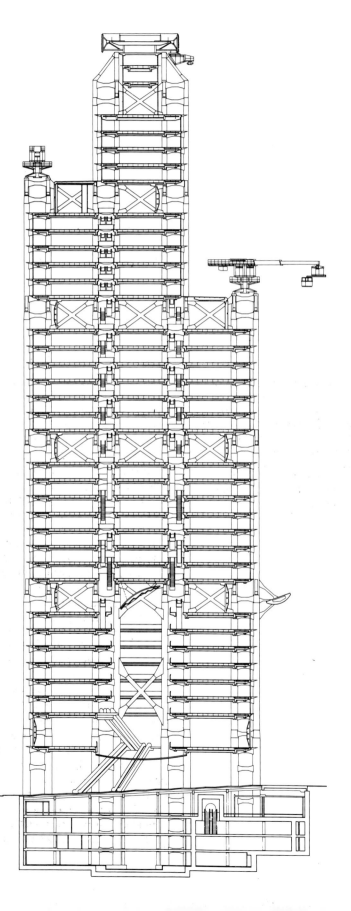

Monuments for a secular age

Unlike the simple repetitive cellular plans of most highrise buildings, Foster's Hongkong and Shanghai Bank offers a variety of different types of space, some double height, some partly outdoor, thanks to the suspended structure. Equally distinctive is the quite different character of the tower on its wide and narrow faces.

The 1980s have seen the renewal of interest among patrons both public and private in using architecture in a monumental way. The phenomenon can partly be explained by motives of vanity – the assertion of corporate prestige and personal ego. But there is also a greater awareness of the role that buildings have in symbolizing the public significance of institutions and creating identities for them. In different ways, Foster, Rogers and Stirling have all played a part in this process.

Of all the architectural inventions of the industrial age, the skyscraper is the only one to have become a genuine part of popular culture. For better or worse, it is now the quintessential symbol of the glamour of the modern metropolis. Yet despite the universality of the skyscraper, it has so far remained, creatively at least, an entirely North American art form. Mies van der Rohe's sketches in 1919, and Gropius's entry for the Chicago Tribune competition of 1922 proved that Europe could produce skyscrapers, but it was only after Mies arrived in Chicago that he was really able to explore the subtleties of glass towers, and to add a new strand to the already vigorous traditions of American high-rises. In Europe and the newly industrializing continents, there are any number of buildings tall enough technically to qualify as skyscrapers, but, almost without exception, they have been pale imitations of American precedents. At worst, they are banal and

urbanistically destructive; at best, sullenly competent. Very tall buildings have a unique capacity to create an identity for institutions, cities and even countries. But by the end of the 1970s, possibly because of the prevailing lack of belief in architectural theory, skyscrapers even in America had become vapid, without the power to communicate or symbolize. Their owners after all had very little to believe in, beyond bland corporate efficiency.

However, when the Hongkong and Shanghai Banking Corporation appointed Norman Foster to design their new headquarters building in 1979, they were determined that it should represent very much more. In selecting Foster from a field of architects from America, Australia and Britain, they gave him a unique opportunity to redefine the skyscraper as a form, and to reinvest it with architectural meaning. To a very great extent he has succeeded, creating a building that is both a landmark and a rich architectural composition.

Architectural symbolism is of crucial importance in Hong Kong. The bank is not simply a commercial undertaking; it is also one of the institutions regarded as vital to the smooth running of Britain's last remaining colony of substance in the years leading up to the transfer of sovereignty to the People's Republic of China in 1996. The bank acts as an arm of government, overseeing economic policy and issuing currency notes, as well as

conducting a world-wide commercial banking
operation. A simple-minded glass slab, lost in
the tiered cliffs of similar buildings that make up
Hong Kong's waterfront, clearly would not have
met the bank's determination to make a strong
statement about itself.

The bank is a colonial-born institution, a
transplant of English and Scots banking
practices of the mid-nineteenth century to the
Far East. Its headquarters have stood on the
same site since the 1870s. When Foster came on
the scene, the bank had outgrown an art deco
building of the 1930s, in its day the tallest and
most technically advanced building between
Cairo and San Francisco. The bank was
determined to build a new headquarters that
would have similar prominence. As the bank's
then chairman, Michael Sandberg, said at the
time, it was looking for the best bank building in
the world.

Foster's design has had to deal with a whole
range of nuances in the kind of messages that
the bank wanted to project about itself. At the
most blatantly political level, the new building is
a commitment to the future of Hong Kong, an
obvious sign that the bank intends to maintain
its position after the Chinese takeover. One of
Mao Tse Tung's first acts as the ruler of China
after his victory over the nationalists in 1948 was
to authorize the addition of an attic storey to the
roof of the Bank of China building in Hong
Kong. It was a gesture designed to make Mao's
bank fractionally taller than its capitalist
neighbour, the Hongkong and Shanghai Bank,

and amounted to a deliberate and costly
assertion of China's claims to eventual
sovereignty over the colony. Foster's £500
million tower has had the side effect of crushing
the old Bank of China building into visual
insignificance – a state of affairs that Peking
moved rapidly to reverse, commissioning I. M.
Pei to design a seventy-storey tower, taller than
anything else on the island.

At the same time, the bank's commercial
success within Hong Kong depends on
attracting the business of local people; 98 per-
cent of whom are Chinese. Thus for all the
swagger and unblushing pride with which
Foster's building is now depicted on all the
bank's currency notes (its high technology
structure incongruous among the customary
swirls and scrolls of the engraver's art), the bank
is keenly aware of the need to present a face that
is sensitive to local tradition and custom. Hence
the use of a geomancer to advise on the most
propitious alignment of the new building with
sea and sky. But the bank is not simply a local
institution. It is one of the world's larger
banking chains, and is represented in America,
Europe and the Middle East, as well as
throughout Asia. So while wanting to identify
itself with its Chinese customers, it is equally
eager to be accepted on an international stage.
This ambiguity partly accounts for the difficulty
that Foster experienced in deciding on an
appropriate colour for the exterior. Should the
expressed steel structure, which ripples across
the facade of the building like a prize-fighter's

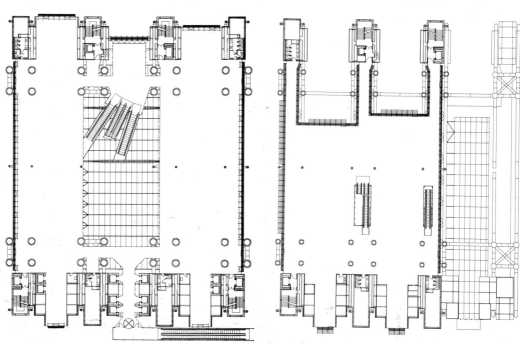

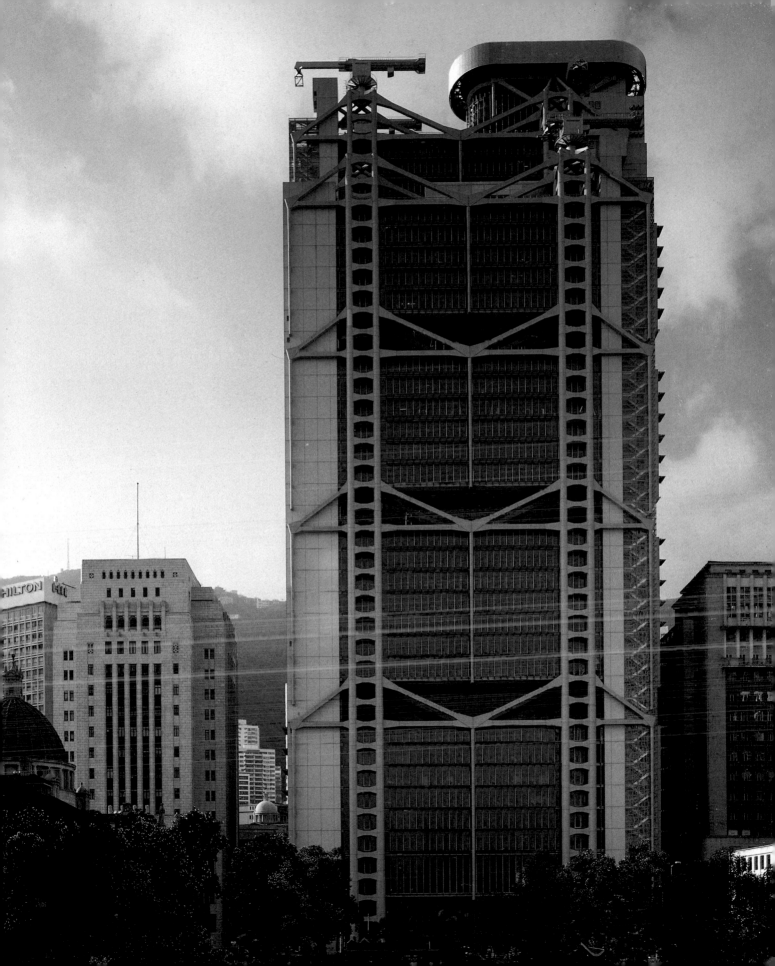

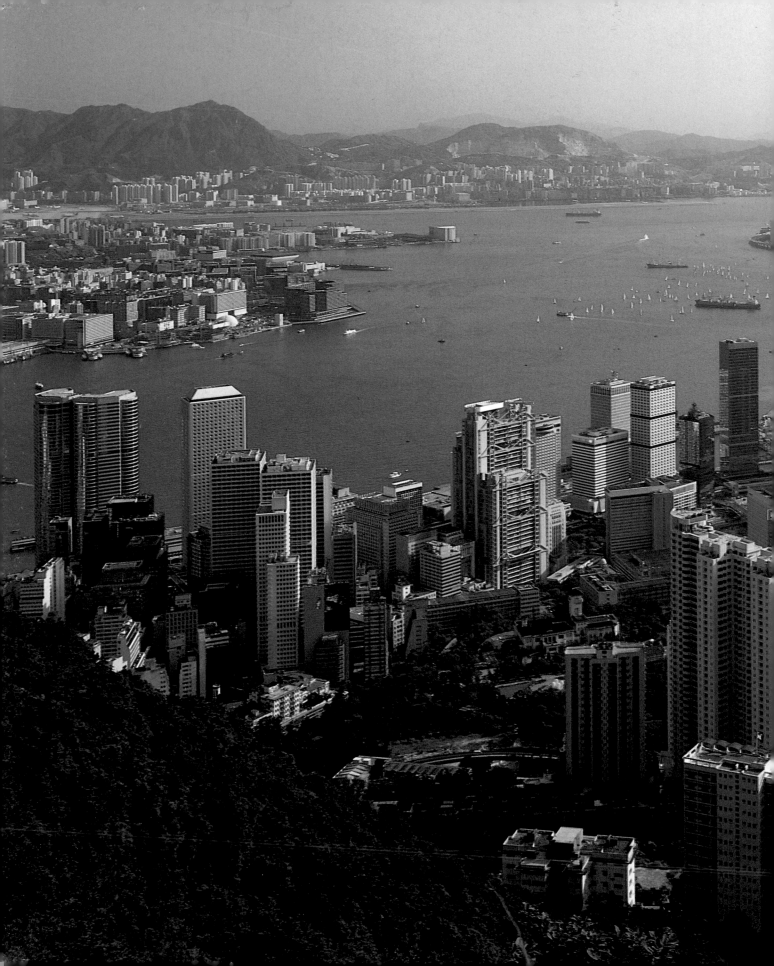

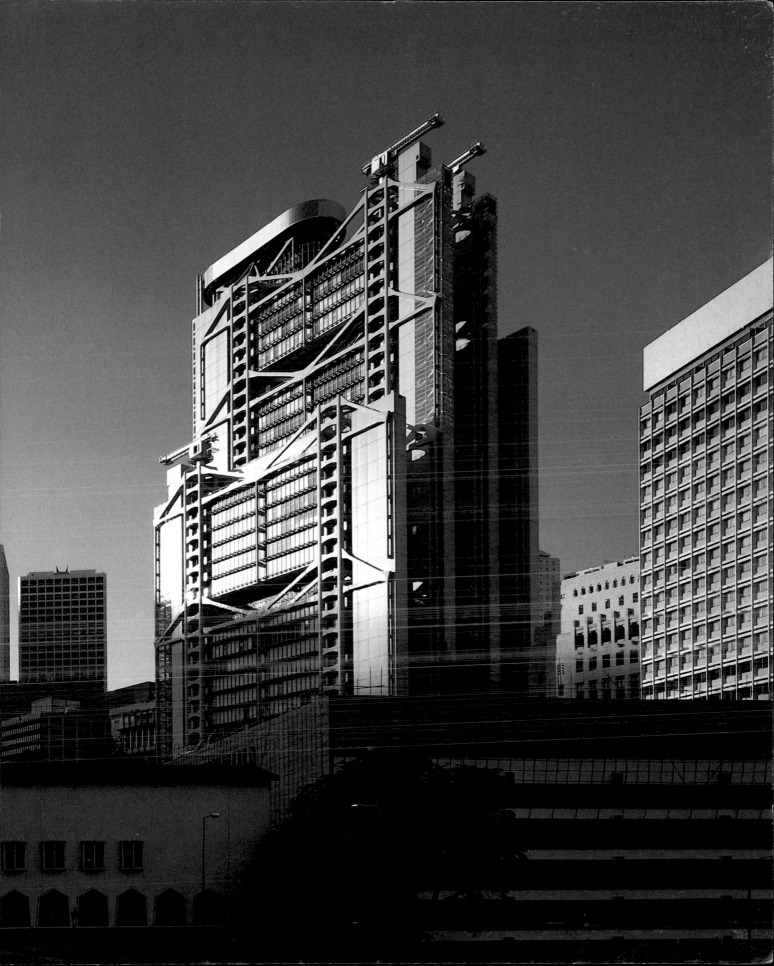

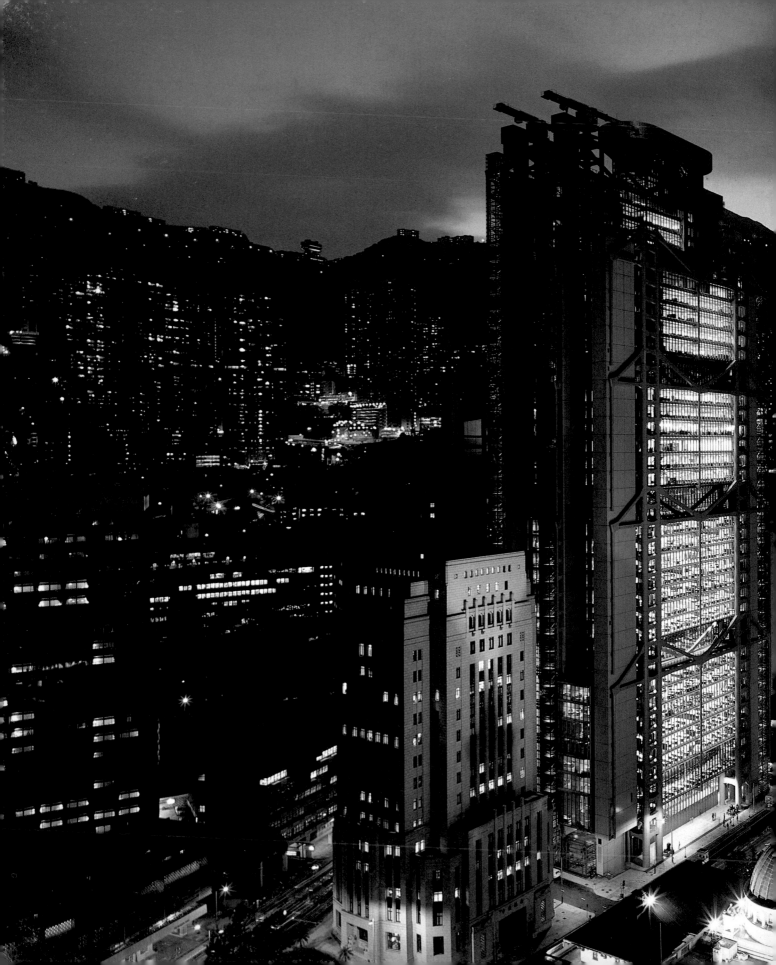

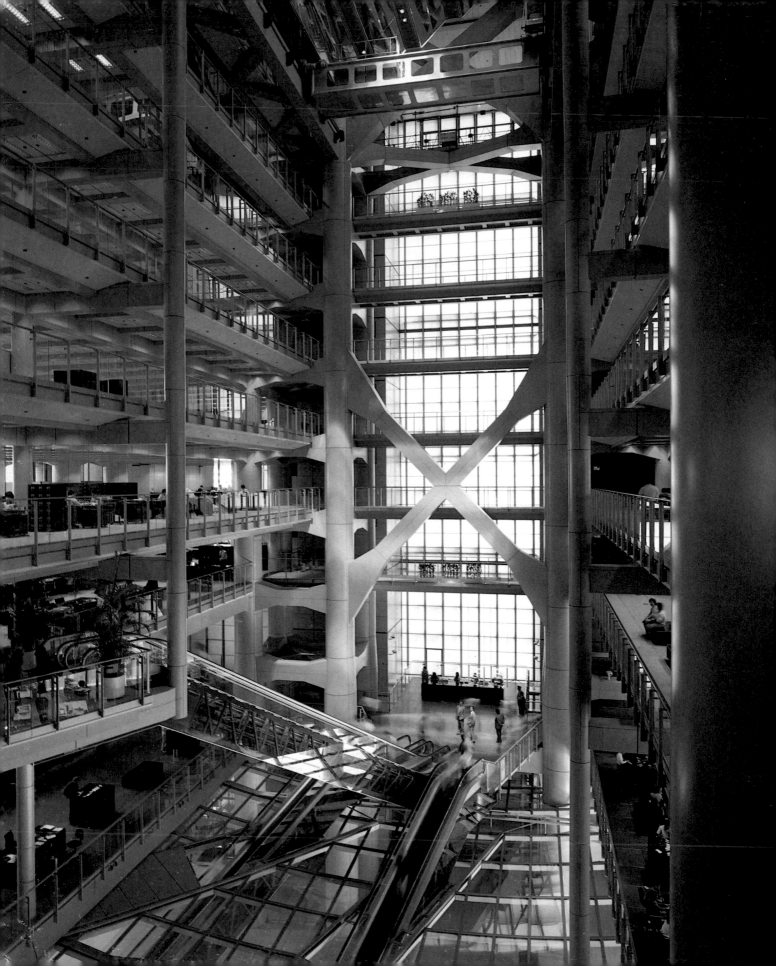

Left *The Hongkong and Shanghai Bank's atrium is flanked on either side by twin rows of office floors suspended from the main structure, leaving unprecedentedly large column-free spaces.* Right *The atrium is topped by a specially designed sunscoop, an array of computer-controlled adjustable mirrors which reflect sunshine from the scoop mounted on the outside of the building (shown here) down into its heart.*

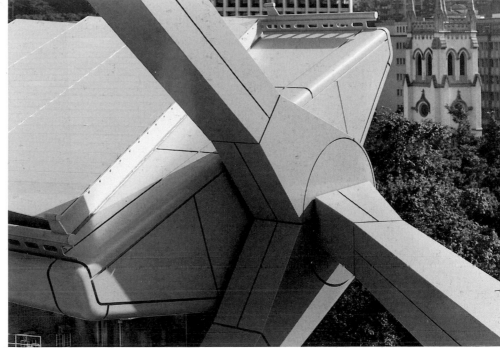

The mighty cross-braces of the Hongkong and Shanghai Bank are powerful presences in the interior, despite their suave cladding.

pectorals, be finished in red, traditionally associated with good fortune, or in a more 'international' neutral shade? (It was eventually decided to opt for the latter.)

Foster's response to the commission amounts to nothing less than the reinvention of the skyscraper in a manner which allows the bank to recapture the lost glamour of the early American examples. A curious characteristic of extreme height in buildings is the tendency that it sometimes has of diminishing them architecturally. They become more like very large household electrical appliances than buildings with presence. The early skyscraper builders combated this problem by treating them as comparable to classical columns, equipped with a base and shaft and topped by an entablature. Reductionist modernism simplified this formula, turning high-rises into boxes, or, in recent decades, into geometrical, vapid mirror-glass extrusions. Typically fronting an empty plaza, with a grandiloquent entrance hall, such towers stacked up floor upon floor of identical accommodation. Philip Johnson's best-known post-modern essay, the New York headquarters of AT&T, does exactly the same underneath its stone-faced broken pediment.

Foster's approach is completely different. Using a unique suspension structure that allows for 100-feet clear span spaces, he has been able to provide a great variety of different types of

space within the main tower, including an atrium at the core and double height spaces at intervals throughout. The building is not a simple rectangle, but is made up of three slabs of different heights, giving the building a plan of different size at different levels. The result is a relatively modest 47-storey structure which has much more than simple height to enforce its claims to attention. It has, first and foremost, the advantage of the finest site on Hong Kong's waterfront, aligned directly across the axis of Statue Square, the business district's last remaining green open space and the colony's only piece of formal civic planning. Amid the claustrophobic web of little streets and the anarchic forests of high-rise towers that dwarf them, it is a civilized oasis. It is physically and symbolically the centre of the colony, housing not only the major banks but also the Hong Kong Club (its original building now demolished, and replaced by a bland tower by Harry Seidler), and the old law courts building.

The square, tightly hemmed in on each side, is open to the harbour front. Almost uniquely among Hong Kong's thickets of closely packed towers, the bank has not just a spectacular view out across the harbour toward Kowloon and mainland China; it also has room in front of it for passers-by to grasp its full height from further away than the usual dizzyingly vertiginous close quarters. Only the occasional tram, a diminutive doubledecker Edwardian

From the side, the Hongkong and Shanghai Bank has the appearance of a series of very slim towers stacked up close together, in sharp contrast to the spreading front and rear faces. This is a view of the east elevation.

survival gliding back and forth against the backdrop of Foster's building, interrupts a sequence of spaces that sweep under the bank at ground level, across a noble granite-floored plaza, across the park and fountains of Statue Square, and on down to the Star Ferry terminal and the waterfront. Foster likes to illustrate the essence of the bank's design with a carefully casual drawing, apparently a child-like doodle, which neatly encapsulates the building as he originally planned it. It shows the tower divided into three slabs of different heights which float clear of the ground; beneath them is the suggestion of a basement. In the top corner is a representation of the sun. Its rays are caught by a scoop, and funnelled down into the atrium of the tower, and then on, through the ground, into the basement of the building.

With the exception of the basement, the diagram describes the completed building exactly. The main banking hall rises for nine floors on either side of a central atrium. The public use the two lower levels and are whisked up by glass-sided escalators that penetrate a glass curtain that cuts across the atrium, but which allows passers-by on the plaza below to look up into the bank. Sunlight is reflected into this space by an array of sunscoops, one attached to the exterior of the building, the other to the top of the atrium. They are each equipped with electric motors, computer-programmed to track the sun, and deliver sunshine to the atrium floor throughout the year. Sadly, the only element from the initial sketch which is missing is one of the most brilliant of Foster's ideas. He had originally planned a glass floor for the atrium at ground level, to allow sunshine to percolate through to the vaults beneath. But in the event, this feature was omitted, and stone substituted. As a result, the deposit vaults, to Chinese investors symbolically one of the most important parts of the bank, are artificially lit.

The bank is made up of clusters of tubular steel columns that support horizontal trusses. Looked at vertically, the building is divided into five zones, each suspended from a double-height suspension truss by a single line of steel hangers, which create 33-metre clear spans on each floor, three times a conventional span. The trusses are supported in turn by steel masts, made up of clusters of four steel columns. In elevation, the building forms three slabs, each defined by the twin mast structures that stand at either end.

The profile of the tower is complicated by the regulations of the Hong Kong Building

Ordinance Office. Originally devised for simple low-rise structures in the 1920s, with the aim of preventing the overshadowing of narrow city streets, these have not been revised to take account of changed conditions. The design was also affected by the demand of the local fire code for protected spaces on the building to act as refuges in case of fire, and by an overall height limit dictated by the emergency descent flight path of the neighbouring Kai Tak airport. Taken together these three sets of regulations have had the effect of limiting the height of the front and rear slabs of the bank. Only the central section rises to the full height of 180 metres. The front facade, overlooking Statue Square, is 35 floors high, and the rear slab has 28 floors. To complicate the picture further, extra setbacks have been introduced into the east side of the building, again because of setback provisions within the building code.

The net effect of all this is to ensure that very few floors are identical in plan. Only the lowest floors are conventionally rectangular, and even these are interrupted by the atrium void which rises up to the level of the first of the suspension trusses. Above this level, the building becomes progressively narrower, reflecting the hierarchy of the building's occupants, and culminates in a penthouse apartment for the chairman. One of Foster's priorities was to escape from the tyranny of the central lift core, a feature which in conventional high-rise buildings isolates each floor and makes for impersonal buildings, with long irritating waits for lifts. Foster's suspension structure, devised with the engineers Ove Arup and Partners, obviates the need for any kind of central structural core. Instead lifts are positioned at each end of the structure and their number is greatly reduced from the standard level of provision by Foster's extensive use of escalators. Visitors and workers circulate through the building by taking a lift to whichever of the five double-height spaces is nearest their eventual destination and then moving on by escalator. Moving around the building in this way enables the spectator to experience the tower as a sequence of spaces, from the double-height dining hall in which diagonal structural bracing stretches away in both directions, up to the higher senior staff floors – from which setbacks in the profile of the side elevations allow views across blue sky to the exterior of the building's further wings – and finally on up to the helicopter pad on the roof.

The ascent into the building, by way of a slender escalator rising up at an angle into the atrium, exploits the situation's full potential for

drama. The atrium itself, with its subdued colour scheme of whites, greys and polished marble, its translucent glass screens, and its views out toward the harbour, is dignified and powerful. From the exterior the carefully considered extruded aluminium window mullions, when viewed from certain angles, appear to close up, giving the building an appearance of depth and solidity not normally associated with glass-curtain walls. From other angles, the building becomes transparent once more. From its narrower side elevations, the impact is entirely different. The stepped profile of slabs of varying heights leaves the towering cross-shaped structural bracing clearly visible: a powerful celebration of engineering skill. Most important of all, the bank is a humane and civilized place to work. It is a popular visual landmark, with the resonance of the Chrysler Building or the Eiffel Tower, and it has been created with a lightness of touch that makes it the most unintimidating of towers.

Building the tower in less than five years represents an extraordinary technological achievement that depended on an unprecedented degree of prefabrication, as well as on a workforce of up to 2000 working in 24-hour shifts at some periods. The structure itself was fabricated in England and the delicate

aluminium cladding, specially tailored for the bank, was made in America. Prefabricated capsules containing washrooms, air-handling equipment, electrical and other services, were assembled in Japan. A specially developed suspended floor system allows all power and telecommunications circuits, as well as airconditioning input and extracts, to be distributed through floor outlets.

Stylistically, the bank is an even braver achievement. At a time when America has plunged into a bout of art deco revivalism and melodrama, Foster has struck out on his own in an altogether different and more rigorous direction. The Hongkong and Shanghai Bank is genuinely a high technology building: its cladding is computer-cut, production-line fabricated fluopolymer coated aluminium. Its flooring is lightweight aluminium honeycomb sheet, like that used in airliners, and its structural design was developed using the most advanced computer analyses and modelling techniques. But to discuss the bank purely in technological terms is to miss the point. Foster has been able to deliver a sustained virtuoso architectural performance at every level, showing himself capable of achieving a craftsmanlike joy in a high-precision finish (as at earlier buildings such as the Willis, Faber and Dumas office), and a successful large-scale architectural and urban composition.

In the ten years after the Olivetti training school at Haslemere opened in 1972, the only new design that James Stirling and Michael Wilford were able to complete was the Southgate housing project in Runcorn, the tail end of an earlier contract. The previous decade had seen a steady stream of Stirling buildings, enough to record a continuing development of his ideas about architectural expression. But in the 1970s, just at the moment when Stirling seemed set on the start of a new direction in one of his periodic stylistic oscillations, with the designs for Derby and St Andrews, work was cut short. There were compensating professorships, at universities from Dusseldorf to New Haven, and still-born projects for locations from the Arabian Gulf to Rotterdam, but a frustrating lack of actual building to test his new discoveries.

It was a lack which clearly weighed increasingly heavily on Stirling as he entered his fifties. In between the regular invitations to enter architectural competitions that at times alone provided a motive for continued activity in the Dickensian warren of Stirling and Wilford's London offices, a much-depleted team of

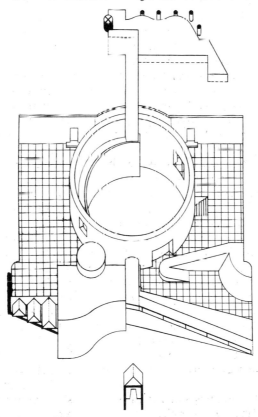

A diagrammatic view of Stirling and Wilford's Staatsgalerie in Stuttgart, completed in 1985. A requirement of the competition brief was the inclusion of a pedestrian route across the sloping site. It winds its way through the open drum at the centre of the museum and down a series of ramps into the street below (bottom).

Opposite and overleaf The entrance forecourt of the Stuttgart Staatsgalerie sets undulating glass and brightly coloured handrails against massive masonry blocks.

assistants found themselves put to such navel-contemplating exercises as the revision of the eighteenth-century plan of Rome by G.B. Nolli to include the entire oeuvre of Stirling's earlier schemes, both realized and unrealized, and the valedictory rendering as crumbling ruins of such cancelled projects as the Columbia chemistry building.

From this dispiriting downward spiral that had some people making comparisons with the career of Mackintosh, the other distinctive architectural talent of this century to have been born in Glasgow, the enthusiasm of the West Germans for architectural competitions provided a timely escape route. There were two false starts. Stirling and Wilford were unsuccessful in competitions to design the Wallraf-Richartz Museum in Cologne, and the Northrhine Westphalia Museum in Dusseldorf. But in 1977 they defeated nine German and three foreign architects to win the commission to design a new extension to the Stuttgart Staatsgalerie. In many ways the Stuttgart scheme grew out Stirling's preoccupation in the

1970s to find ways to start healing the damage done to European cities by post-war reconstruction. Both of the earlier German schemes addressed this issue, by attempting to create monuments that at the same time allowed for the preservation of existing buildings, and which by their urbanistic planning were able to introduce a renewed sense of order and humanity to the city.

From the unsuccessful Dusseldorf project came the most striking invention of the Stuttgart design, a huge drum, functioning as both an outdoor space and a circulatory device. But despite the manifestly civilizing impulses behind Stirling and Wilford's Stuttgart design, it at once became notorious in Germany, as much for the violence of the reaction against it in some circles as for any real doubts about its substance. Gunther Behnisch, the architect of the Munich Olympic stadium and an unsuccessful participant in the Stuttgart competition, was the most vociferous in his objections to Stirling's design, and he, together with Frei Otto and others, joined in a press

The central drum of the Stuttgart Staatsgalerie succeeds in providing an outdoor space that is popular and useful, a rare achievement in post-war urban planning. The drawing below shows how parking at the Stuttgart Staatsgalerie is banished below ground, providing a raised level for the rest of the building, whose height is limited to that of the adjoining original museum building (left).

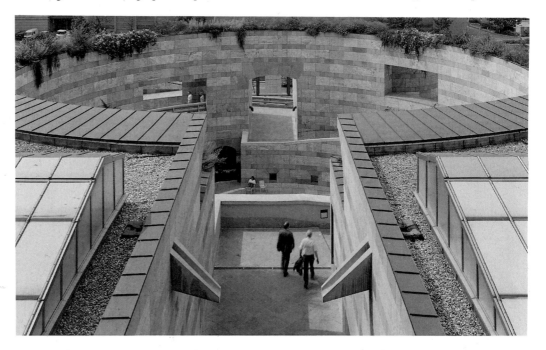

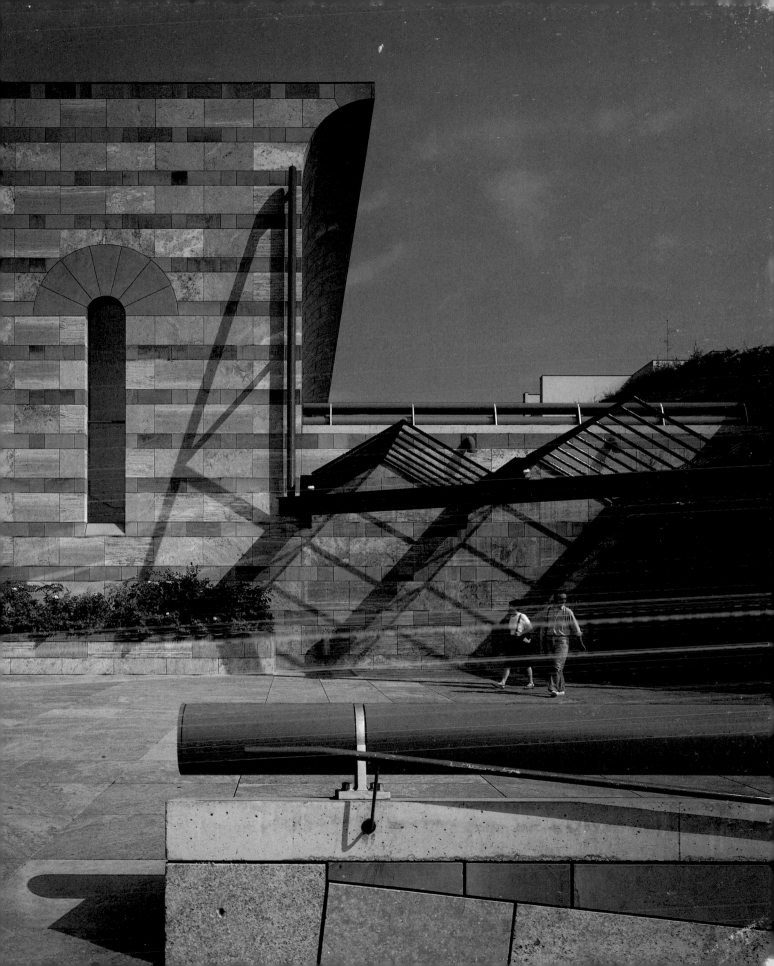

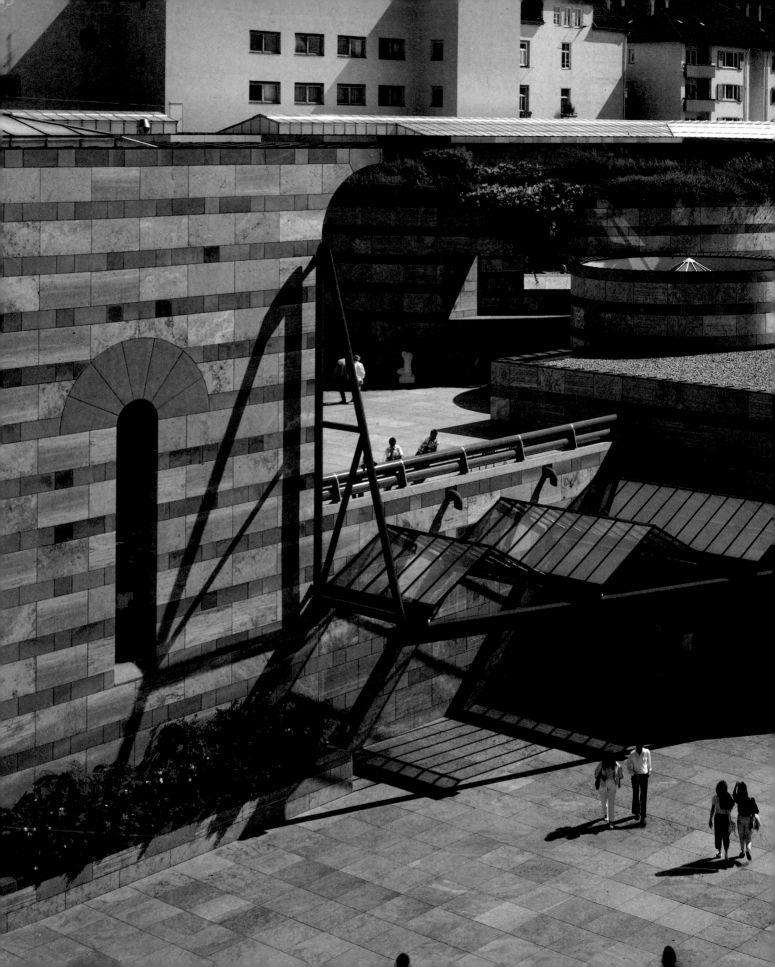

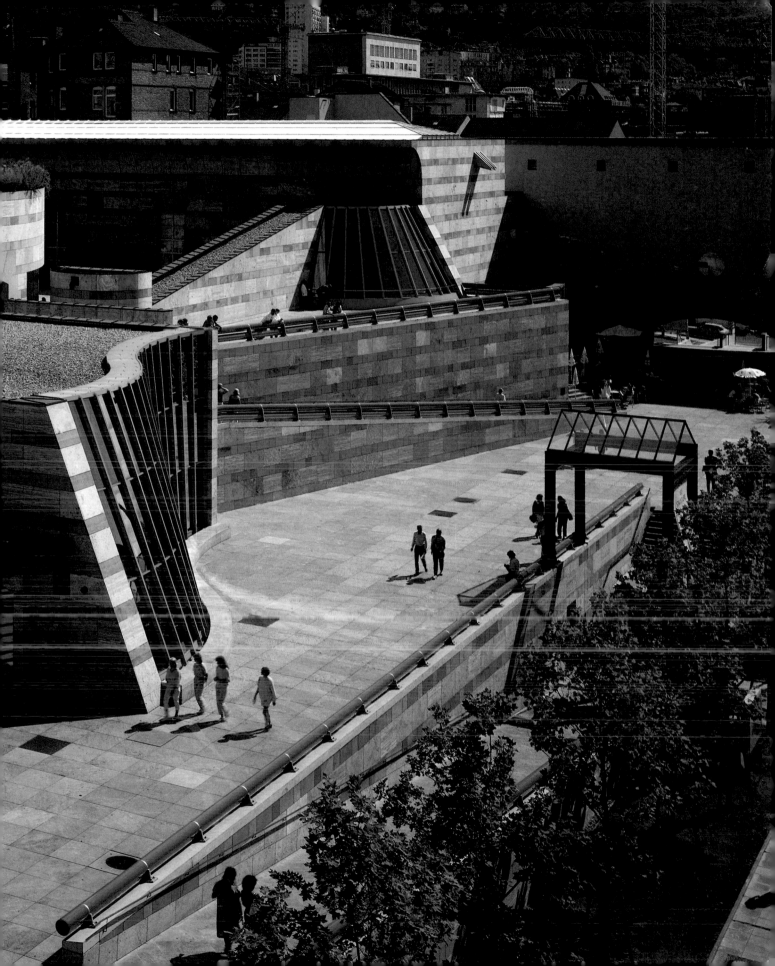

Left *The interiors of the galleries of Stirling and Wilford's extension to the Stuttgart Staatsgalerie evoke a nineteenth-century atmosphere by the architects' use of an enfilade layout and pedimented doorways.*

Right *Stirling's plan for the Staatsgalerie has inevitably invited comparison with Schinkel's Altes Museum in Berlin; however, Stirling's drum is open to the sky, whereas Schinkel's is an internal space. And Schinkel has a formal facade, a feature which Stirling omits.*

campaign against it. Stirling had produced a collage of architectural fragments ordered by a plan that is more a commentary on Karl Friedrich Schinkel's Altes Museum in Berlin of 1824 than a descendant of it. At public debates within Stuttgart the scheme was attacked as overblown, monumental, even fascist, by architects who clearly felt threatened by what they saw as Stirling's revision of modernist orthodoxy. Behnisch, a former prisoner of war in England, was the most outspoken in his equation of classical forms with authoritarian symbolism. He called Stirling's design academic and inhuman. In its place he argued that architecture appropriate to the democratic ideals of a free society should be abstract and indeterminate, 'avoiding representation, monumentality, and the pursuit of the art object'.[1]

Stirling maintained an ironic detachment throughout the row, but did confess himself 'sick and tired of boring, meaningless non-committed faceless flexibility, and the open endedness of so much present day architecture'.[2] Copies of some of the more vituperative correspondence attacking the design are rumoured to have found a place in a capsule buried beneath the museum's foundation stone, together with one of Stirling's trademarks, a voluminous blue shirt. But by 1984 the controversy had died away. It had become perfectly clear that Stirling was not the

apostate modernist that his opponents had assumed. Rather he had carried off with remarkable skill a design that went a long way to reintegrating modernism within the continuing tradition of architectural history.

As a piece of architecture, the Staatsgalerie achieves much of its power by the way in which it succeeds in addressing so many issues at such different levels. Most importantly perhaps, the museum has been a huge popular success. It has capitalized on the transformation that has overtaken museums everywhere in the last two decades, turning them from didactic academic retreats, housing collections in conditions appropriate for scholarship or connoisseurship, into public spaces. Museums have become substitutes for more traditional civic spaces and they attract people as much for the opportunity to experience a space within which they can feel some sense of participating in civic life, as actually to see an exhibit within a collection.

To many, the sheer number of visitors provides a measure of success. With nearly one million visitors in the first six months after its opening, the Stuttgart Staatsgalerie has gone from fifty-second to first place in the table of attendances at German museums. Yet this has been achieved without sacrificing the demands of curators for an unassertive but dignified setting in which to display works of art. With its enfilade of galleries opening one from another, the museum's interior is in part a deliberate

Left *As well as museum galleries, the Staatsgalerie contains the Bauhaus theatre archive, a library and several performance spaces, of which this is one.*

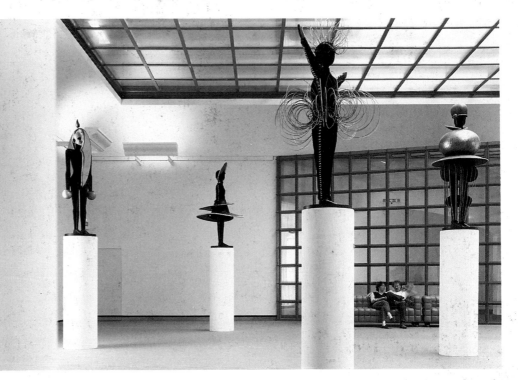

Right *Stirling and Wilford's treatment of the gallery interiors at Stuttgart includes such traditional features as coved ceilings, together with rather more light-hearted touches, notably the use of a floating section of cornice moulding as a light fitting.*

evocation of a nineteenth-century museum, a type which Stirling has said that he finds more convincing than twentieth-century models.

At the urban level, the gallery's monumental drum, the focus of a pedestrian route that cuts diagonally across the site, creates a new kind of civic space for Stuttgart with something of the magnetism that the Place du Beaubourg has had in Paris. 'I thought that it was important to try and preserve the identity of this corner of Stuttgart, a city which has been so damaged by war and post war rebuilding', said Stirling in his speech at the topping-out ceremony for the Staatsgalerie. 'Some think it is too monumental, though I believe that monuments are an essential element in a city. A city without monuments would be no city at all. Others thought that by keeping the old buildings on the Eugenstrasse [the street that flanks one edge of the site] we would be compromising the design of the new building. But compromise is the essence of architecture. Compromise with the site, with user requirements, costs and technology.'[3]

Stirling's architecture addresses not only the public, but also a specialized audience of architects and critics. He has avoided polemical content in his public utterances; instead Stuttgart itself is to be read as an architectural commentary, containing erudition, wit and broad comedy. It is a collage of elements from different periods deployed by Stirling in a

manner that he believes enlightening or appropriate for a building that is a museum, and for such a building location in the specific context of Stuttgart. Nearby is the Weissenhofsiedlung's encyclopaedic collection of modernist set pieces, a housing programme designed by Mies van der Rohe and incorporating works by Le Corbusier and the Dutch architect J.J.P. Oud. Modernism is therefore an inescapable part of the Staatsgalerie's context.

Stirling rehearses the classical nineteenth-century museum plan of the Altes Museum, but transforms it. Instead of focusing the plan on a domed central space, Stirling has placed a drum outside the museum, floating disassembled outside its walls, tied down only by a circulation route. The regularity of the permanent collection's galleries run into the Corbusian free plan of the temporary exhibition spaces, as Alan Colquhoun has pointed out in the *Architectural Review*.[4] The disparate elements of the museum, lacking any facade other than a steel aedicule, are held together by the grammatical rules for the use of materials that Stirling has devised for himself. Entrances are denoted by steel and glass constructivist canopies, for example. Rules apply for the scale of their provision: three modules over the gallery entrance, two over the theatre entrance, one over the staff entrance. Another hierarchy applies to the provision of windows: over the

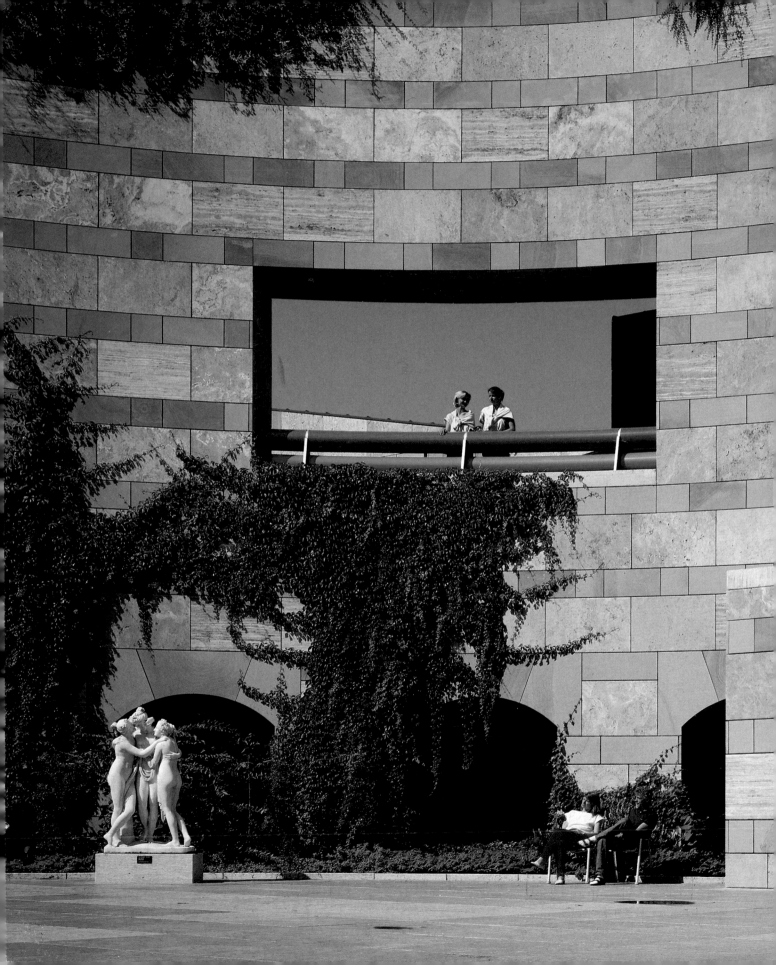

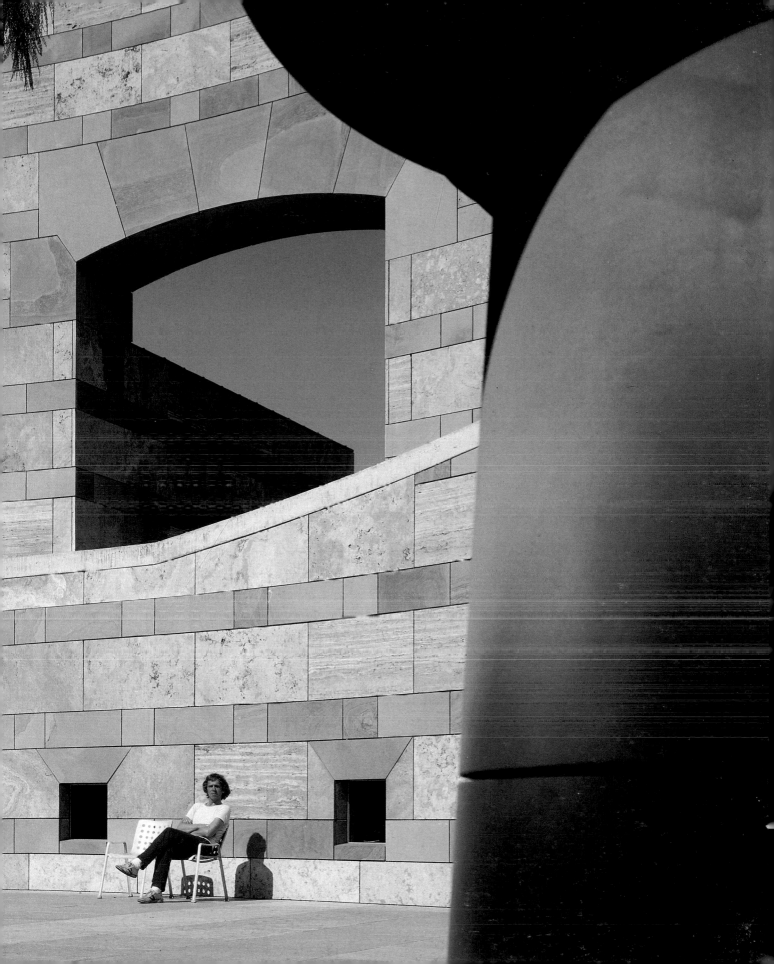

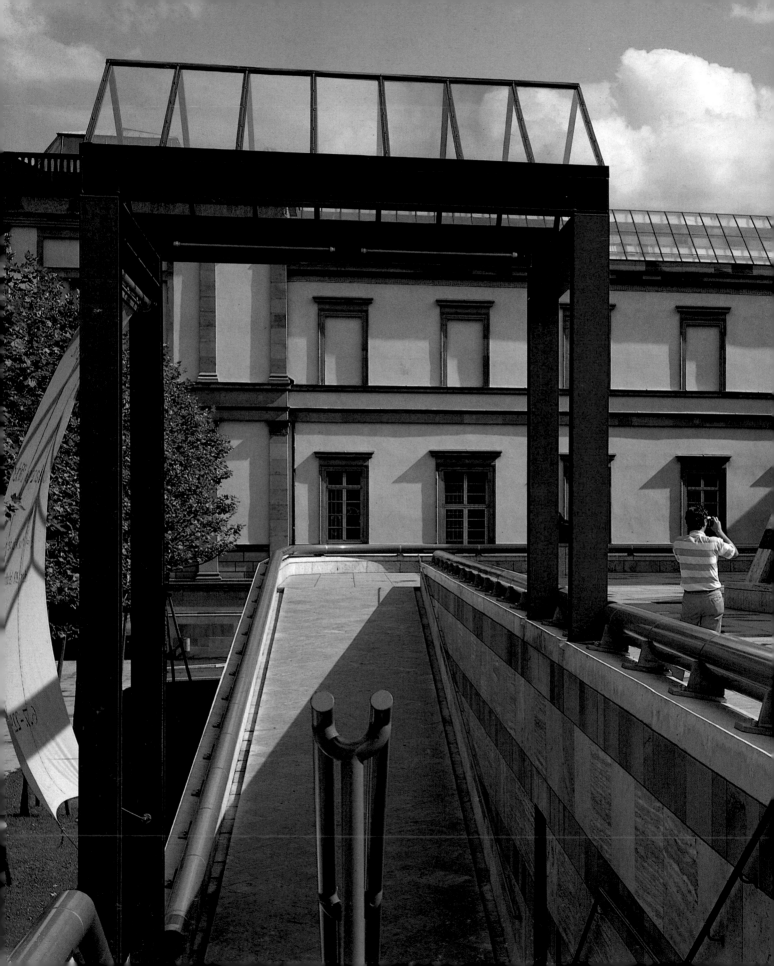

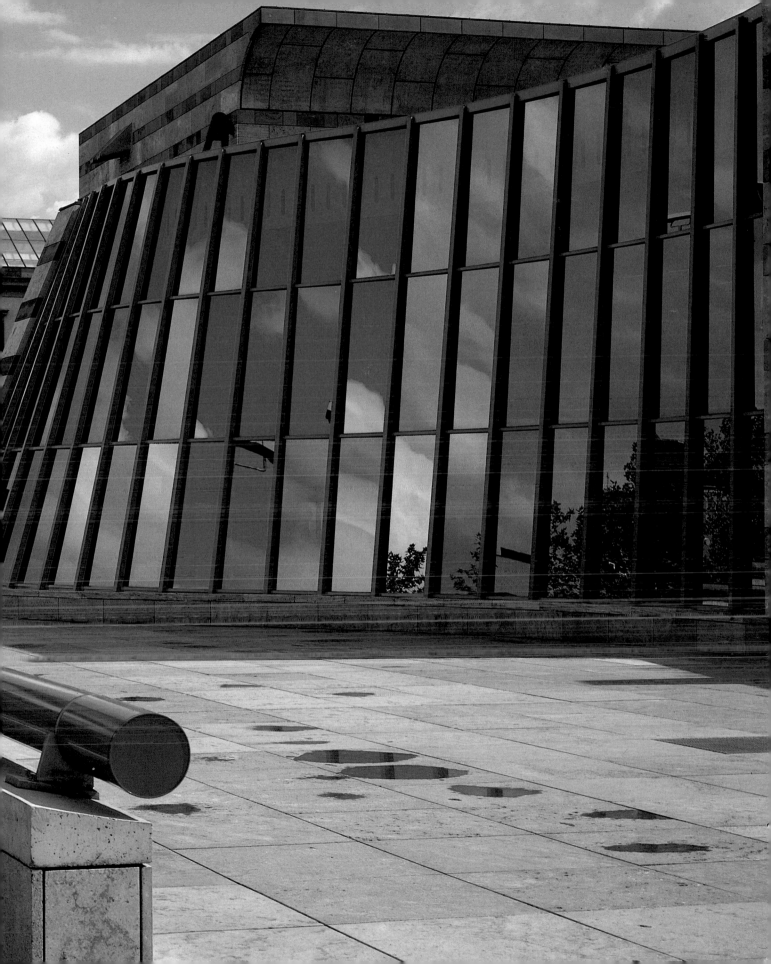

Left Designed in 1980, and completed in 1986, Stirling and Wilford's Clore Gallery will accommodate the Turner Bequest, previously divided between the Tate and the British Museum. This is Stirling's first major building in central London and the beginning of his masterplan for the expansion of the Tate. This is a view from the Tate's portico.

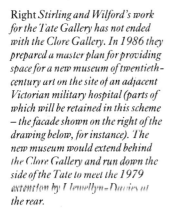

Right Stirling and Wilford's work for the Tate Gallery has not ended with the Clore Gallery. In 1986 they prepared a master plan for providing space for a new museum of twentieth-century art on the site of an adjacent Victorian military hospital (parts of which will be retained in this scheme – the facade shown on the right of the drawing below, for instance). The new museum would extend behind the Clore Gallery and run down the side of the Tate to meet the 1979 extension by Llewellyn-Davies at the rear.

But when in 1978 Lloyd's was facing up to the troubling prospect of outgrowing its underwriting room for the third time in fifty years, it was in the mood for more radical solutions. It had already taken the decisive step of moving a substantial part of its clerical staff to a computer centre in Chatham, housed in a new building by Arup Associates. To ensure that Lloyd's continuing growth did not force it to make yet another quick move out of any new underwriting room, its governing council went to the Royal Institute of British Architects for help in choosing a suitable architect.

The then president of the RIBA, Gordon Graham, who two years later was to offer the Hongkong and Shanghai Banking Corporation similar advice, recommended a new form of limited competition. A shortlist of architects, selected from a study of more than forty firms, was invited to submit observations on the best strategy for dealing with Lloyd's growth over the next fifty years. The intention was to allow Lloyd's to select not a specific design to which they would be committed before they had time to develop a relationship with its architect, but instead to choose an architect with whom they believed they would be able to work, and to draw up a detailed design thereafter. Apart from Rogers, at that time still in partnership with Renzo Piano, the shortlist included Norman Foster, Arup Associates, I. M. Pei, and a French and a Canadian practice.

Lloyd's importance as a financial institution in London is comparable only to that of the Bank of England or of the Stock Exchange. It has an essential role to play in the maintenance of London as the world's biggest financial centre. Thousands of jobs, and a huge part of Britain's crucial earnings from the 'invisible' export of financial services, depend on its

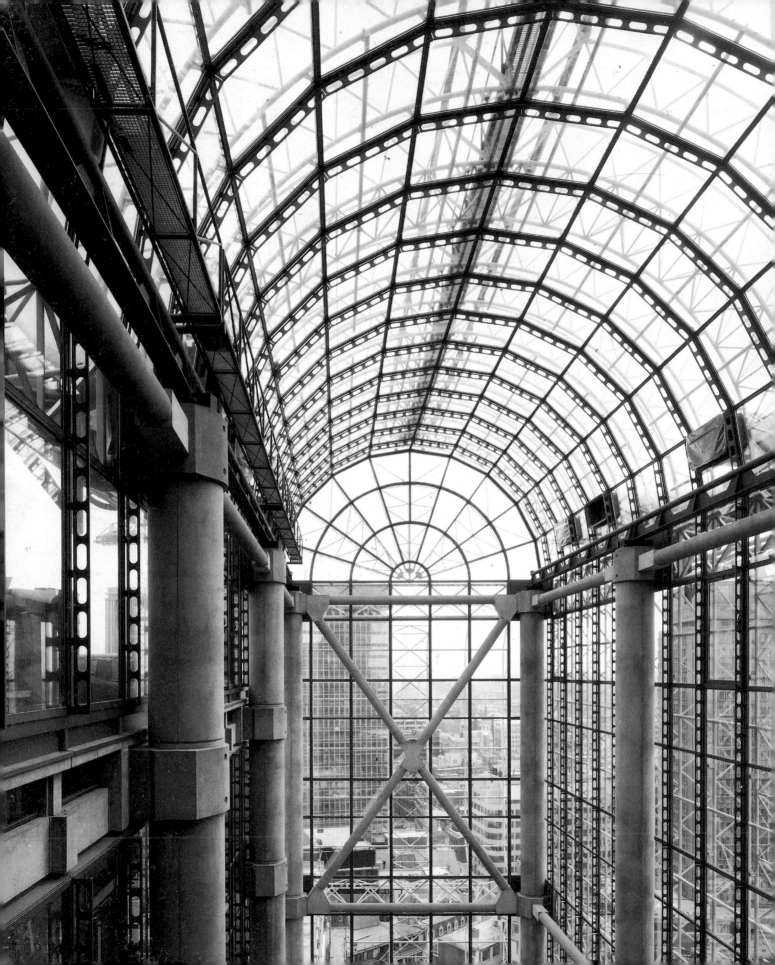

efficient functioning. Its very presence underpins property values within the City of London: some office rents are measured in direct proportion to their proximity to it. Yet until reforms of its administrative practices were made in the 1980s, Lloyd's was still run in a quintessentially British manner to give the appearance of a gentleman's club, shaped by the traditions of the original coffee house after which it is named. It is in essence a market place, a forum in which underwriters organized into syndicates set up stalls and gather to do business with visiting insurance brokers looking for cover for their clients. Like any market, personal contact between customers and dealers is vital. That fact has ensured that Lloyd's has continued to operate from a single underwriting room despite the escalating application of electronic communications.

The rising number of underwriters wishing to work at Lloyd's put ever-increasing pressure on the limited space within the old underwriting room. The essence of Rogers's Lloyd's design, therefore, is an arrangement that will allow for any foreseeable growth to be accommodated without compromising the single-space underwriting room. The centre of the building is a twelve-storey-high barrel-vaulted atrium

that rises up through the middle of a series of regular rectangular office floors (an arrangement that is strikingly close to that of the Hongkong and Shanghai Bank). The underwriting room is on the principal floor, just above street level, and future growth will take place by spilling over into the lower levels of office space around the atrium, which is criss-crossed by escalators. Surrounding the atrium are six towers, containing lifts, stairs, washrooms and service ducts. The towers are expressed as the dominant elements in the overall composition, a measure of Rogers's commitment to Louis Kahn's predilection for 'served' and 'servant' spaces. Rogers explains the division between the two as follows: 'whereas the frame of the building has a long life expectancy, the servant areas, filled with mechanical equipment, have an extremely short life, especially in this energy critical period'.[5]

Rogers's original scheme for the structure, developed with the engineers from Ove Arup and Partners who had also worked on the Hongkong and Shanghai Bank, was to use a tubular steel system filled with water (suitably laced with anti-freeze) that would do away with the need for any applied fire proofing. It was a method that had earlier been applied

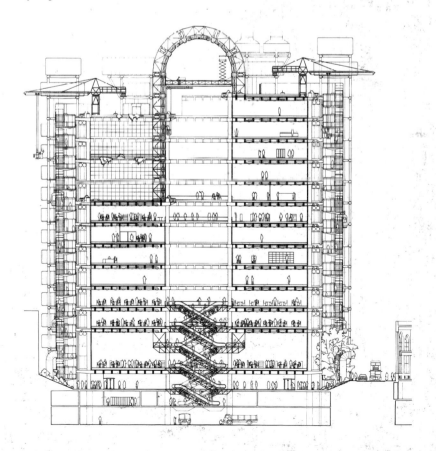

In cross section, the Lloyd's building has parallels with Foster's Hongkong and Shanghai Bank. On each side of the office floors that surround the central atrium are towers containing stairs and services that stand outside the main fabric of the building. The dealing room shown in plan on page 180 is the floor immediately above ground-level.

The dealing room in Rogers's new
Lloyd's building. Future demand for
space will be met by extending the
dealing floor upwards onto the lower
tiers of the atrium which are linked to
this floor by escalators, meeting the
requirement of Lloyd's that all its
dealing activities should be kept in a
single space.

successfully on a more modest Arup building in London. But in the event it proved impossible to secure the necessary technical approvals within the time limit set by Lloyd's, and instead a concrete structure was adopted. With its smoothly finished circular members, the structure looks as if it could be fabricated from steel, were it not for its matt finish, which ensures that it stands in distinct contrast to the aluminium cladding on the services towers.

Rogers makes the analogy with a Meccano set that he first used in connection with the Beaubourg. He sees Lloyd's as a flexible kit of parts, continually moving and changing, with the mechanical equipment in particular designed to sit loosely within the framework of the towers, easily accessible for maintenance, and replaceable in the case of obsolescence. According to Rogers, 'the key to this changing juxtaposition of parts is the legibility of the role of each technological component, which is functionally stressed to the full. Thus one may recognize in each part, its process of manufacture, erection, maintenance, and finally demolition: the how, why and what of the building. Each single element is isolated and used to give order. Nothing is hidden, everything is expressed. The legibility of the parts gives the building scale, grain and

shadow.'[6]

But Rogers's enthusiasm for the ad hoc expression of the technological content of buildings, which is increasing all the time with the ever-higher information-handling content of modern office buildings, is tempered at Lloyd's by an attempt to address the city around it. Rogers is perfectly open about using the picturesque possibilities of expressing the distribution of services in free-standing towers as a gesture toward Lloyd's setting: 'Our intention in the design of the Lloyd's building has been to create a more articulated, layered, building by the manipulation of plan, section and elevation, in a way that would link and weave together both the over-simplified twentieth century blocks that surround it, and the richer, more varied architecture of the past.'[7] Rogers has often compared the Lloyd's building with the Gothic exuberance of George Edmund Street's law courts in the Strand, which also use stair towers to create a dynamic, fragmented composition.

Rogers has taken a path which steers between extremes: the straightforward expression of the 'how, why and what' of the building, and the response to a setting that makes formal demands. One result of that compromise has been that Lloyd's has ended up

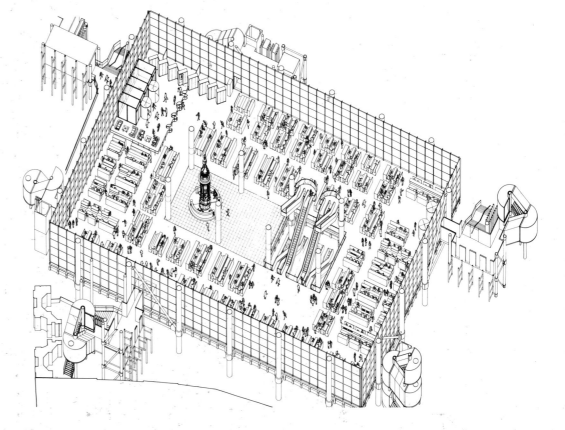

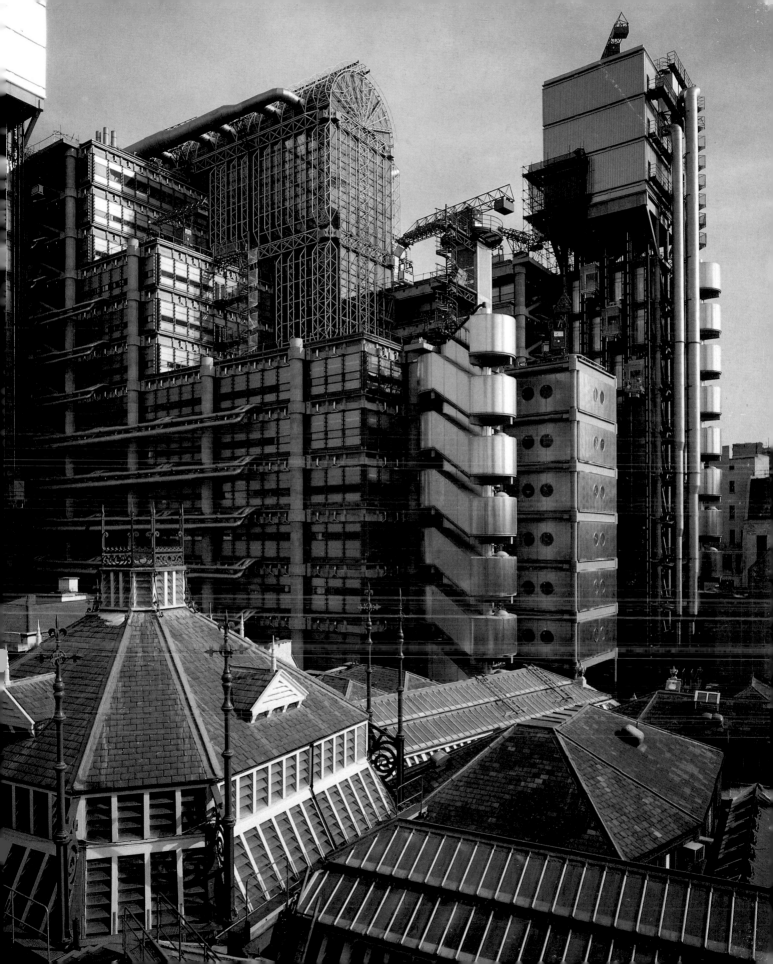

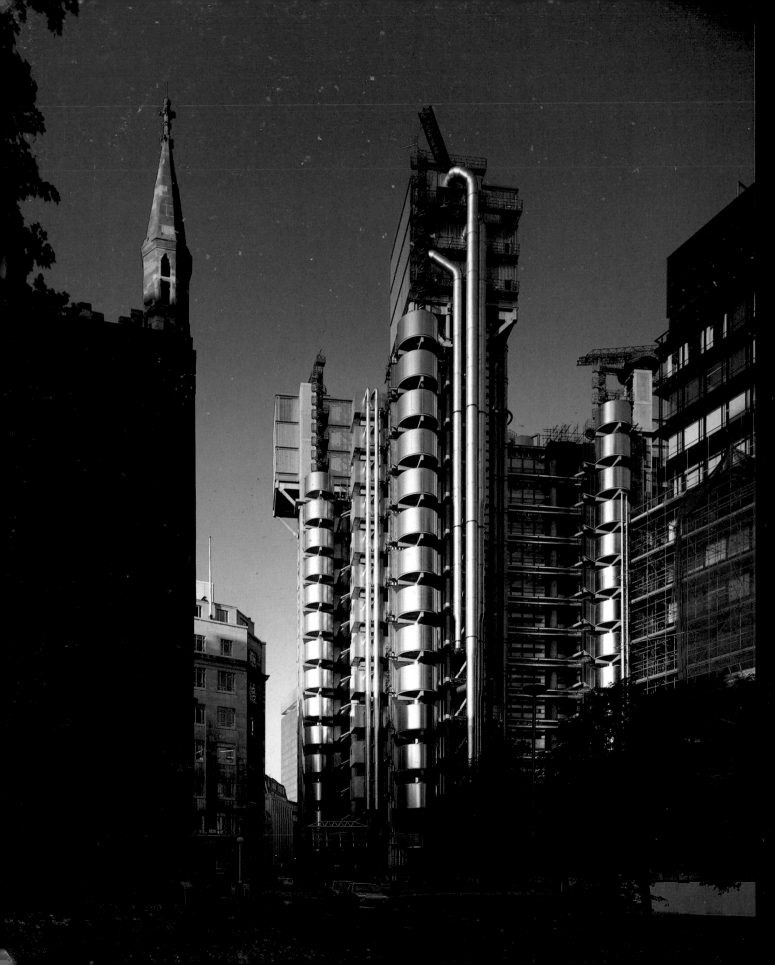

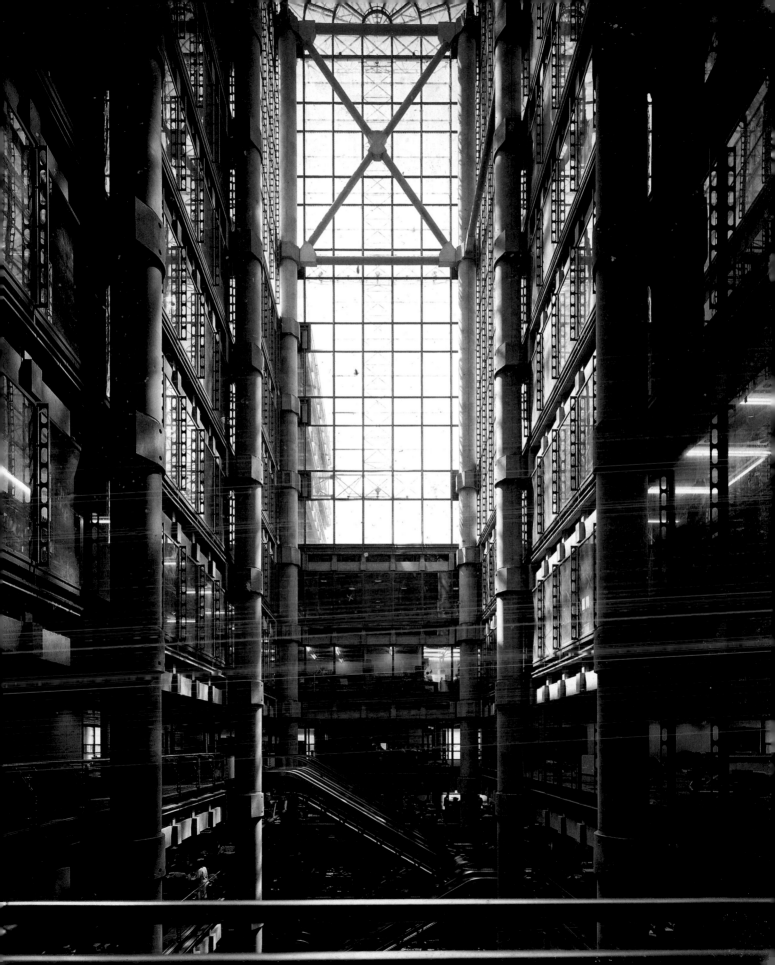

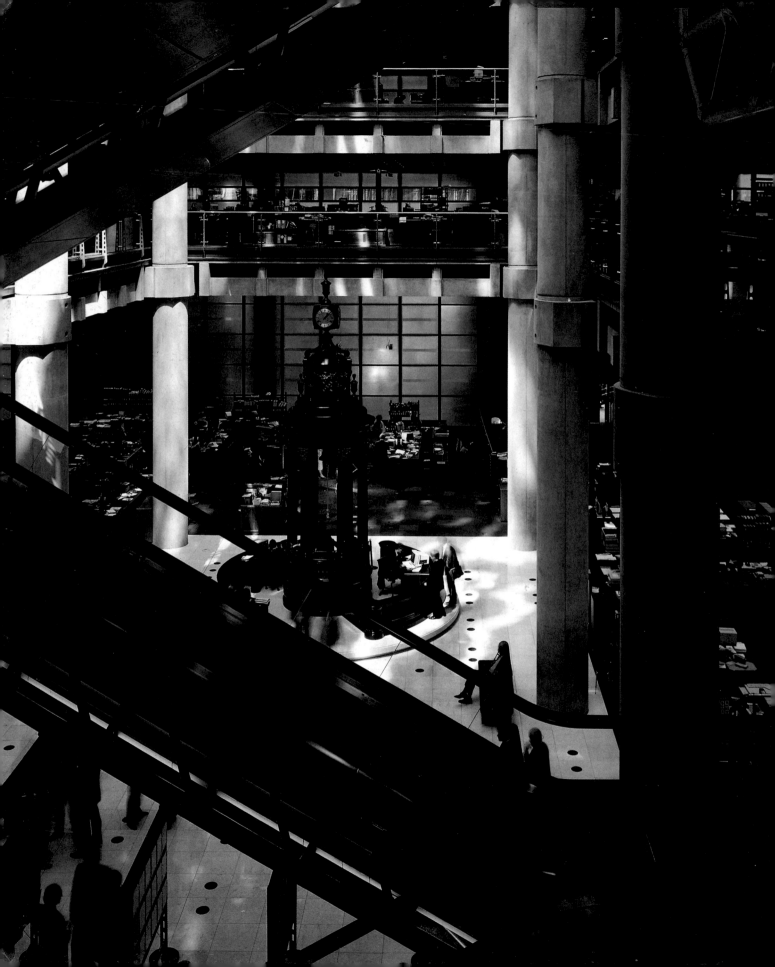

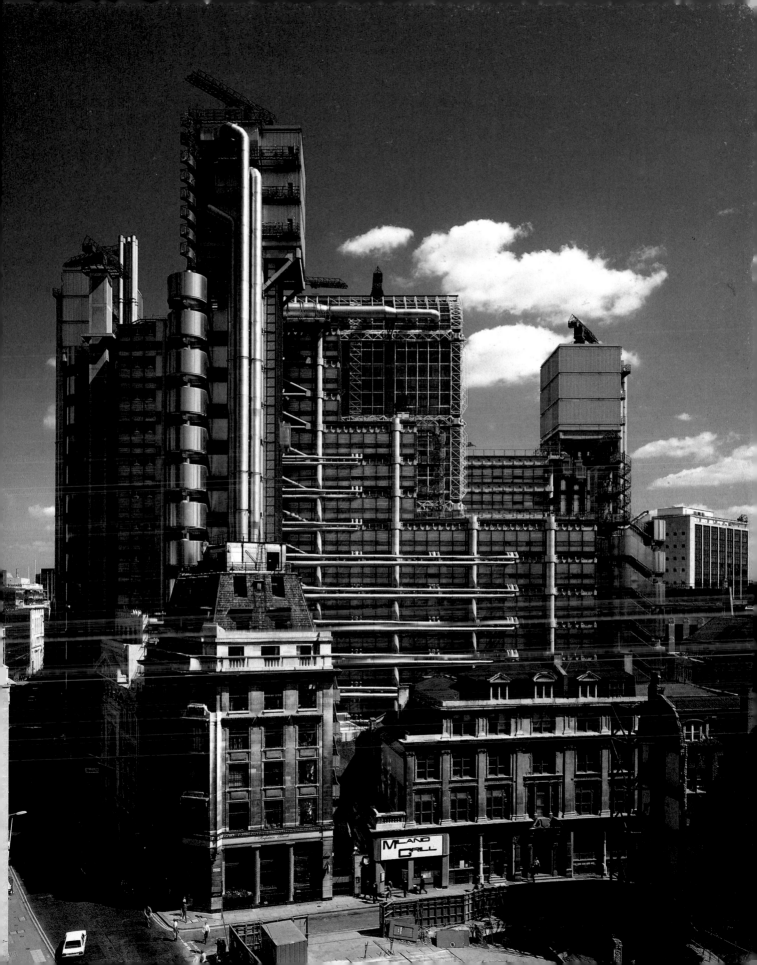

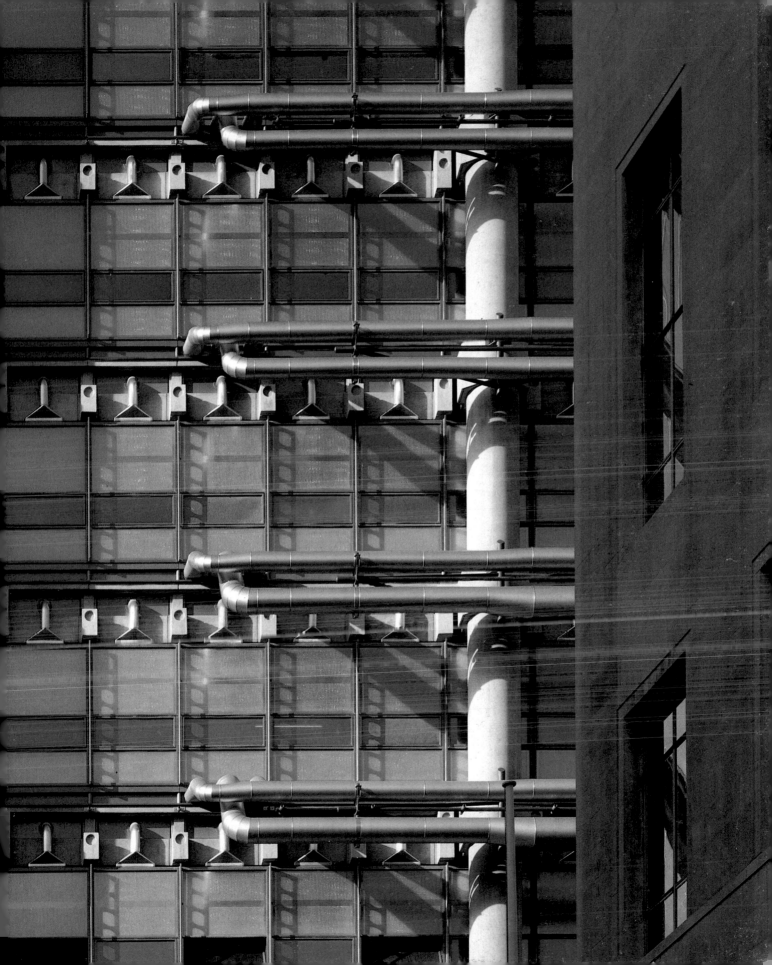

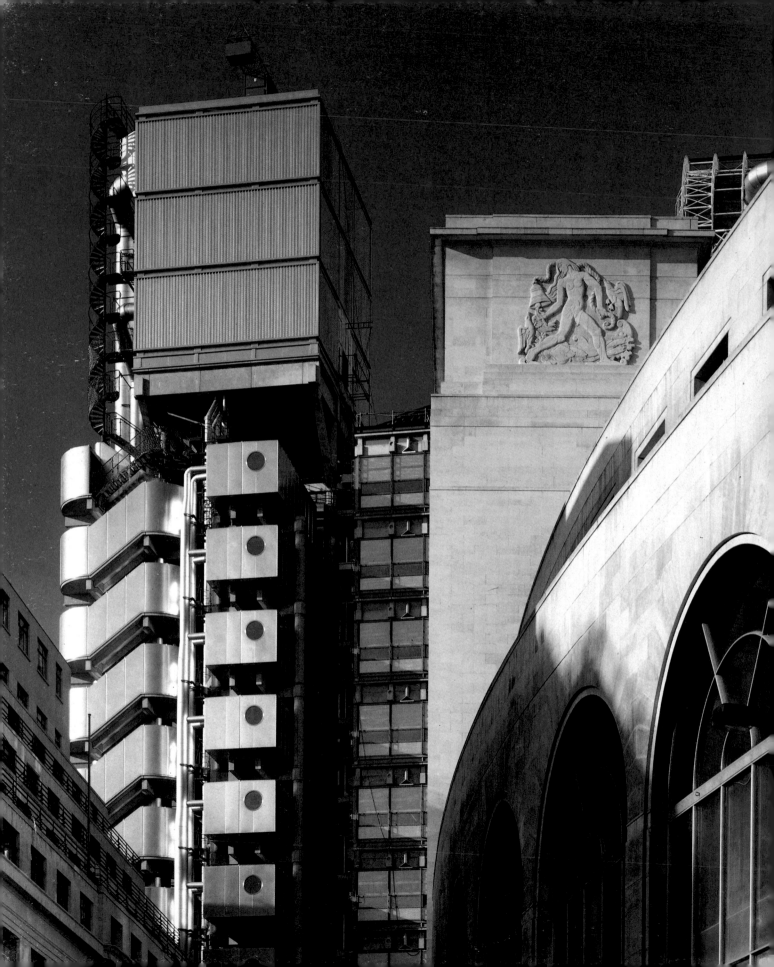

Left *The new Lloyd's building overshadows the old, designed by Sir Edwin Cooper (right). The series of metal cubes with portholes contains washrooms, to the left of which are the escape stairs with a block containing services above.*

Right *An early version of the Lloyd's building. The service towers became considerably more prominent to meet the vastly increased demands made of them by technological advances introduced only after construction had started.*

with a completely different character when seen from different aspects. From a point immediately adjacent to the Commercial Union tower, the most prominent Mies-inspired building in London and clearly one of the buildings that Rogers is thinking of when he talks of the lack of legibility of such architecture, Lloyd's does indeed present a carefully composed transition between the scale of the large 1960s blocks and the richer, more complex, and much smaller Victorian stone buildings of the City. The delicacy and refinement with which the service towers have been treated, the polished glitter of stainless steel and aluminium and the subtlety of the dimpled glass walls make this an urbane and civilized building.

But from other angles, the mechanistic quality of the building which has alarmed some critics predominates. This is especially so in the view from the glass-roofed Leadenhall Market immediately to the rear of Lloyd's. From there the building presents so much visual information, so much of the 'legibility' of which Rogers speaks, that the result is too powerful to accept comfortably. So many strident elements – lifts, airconditioning ducts, mullions, and exposed structure – compete for attention at the same time, that the building becomes almost an abstraction.

It is this quality that prompted Peter Cook, Archigram's founding father, to write in his introduction to the monograph that Rogers himself prepared on his work that he was 'delighted that Rogers' work is now achieving a level of uncomfortableness for the general-level English architects that one noticed with Stirling's work some ten years ago. They *have* to admit that it is good, but could they bring themselves to do it – even if they had the talent anyway?'[8] This is another way of saying that Rogers has gone beyond the simple, easy course of a building which grows out of the orderly arrangement of its working parts. There is an expressionist quality to some of the details at Lloyd's that recalls not so much the Paxton of the Crystal Palace, cited so often as an inspiration for Lloyd's barrel vault, but the structural fascinations of Gaudí. The twin-duct airconditioning system, curving into the building from outside the atrium wall, has exactly this kind of sculptural quality. And in this connection it is fascinating to see that so many of Rogers's projects after Lloyd's (his entry for the first National Gallery extension competition and the Whittington Street development in particular) have begun to draw on sources such as Mendelsohn.

This expressionist quality is in fact the real strength of Lloyd's. It is a building which has gone to extremes that are impossible to absorb painlessly. It will go on and on looking extraordinary and will never be consumed in the way that those mirror-glass two-day wonders of Dallas or the art deco revivalism of the American architect Helmut Jahn are consumed, turned into instant celebrities and then just as instantly discarded, visually worn out.

It would be wrong, however, to discuss Lloyd's simply as an object within space. Rogers's touch is surest when he is dealing with urban concerns. His buildings are extraordinary, but nevertheless they conform to the traditional grain of cities, in which narrow streets are mixed with open spaces, and are catalysts for bringing new life into the urban setting. The Beaubourg is not simply a building that stops with its perimeter wall: the square in front is just as much one of its great spaces as the exhibition floors within. And it is this quality that Rogers has sought to bring to Lloyd's too. Thus it attempts to reinforce the sense of enclosure around Leadenhall Market, as well as to give a sense of the private activities within Lloyd's to passers-by, and to create a new focus within the City of London.

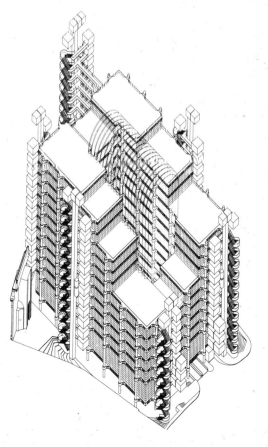

Epilogue

The 1980s have been presented by many commentators as a watershed for British architecture, in which an alleged loss of faith in the certainties of the recent past has swept aside a prevailing set of architectural dogmas, opening up the way for a more eclectic, and, it is argued by some, a more popular form of architectural expression. But in fact, the picture is by no means so clear, or so simple.

Firstly, the great majority of architectural work is still carried out, as it has been for the past fifty years or more, by large architectural organizations, now mostly private rather than public, which have next to no interest in the practice of architecture as an art. Most architectural critics have taken an equally small interest in their buildings and refuse to take them seriously, or even to discuss them. Yet it is these organizations that are responsible for the greater part of the changes that we see in the fabric of Britain's towns and cities, and indeed the picture is not so different elsewhere in the world, where by and large the same kind of architects exist and do by and large the same kind of work.

For such architects, the work of those who aspire to 'art', if so it may be described, is a crib, a pattern book in almost exactly the eighteenth-century sense, a source of imagery to be selected or discarded as seems expedient. Whatever the suitability of modernist mannerisms for such a purpose, there are obvious advantages in this system for those who define themselves as up-to-date by borrowing the motifs of those architects defined by the critics as significant. Hence, during the 1960s, those firms which wished to present themselves as being of an enlightened outlook were quick to abandon the no longer fashionable vocabulary of Brutalism – boardmarked concrete – and adopted instead the red tiles and patent glazing that clearly derive from a superficial enthusiasm for Stirling and Gowan's Leicester building. In the 1970s, the government's tax incentives for industrial buildings led to a glut of new factories and warehouses for which the elegantly refined sheds of Foster and Rogers proved the model. After the mushrooming of hundreds of crinkly-tin imitations of the Reliance Controls building, the sudden eruption of the Fleetguard factory's masted structure (1980) may be explicable in part at least as an attempt to keep ahead of the pack.

The 1980s, with Stirling building once again, have seen saturation coverage of post modernism in the architectural media: hence the first signs of a wave of masonry-skinned mini-monuments that represent an attempt to tame the disturbing quality of Stirling's work. It is an unpopular vanguard role that Foster, Rogers and Stirling have all found themselves forced to play. But the attention that has been focused on them, and in particular the opportunities that this has given them to build

on a large scale, and with relatively unconstricted budgets, has inevitably given them a function that goes beyond the simple unselfconscious practice of architecture.

They do in some way represent British architecture, by standing for widespread concerns with which it is now preoccupied, and the excellence to which it can aspire. They have both influenced other architects and represented the concerns of the profession as a whole. But they are not an isolated phenomenon. They have links with and debts to other architects both here and abroad. But as far as the British architectural picture is concerned, it is the sheer quantity of work that they have been able to build that singles them out from other 'art' architects. Cedric Price and Peter Cook, if not the illegitimate parents of the Beaubourg, then at least its curtain-raisers, have between them built precisely three buildings. Nick Grimshaw, who has dedicated his career to the 'kit-of-parts' approach, has been trapped in the minimal budgets of factory estates for the greater part of his career. The younger generation – people like Ian Ritchie, Robin Stanton, Richard Horden and others who have graduated through the Foster and Rogers offices – is still struggling, confirming if there were any doubt that in architecture opportunity is even more important than inspiration. Of this group, only Michael Hopkins, a one-time partner of Norman Foster, is now beginning to graduate to the kind of commissions and the budgets that allow architectural reputations to be made. Stirling, with the emphasis of his work rather different from that of Foster and Rogers, is in many ways even more isolated. There is nobody else in Britain with both his breadth of ambition and the opportunity to put it into practice.

In the years since 1945, the restricted scope of the British architectural scene has allowed some figures to assume much more importance at home than they would elsewhere have been granted. It was, therefore, particularly startling for the British, who have in this century enjoyed high regard internationally for the intellectual calibre of their architectural debate, but hardly any – since Lutyens at least – for the quality of their realized work, to find that not just one but three contemporary architects were being treated with the utmost seriousness abroad, perhaps even more than at home. All three are in demand as much for teaching as for architectural commissions.

Their success signals both the end of the provincialism of British architecture and the growing internationalism of the architectural world. Similar debates now take place in New York and Tokyo, as well as in London, and often with many of the same personnel involved. Cities like Frankfurt, Los Angeles and Paris have thrown off the parochialism that demands that the prime jobs go to the local heroes. Despite its lack of reciprocal generosity, no country has benefited more from that openness than Britain.

On the international stage, Stirling is now perhaps the maturest talent of his generation. In his objectives he is comparable perhaps only to Arata Isozaki and Michael Graves, although, with a much wider spread of realized buildings than either of them, he has been much more influential. Stirling and Wilford have now built two important buildings in America, two in Germany, and a whole series in Britain, as well as having planned highly influential schemes in Italy, Peru, Iran, Qatar and Holland. Such a wide spread has never before been possible.

The work of Foster and Rogers also covers an unprecedented geographical sweep, from Norway to Hong Kong, and from Seattle to Florence. And yet this is not an example of the way in which international modernism has made the world lose its diversity; their work has been in demand because of their talent for responding to specific places. Rogers and Foster, with their almost innocent abiding faith in the virtues of making things, their acceptance of change rather than fear of it, and their enthusiasm for the creative power of technology, have chosen to follow a rather different course from Stirling's later work, but it is one which has also attracted many followers around the world. Each of the three has had pressing offers to leave Britain, but all have chosen to stay in London, where the distinctive atmosphere of the architectural community has given their work a specific Britishness.

Architecture is as much a product of patronage as of individual inspiration. Great buildings are not achieved in private, on canvas in a studio; they depend on the public, and on the individual will, to see them realized. The success of Foster, Rogers and Stirling has at least in part been due to the way they have been able to communicate with the people who commission them. The real change of the last decade, in Britain at least, is that architecture has been transformed from an intensely private debate, carried out on paper and in the smoke-filled rooms of architectural schools, into a matter of genuine public concern, fought out on the streets once more.

Norman Foster

Born 1 June 1935,
Manchester. Educated at the
University of Manchester
School of Architecture and
Department of Town and
Country Planning.
Postgraduate studies at Yale
University School of
Architecture. Married the
architect Wendy Cheeseman
in 1964. Two children.
Worked in partnership with
Richard and Su Rogers and
Wendy Foster as Team 4
between 1963 and 1967.
Since then has practised as
Foster Associates.

*Norman Foster, with a model of the
double-skin Dymaxion house,
designed in conjunction with
Buckminster Fuller.*

Buildings and projects

Key	● Building under construction or completed
	○ Project

Team 4

1963	● Retreat at Pill Creek, Feock, Cornwall
1964	● Extension to Forest Road School, London
	○ Waterfront housing, Pill Creek, Feock, Cornwall
1965	○ Housing for Wates Ltd, Coulsdon, Surrey
1966	● Jaffe House, Radlett, Hertfordshire
	● Creek Vean House, Pill Creek, Feock, Cornwall
1967	● Three houses, Murray Mews, London
	● Factory for Reliance Controls Ltd, Swindon, Wiltshire

Foster Associates

1967	○ School in Newport, Gwent
1968	● Temporary air-supported structure for Computer Technology Ltd, Hemel Hempstead, Hertfordshire
1969	● Amenity Centre for Fred Olsen Ltd, Millwall Docks, London
1971	○ Climatroffice (with Buckminster Fuller)
	○ Theatre for St Peter's College, Oxford (with Buckminster Fuller)
	● Studio for Foster Associates Ltd, Great Portland Street, London
	● Advance Head Office for IBM, Cosham, Hampshire
	● Offices for Computer Technology Ltd, Hemel Hempstead, Hertfordshire
	● Special Care Unit school, Hackney, London
	● Passenger terminal for Fred Olsen Ltd, Millwall Docks, London

Buildings and projects

Norman Foster has taught at: University of Pennsylvania; Architectural Association, London; Bath Academy of Art; London Polytechnic (external examiner and member of Visiting Board of Education); Royal Institute of British Architects. Winner of the Royal Gold Medal for Architecture, 1983; Associate Royal Academician.

Principal exhibitions: 'Original Drawings: Foster Associates', Royal Institute of British Architects (Heinz Gallery), London, 1978; 'Three New Skyscrapers', Museum of Modern Art, New York, 1983; 'Norman Foster: Architect. Selected Works 1962/84', Whitworth Art Gallery, Manchester, 1984; 'Norman Foster', Sainsbury Centre, University of East Anglia, 1985; 'Norman Foster', Institut français d'architecture, Paris, 1986; 'New Architecture: Foster, Rogers, Stirling', Royal Academy of Arts, London, 1986.

	
1972	○ Headquarters for Volkswagen/Audi, Milton Keynes, Buckinghamshire
1973	● Factory for SAPA, Tibshelf, Derbyshire
	● Factory for Modern Art Glass Ltd, Thamesmead, Kent
	● Interiors of Orange Hand boyswear shops for Burton Menswear (destroyed)
1974	○ Offices for Fred Olsen Ltd, Vestby, Norway
	● Travel Agency for Fred Olsen Ltd, Regent Street, London (destroyed)
1975	● Public housing, Bean Hill, Milton Keynes, Buckinghamshire (now altered)
	● Head office for Willis, Faber and Dumas, Ipswich, Suffolk
	● Palmerston Special School, Liverpool
1976	○ Regional planning studies for Gomera, Canary Islands
	○ Masterplan for St Helier harbour, Jersey
1977	○ Interchange for London Transport, Hammersmith, London
	● Technical Park for IBM, Greenford, Middlesex (Stage 1)
1978	○ Extension and residential tower for the Whitney Museum, New York (with Derek Walker Associates)
	○ Experimental Dwelling System
	○ Open House community centre, Cwmbran, Gwent
	● Sainsbury Centre for Visual Arts, University of East Anglia, Norwich
1979	○ House systems studies
	● Shop for 'Joseph', Knightsbridge, London (now altered)
	● Headquarters for the Hongkong and Shanghai Banking Corporation, Hong Kong (completed 1986)
1980	● Passenger terminal for Stansted Airport, Essex (scheduled for completion in 1990)
	● Technical Park for IBM, Greenford, Middlesex (Stage 2)
1981	● National German Indoor Athletics Stadium, Frankfurt, (building is expected to begin in 1986)
	Furniture for Foster Associates Ltd.
1982	○ Office Tower for headquarters of Humana Inc., Louisville, Kentucky
	○ Autonomous House, USA (with Buckminster Fuller)
1983	● Distribution centre for Renault UK Ltd, Swindon, Wiltshire
	○ New Broadcasting Centre for the BBC, Langham Place, London
1984	● New masterplan for technical park for IBM at Greenford, Middlesex
	● Major refit for IBM Head Office, Cosham, Hampshire
1985	● Médiathèque arts centre, Nîmes
1986	Furniture for Tecno, Italy
	● Interiors of shops for Katharine Hamnett Ltd, London

Richard Rogers

Born 23 July 1933, Florence, of British parents. Educated at the Architectural Association, London, and Yale University School of Architecture. Married, first, the architect Su Brumwell, second, Ruth Elias. Five children. Worked in partnership with Norman and Wendy Foster and Su Rogers until 1967 and with Su Rogers until 1971, from 1971 until 1977 worked in partnership with Renzo Piano as Piano + Rogers. John Young joined the partnership in 1969, followed in 1971 by Marco Goldschmied. In 1977 established a new partnership (Richard Rogers and Partners), which includes Marco Goldschmied, John Young and Mike Davies. Has taught at the University of California (Los Angeles and Berkeley), and at Princeton, Harvard, Cornell, McGill, Hong Kong, Aachen and Cambridge universities; examiner at the Architectural Association, London. Winner of the Royal Gold Medal for Architecture, 1985; Légion d'Honneur; honorary doctorate of the Royal College of Art; Associate Royal Academician; honorary member of the American Institute of Architects.

Principal exhibition: 'New Architecture: Foster, Rogers, Stirling', Royal Academy of Arts, London, 1986.

Buildings and projects

Team 4

1963	● Retreat at Pill Creek, Feock, Cornwall
1964	● Extension to Forest Road School, London
	○ Waterfront housing, Pill Creek, Feock, Cornwall
1965	○ Housing for Wates Ltd, Coulsdon, Surrey
1966	● Jaffe House, Radlett, Hertfordshire
	● Creek Vean House, Pill Creek, Feock, Cornwall
1967	● Three houses, Murray Mews, London
	● Factory for Reliance Controls Ltd, Swindon, Wiltshire

Richard and Su Rogers

1967–8	● Spender House, Ulting, Essex
1968	○ Zip-up House No 1
1968–9	● House for Richard Rogers's parents, Wimbledon, London
1969	● York Mason House, London
	● Offices and studio for Design Research Unit (DRU), Aybrook Street, London
1969–70	● Factory for Universal Oil Products, Ashford, Kent
1971	○ Zip-up House No 2
	● Roof extension for Design Research Unit (DRU), Aybrook Street, London

Piano + Rogers

1971	● Service module for ARAM (medical centre), Washington DC
	● Centre National d'Art et de Culture Georges-Pompidou, Paris (completed 1976)
	● Institut de Recherche et coordination Acoustique/Musique, Paris (completed 1976)
1972–3	● Offices and factory for B&B Italia, Como
1973	○ Park Road development, St John's Wood, London
1973–4	● Factory for Universal Oil Products, Tadworth, Surrey
1974–5	● Laboratory for PA Technology, Phase 1, Melbourn, Hertfordshire
1977	○ Housing at Millbank, London

Richard Rogers and Partners

1977	○ Fleet Air Museum, Yeovilton, Somerset
1978	● Headquarters for Lloyd's, City of London (completed 1986)
1979	○ Laboratories for Napp, Cambridge
	○ Redevelopment of Coin Street, London (abandoned 1984)
1980	● Fleetguard Factory for Fleetguard, Quimper, Brittany
1981	○ Development study, Free Trade Wharf, Limehouse, London
	● Laboratory for PA Technology, Phase 2, Melbourn, Hertfordshire
1982	● Factory for Inmos, Newport, Gwent
	○ Extension for the National Gallery, London
1982–3	● Laboratories and offices for PA Technology, Princeton, New Jersey
1983	● Industrial units and housing at Thames Wharf, Hammersmith, London
	○ Redevelopment of Whittington Avenue, City of London

Richard Rogers, photographed on the roof of the new Lloyd's building, London.

Buildings and projects

1983–4	● Industrial units at Maidenhead, Berkshire
1984	○ Planning study for urban conservation, Florence
	○ Royal Docks strategic plan, London
1985	● Factory for Linn Products, Glasgow (completion in 1987)
	○ Office development, First Church of Christ Scientist, Seattle
	○ Office development for Saatchi and Saatchi, New York
1986–7	● Redevelopment of Billingsgate Market, London, as Trading Floor and Offices for Citibank
	○ Shopping centres in Paris and Nantes
	○ Headquarters for the Wellcome Foundation

James Stirling

Born 1926, Glasgow. Educated at the University of Liverpool School of Architecture and the University of London School of Town Planning and Regional Research. Married Mary Shand, 1966. Three children. Senior assistant with Lyons, Israel and Ellis, 1953–6. Worked in partnership with James Gowan as Stirling and Gowan from 1956 until 1963, then practised as sole partner in the firm of James Stirling until 1971, when Michael Wilford became a partner. The partnership is now known as James Stirling, Michael Wilford and Associates.

James Stirling

1950	○ Town-centre building for Newton Aycliffe, Durham (thesis for University of Liverpool)
1951	○ Office building and film institute for the I Ionan Competition of the Liverpool Architectural Society
	○ Core and crosswall house
	○ Stiff dom-ino housing
1952	○ Technical College, Poole, Dorset
1953	○ Sheffield University (with Alan Cordingley)
	○ House in north London
1954	○ House in Woolton Park, Liverpool
1955	○ Village project (with Team X)

James Stirling and James Gowan

1955	● Flats at Ham Common, Richmond, London (completed 1958)
1956	● House on the Isle of Wight (completed 1958)
	○ Studies for a house
	○ House in the Chilterns
1957	○ Three houses for the Mavrolean family
	● House conversion in Kensington, London (completed 1959)
	○ Expandable house
	● Infill housing, Preston, Lancashire (completed 1959)
1958	○ Steel-mill cladding
	○ Churchill College, Cambridge
	● School assembly hall, Camberwell, London (completed 1961)
1959	○ Student apartments for Selwyn College, Cambridge
	● Engineering Building, Leicester University (completed 1963)
1960	● Children's home, Putney, London (completed 1964)
	● Old people's home, Blackheath, London

James Stirling

1964	● History Faculty Building for Cambridge University (completed 1967)
	● Flats, Camden Town, London (completed 1968)
	● Accommodation for St Andrews University (completed 1968)
1965	○ Headquarters for Dorman Long
1966	● Florey Building, Queen's College, Oxford (completed 1971)
1967	● Housing at Runcorn New Town (completed 1976)
1968	○ Redevelopment study for New York City (with Arthur Baker)

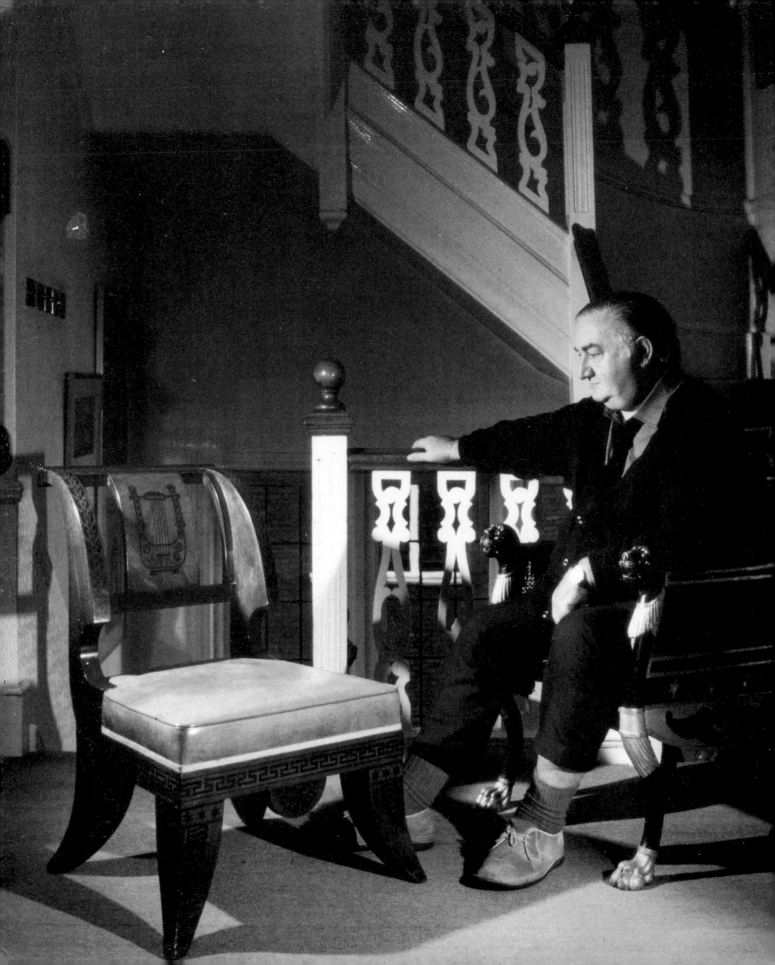

Visiting lecturer at the
Architectural Association,
London, 1955, at Regent
Street Polytechnic, London,
1956-7, and at Cambridge
University School of
Architecture, 1958. Charles
Davenport Visiting Professor
at Yale University School of
Architecture from 1967.
Guest professor at Dusseldorf
Kunstakademie from 1977.
Winner of the Royal Gold
Medal for Architecture, 1980,
and the Pritzker Prize, 1981;
Associate Royal Academician.

Principal exhibitions:
'James Stirling – Three
Buildings', Museum of
Modern Art, New York, 1969;
'James Stirling', Royal
Institute of British Architects
(Heinz Gallery), London,
1974; 'New Architecture:
Foster, Rogers, Stirling',
Royal Academy of Arts,
London, 1986.

*James Stirling at home, with part of
his collection of Thomas Hope
furniture.*

Buildings and projects

1969	● Low-cost mass housing, Lima (completed 1976)
	● Olivetti training school, Haslemere, Surrey (completed 1972)
	○ Data-processing complex and corporate headquarters for Siemens AG, Munich
1970	○ Civic Centre, Derby

James Stirling and Michael Wilford

1971	○ Headquarters for Olivetti, Milton Keynes, Buckinghamshire
	○ Arts centre for St Andrews University
1972	● Southgate housing at Runcorn New Town (completed 1977)
1975	○ Museum for Northrhine Westphalia, Düsseldorf
	○ Wallraf-Richartz Museum, Cologne
1976	○ Meineke Strasse, Berlin
	○ Government Centre, Doha
	○ Regional Centre, Tuscany (with Castore, Malanima and Rizzi)
1977	○ Revisions to G. B. Nolli's plan for Rome
	○ Dresdner Bank, Marburg
	○ Housing study of Muller Pier, Rotterdam
	● New building and chamber theatre for the Staatsgalerie, Stuttgart (completed 1984)
1978	○ Institute of Biology and Biochemistry, Tehran (in association with Burckhardt and Partner)
	○ Bayer AG PF Zentrum, Monheim
	○ Fifteen luxury houses, Manhattan, New York
1979	● Extension of School of Architecture, Rice University, Houston (completed 1981)
	● Wissenschaftszentrum, Berlin (completion in 1987)
	● Arthur M. Sackler Museum (extension of Fogg Museum), Harvard, Massachusetts (completed 1984)
	● Theatre school, auditorium and concert hall, Stuttgart
1980	○ Chemistry department for Columbia University, New York
	● Clore Gallery for Tate Gallery, London (scheduled for completion in 1987)
	○ Master plan for Tate Gallery expansion
1981	○ Houston Plaza, Houston
1982	● Performing Arts Center, Cornell University, Ithaca, New York (completed 1986)
1983	○ New town for Casalecchio di reno, Bologna
	○ Proposals for reuse of Fiat Lingotto Factory, Turin
	○ Headquarters for British Telecom National Networks, Milton Keynes, Buckinghamshire
	○ Public library for Latina, near Rome
1984	● Conversion of the Albert Dock, Liverpool, for the Tate Gallery (scheduled for completion in 1988)
1985	○ Extension for the National Gallery, London
	○ Building for the J. Paul Getty Museum, Malibu, California
	○ Redevelopment of No. 1, Poultry, City of London
	○ Museums of New Art and Sculpture, Tate Gallery, London
	○ Transport interchange, Bilbao
1986	○ Thyssen Museum, Lugano

Bibliography and sources of illustrations

AD Architectural Design
AR Architectural Review
RIBAJ Journal of the Royal
Institute of British
Architects

Appleyard, Bryan, *Richard Rogers: A biography* (London, 1986)
Arnell, P. and T. Bickford, *James Stirling: Buildings and Projects*. Introduction by Colin Rowe. (London, 1984)
Banham, Reyner, *Age of the Masters: A Personal View of Modern Architecture* (London, 1975)
———— *The Architecture of the Well Tempered Environment* (London, 1969)
———— 'The History Faculty Building, Cambridge', *AR*, November 1968, p.329
———— *Megastructure: Urban Futures of the Recent Past* (London, 1976)
Banham, Reyner, Norman Foster and L. Butt, *Foster Associates* (London, 1979)

Campbell Cole, Barbie, and Ruth Elias Rogers (eds), *Richard Rogers + Architects* (London, 1985)
Chermayeff, Serge, and Christopher Alexander, *Community and Privacy* (London, 1963)
Colquhoun, Alan, 'A Critique', *AD*, February 1977, p.98
———— 'The Democratic Monument', *AR*, December 1984, p.20
Conrads, Ulrich (ed.), *Programmes and Manifestoes on 20th-Century Architecture* (London, 1970)
Curtis, William, *Modern Architecture since 1900* (Oxford, 1982)
Drexler, Arthur, *Transformations in Modern Architecture* (New York, 1979)
Emanuel, Muriel (ed.), *Contemporary Architects* (London, 1982)
Foster, Norman, 'Foster Associates, Recent Work', *AD*, November 1972, p.

———— 'Exploring the client's range of options', *RIBAJ*, June 1970, p.246
Frampton, Kenneth, *Modern Architecture: A Critical History* (London, 1980; revised and enlarged edition, 1985)
Jacobus, John, 'Engineering Building, Leicester University', *AR*, April 1964, p.253
James Stirling, AD Profile (London, 1982)
Jencks, Charles, *The Language of Post-Modern Architecture* (London, 1977; 4th edn, 1984)
———— *Late Modern Architecture* (London, 1980)
———— *Modern Movements in Architecture* (London, 1973)
Jencks, Charles, and William Chaitkin, *Current Architecture* (London, 1982)
Krier, Leon, 'The Reconstruction of the European City', in P. Portoghesi, *The Presence of the Past*, catalogue of the first international

architecture exhibition, Venice (Milan, 1980)

Lampugnani, V.M. (ed.), *The Thames and Hudson Encyclopaedia of 20th-Century Architecture* (London, 1986)

Lasdun, Denys (ed.), *Architecture in an Age of Scepticism* (London, 1984)

Norman Foster: Architect. Selected Works 1962/84. Catalogue of an exhibition at the Whitworth Art Gallery. (Manchester, 1984)

Pevsner, Nikolaus, *Pioneers of Modern Design from William Morris to Walter Gropius* (London, 1949)

Rogers, Richard, 'Architects' Approach to Architecture', *RIBAJ*, January 1977, p.11

———— 'The Coin Street Development', *AR*, May 1981, p.273

Rogers, Richard, and Renzo Piano, 'Architecture', *AD*, May 1975, p.276

———— 'A Statement', *AD*, February 1977, p.87

Rossi, Aldo, *The Architecture of the City* (Cambridge, Mass., and London, 1981; translation of *L'architettura della città*, 1966)

Saint, Andrew, *The Image of the Architect* (London, 1983)

Spaeth, David, *Mies van der Rohe* (New York, 1985)

Stirling, James, 'An Architects' Approach to Architecture', *RIBAJ*, May 1965, p.231

———— *Buildings and Projects 1950-1974* (London, 1975)

———— 'From Garches to Jaoul', *AR*, September 1955, p.151

———— 'Regionalism and Modern Architecture', in Trevor Dannatt (ed.), *Architects' Year Book*, 8, 1957, p.62

Suckle, Abby (ed.), *By Their Own Design* (London, 1980)

Tafuri, Manfredo, and Francesco Dal Co, *Modern Architecture* (London, 1980)

Watkin, David, *Morality and Architecture* (Oxford, 1977)

———— *The Rise of Architectural History* (London, 1980)

Notes on the text

Abbreviated references are to books and articles listed in the bibliography

**Chapter One:
Three careers**
Pages 9–31
1 Stirling, 'From Garches to Jaoul', p.151
2 Stirling, *Buildings and Projects 1950-1974*, p.14
3 Speech of acceptance at the presentation of the Royal Gold Medal for architecture, 1980, published in *James Stirling, AD* Profile, p.12
4 Stirling, 'Regionalism and Modern Architecture', pp.62-64
5 Ibid.
6 Ibid.
7 Jacobus, 'Engineering Building, Leicester University', p.254
8 Rogers and Piano, 'Architecture', pp.276-277
9 Ibid.
10 Rogers and Piano, 'A Statement', p.87
11 Colquhoun, 'A Critique', p.98
12 Norman Foster, in conversation with the author, 1979
13 Speech of acceptance at the presentation of the Royal Gold Medal for Architecture, 1980, published in *James Stirling, AD* Profile, p.12

**Chapter Two:
The modern tradition**
Pages 33–47
1 Walter Gropius, *The New Architecture and the Bauhaus* (London, 1935), p.17
2 Quoted in Spaeth, *Mies van der Rohe*, p.7
3 *James Stirling*, AD Profile, p.12
4 Jencks, *The Language of Post-Modern Architecture*, p.12
5 Speech of acceptance at the presentation of the Pritzker Prize, 1981, published in *James Stirling, AD* Profile, p.21
6 *James Stirling, AD* Profile, p.12
7 Quoted in Lasdun (ed.), *Architecture in an Age of Scepticism*, p.135
8 Norman Foster, in conversation with the author, 1981
9 Ibid.
10 *Norman Foster: Architect* (unnumbered pages)
11 Foster, 'Foster Associates, Recent Work', p.237
12 Quoted in Emanuel (ed.), *Contemporary Architects*, p.151
13 Quoted in Campbell Cole and Elias Rogers, *Richard Rogers + Architects*, p.17
14 Ibid., p.19
15 Ibid., p.18
16 Ibid., p.19
17 Ibid.

**Chapter Three:
The machine aesthetic**
Pages 49-61
1 Stirling, *Buildings and Projects 1950-1974*, pp.19-20
2 Quoted in Suckle (ed.), *By Their Own Design*, p.159

**Chapter Four:
Architecture as a political art**
Pages 63-71
1 Rogers, 'Architects'

Approach to Architecture',
p.11
2 Ibid.
3 Rogers, 'The Coin Street
Development', p.273
4 Arnell and Bickford,
*James Stirling: Buildings and
Projects*, p.105
5 Watkin, *Morality and
Architecture*, pp.11-12
6 Arnell and Bickford,
*James Stirling: Buildings and
Projects*, p.105
7 Le Corbusier, *Vers une
architecture* (1923); the
quotation is from the English
translation, *Towards a New
Architecture* (London, 1937,
repr. 1946), p.250
8 Foster, 'Exploring the
client's range of options',
p.246
9 Foster, 'Foster Associates,
Recent Work', p.237

Chapter Five:
Working methods
Pages 73-87
1 Stirling, 'An Architect's
Approach to Architecture',
p.237
2 Ibid., p.236

3 Ibid., p.239
4 Ibid., p.237
5 *Norman Foster: Architect*
(unnumbered pages)
6 Heseltine, unpublished
speech made to the RIBA
annual conference,
Newcastle, 1980 (author's
own transcript)
7 Ibid.

Chapter Six:
Plan and non-plan
Pages 89-107
1 *James Stirling*, AD Profile,
p.64

Chapter Seven:
Building in the city
Pages 109-133
1 Krier, 'The
Reconstruction of the
European City', p.217
2 Ibid.
3 From the CIAM charter
of Athens, reprinted in
Conrads (ed.), *Programmes
and Manifestoes on 20th-
Century Architecture*, p.139
4 From Walter Gropius and
Martin Wagner, 'A

Programme for the City
Reconstructed', reprinted in
Conrads (ed.), *Programmes
and Manifestoes on 20th-
Century Architecture*, p.146
5 Krier, 'The
Reconstruction of the
European City', p.217
6 Norman Foster, in
conversation with the author,
1979
7 *Norman Foster: Architect*
(unnumbered pages)
8 Ibid.
9 Ibid.
10 Stirling, 'From Garches
to Jaoul', p.146
11 Arnell and Bickford,
*James Stirling: Buildings and
Projects*, p.197

Chapter Eight:
Living with the past
Pages 135-145
1 Vincent Scully,
Introduction to *Global
Architecture, Document 1*
(Tokyo, 1979), p.16
2 Campbell Cole and Elias
Rogers (eds), *Richard Rogers +
Architects*, p.19
3 Ibid.

Chapter Nine:
**Monuments for a
secular age**
Pages 147-189
1 Quoted in Emanuel (ed.),
Contemporary Architects, p.84
2 Arnell and Bickford,
*James Stirling: Buildings and
Projects*, p.252
3 *James Stirling*, AD Profile,
p.56
4 Colquhoun, 'The
Democratic Monument', p.20
5 Campbell Cole and Elias
Rogers (eds), *Richard Rogers +
Architects*, p.18
6 Ibid., p.131
7 Ibid., p.130
8 Ibid., p.9

Index